OVER HONG KONG

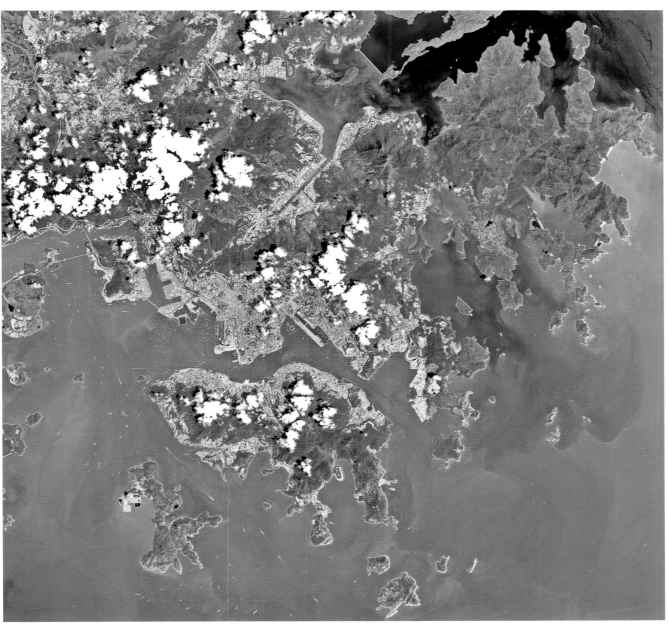

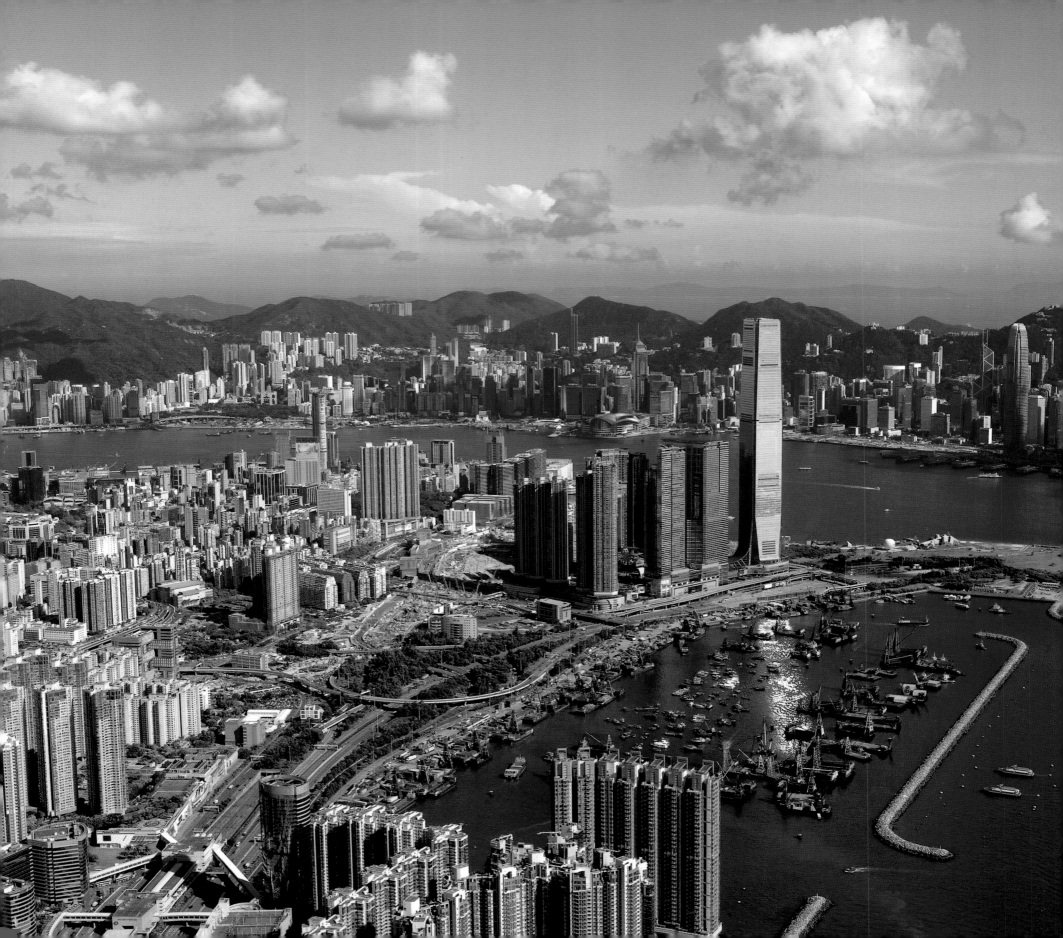

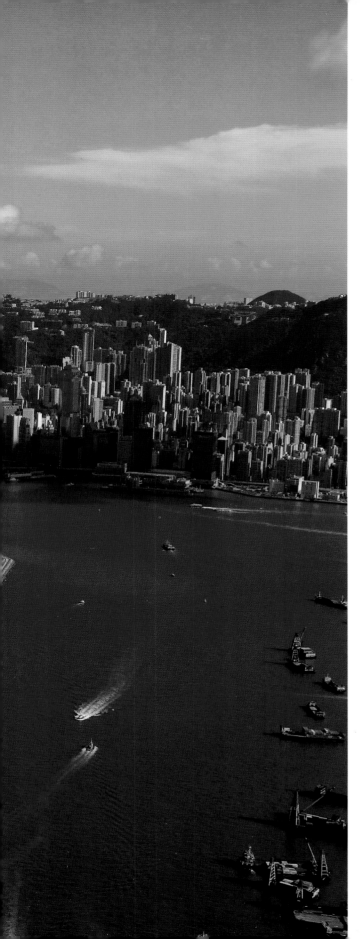

FOREWORD

Hong Kong is my home. I was born here and have spent most of my life here.

In my younger days, my father took me to see many places of the territory – from traditional villages, lush countryside and sparkling seascapes to narrow shopping alleys and the hustle and bustle of our vibrant city. I learned to appreciate the many different facets of Hong Kong – its history, its scenic beauty, the tranquillity of the countryside and the dynamism of its business districts. Everywhere one looks, there is a scene to delight the eye.

Looking through this magnificent photo story of Hong Kong, I am convinced more than ever that Hong Kong and the people here, with their amazing vitality and resilience, would only grow to become more successful. While my business is to continue building quality spaces for people to live and work in and to enjoy, I have a broader concern for the well-being and development of the people of Hong Kong, especially our younger generations who will one day become the pillars of our society.

Care for the people and the place where we all live is the spirit underlining my company's motto of *Building Homes with Heart*. It is the very basis of our philosophy. My job, indeed my passion, is to make sure that we mean what we say, that is building homes with heart. Preserving the beauty of Hong Kong truly is at the heart of what we do.

The wonderful photographs on these pages, taken from the air, offer an unusual and dramatic perspective of how Hong Kong – and our Group – has evolved over the years. They transport us into a previous era while also providing a glimpse of progress yet to come.

They remind me very much of why Hong Kong is, and will remain, my home.

Kwok Ping-luen, Raymond
Chairman and Managing Director
Sun Hung Kai Properties

AIRPHOTO INTERNATIONAL LTD.
BONHAM MEDIA & PR LTD.

Odyssey Books & Maps is a division of Airphoto International Ltd.
5C, Wise Mansion, 52 Robinson Road, Hong Kong.
Tel: (852) 2856 3896
E-mail: magnus@odysseypublications.com
www.odysseypublications.com

Distribution in the USA by Independent Publishers Group,
814 N. Franklin Street, Chicago, IL 60610, USA.
Tel: (1) 312 337 0747; Fax: (1) 312 337 5985; www.ipgbook.com

Distribution in the UK and Europe by Cordee Ltd.
11 Jacknell Road, Dodwells Bridge Industrial Estate,
Hinckley, Leicestershire LE10 3BS, UK.
Tel: (1455) 611-185; info@cordee.co.uk; www.cordee.co.uk

Distribution in Australia by Woodslane Pty Ltd.
10 Apollo Street, Warriewood, NSW 2102, Australia.
Tel: (2) 8445 2300; Fax: (2) 9997 5850; www.woodslane.com.au

Over Hong Kong Volume Nine, First Impression, 2018
ISBN: 978-962-217-880-9
Library of Congress Catalog Card Number has been requested.
Copyright © 2018, published by Airphoto International Ltd
and Bonham Media & PR Ltd.

Managing Editor: David Chappell
Designer: Au Yeung Chui Kwai

Printed in Hong Kong by Paramount Printing Company Ltd.

Over Hong Kong

Primary Photography by Moby Lau Hoi Tung, Lew Roberts,
Magnus Bartlett, Kasyan Bartlett
Primary Drone Photography by D J Clark
Satellite images sourced by Martin Ruzek
Foreword by Raymond Kwok Ping-luen
Preface by Alan Cheung
Introduction by David Dodwell
Postscript by Yip Dicky, Peter, BBS, MBE, AE, JP
Text by David Chappell

Acknowledgements

This edition would not have been possible without the generous support of Raymond Kwok Ping-luen and
Sun Hung Kai Properties.

The Publisher wishes to thank the following people and organisations:

Diana Chou, Chairman, DGA Group, special thanks for her invaluable support and encouragement from
the outset

Yip Dicky, Peter, BBS, MBE, AE, JP

Stephen Yiu at Multilingual Translation Services

Alan Cheung and The Hong Kong Collectors Society for photographs on pages 6, 50 & 74

Ronna Lau and Kasyan Bartlett, for gracious assistance with respect to intellectual property

Alastair Gray, for guidance with respect to drone technology

Cliff Dunnaway at Tiger Bay, and Gordon Andreassand, for archival advice

Paul Kwan at Paramount Printing Ltd

Ela Lo, Michael Wong and all the support staff at Heliservices HK over three decades of flying over Hong Kong

Sir Michael Kadoorie for his tireless and on-going efforts to facilitate helicopter services in HK and the region

Sir David Tang, for helping us get off the ground in the early eighties, RIP

Worldwide Cruise Terminals for the photograph on page 79

Royal Air Force for photographs on pages 17 & 40

Sun Hung Kai Properties for photographs on pages 98 & 106

Landsat images courtesy of the US Geological Survey and NASA

The map on page 140 is printed by courtesy of the Survey & Mapping Office, Lands Department, HKSAR
Government and © HKSAR Government.

We extend our apologies to anyone inadvertently overlooked and missing credits or permissions will be
addressed in future editions.

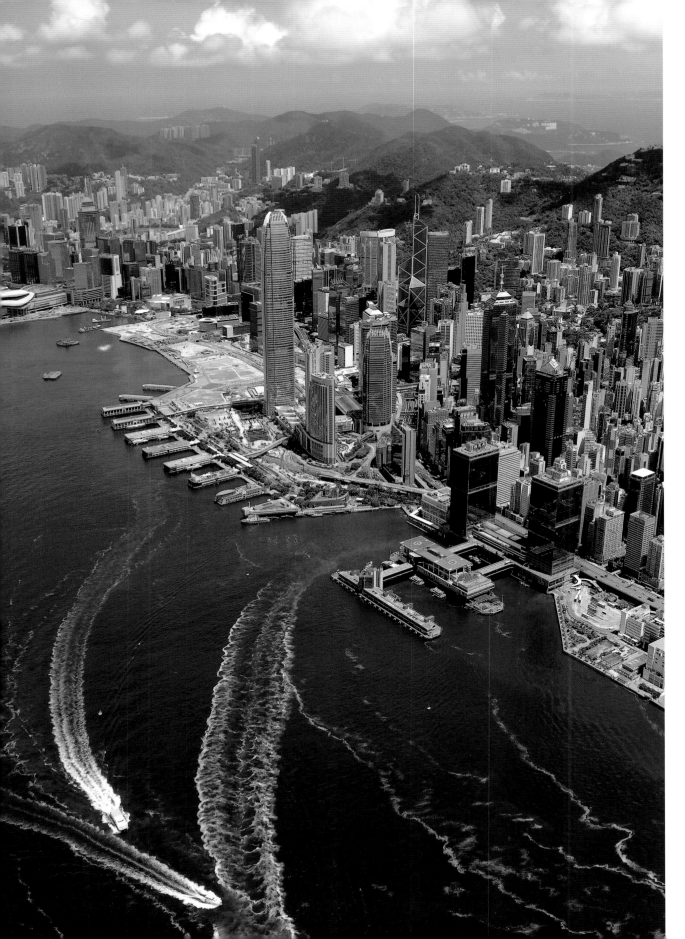

Contents

Preface

The Story of a Significant City – HONG KONG

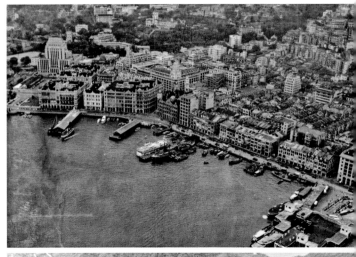

Before 1841, what is now known as Hong Kong was a collection of small villages, with a population of around 10,000 people. The inhabitants living here mainly relied on fishing and farming, but with other trades such as incense-making. Curiously, it is that trade which gave Hong Kong its name, Fragrant Harbour.

There was little change until after the occupation by the British in 1841. The manner of living gradually evolved from then on. At the very beginning of the occupation, the majority of lands on Hong Kong Island were divided into districts along the northern shore; the City of Victoria (Central) and East Point (Causeway Bay) with a major military area, Victoria Cantonment, between them where Admiralty is now. In those early days, the British treated Canton and Macau as the primary bases for trading, whilst Hong Kong was comparatively not so important, its sole advantage being a safe harbour.

Looking at the layout of the city, the major area of Victoria was regarded as the centre of political, financial and commercial life. The Europeans (regarded as the rich people unused to living in the tropics) mostly lived uphill and, of course, on The Peak. The Chinese people all lived at the eastern and western ends of the Island. It wasn't until 1947 that the ban on Chinese people living on The Peak was rescinded, though for some 20 years the law had not been enforced.

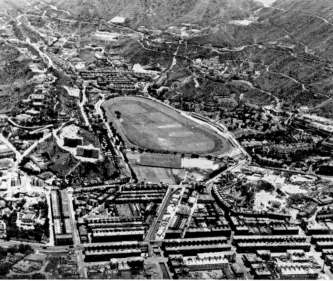

As had previously happened in Macau and Canton, Chinese and Western merchants found ways to work together for their mutual benefit. Undoubtedly, the Westerners learnt a lot about the techniques of trading in China from their local counterparts

European merchants established their own piers along the praya on the northern side of the Island, making it easy to land imported goods from ships unloading in the harbour. Until the 1860s, it was not easy for Chinese traders to get access to this central waterfront. Thereafter, matters became easier when the government started building roads to link up the central area and the adjoining districts. A hangover of that artificial segregation can still be seen today in the way that, for instance, the dried seafood industry is concentrated in Western District.

Although there was no precise planning for the city's development, many splendid grand buildings were erected, such as the General Post Office, Alexandra House, the Supreme Court, City Hall, and Hong Kong Club – though only the Supreme Court now remains. The Colonial styles, Victorian and Edwardian, had a special design of verandas which acted as architectural air-conditioners.

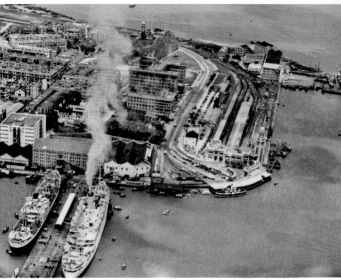

Looking back on the development of Hong Kong since 1841 to present we can be amazed and proud at how the "Barren Island" has grown from a collection tiny villages into an international city that has a distinctive position on the world map.

Alan Cheung
Vice-President, Hong Kong Collectors Society

Introduction

David Dodwell

For the three decades that I have called Hong Kong home, there have always been two books close at hand: Richard Hughes' *Borrowed Place, Borrowed Time*, and one or other of the numerous editions of *Over Hong Kong*.

From Richard Hughes, I learned the word "rambunctious" – a character trait at the heart of Hong Kong people, and even the place itself. From Magnus' photographic treasure, I learned the importance of perspective, and how important it is to step back and assess things from a distance.

Over these three decades, I have had the privilege of providing an introduction to *Over Hong Kong* twice before. There is always a frisson as you open the new portfolio of magnificent aerial photographs: what story will they tell; what changes will they reveal? One thing is always reliably revealed: for Hong Kong, the only constant is change. That may in many circumstances seem like a cliché, but here, as you browse these aerial glimpses into Hong Kong life, that is dramatically not so.

Go back to Russell Spurr, introducing that first *Over Hong Kong* edition in 1982, and the metamorphoses witnessed here are clear: Russell recalled his first landing in Hong Kong in 1946: "There were more warships than merchantmen in the harbour. And a great many wrecks. Tall-funnelled ferries belched coal smoke... Kai Tak airport had a burned out hangar, two or three tin shacks and a high wire fence.... This Pearl of the Orient was of questionable value. The end of the war left Hong Kong shabby, hungry and benumbed."

From 600,000 people in 1946 to around 7.3m people today, the city has exploded beyond imagination. Kai Tak airport closed 20 years ago, and the world-beating Hong Kong International Airport at Chek Lap Kok on Lantau today handles around 70m passengers a year. Massive new towns like Tseung Kwan O, Shatin and Yuen Long have replaced sleepy New Territories villages. It is sobering to scan across the Kowloon peninsula opposite Central, count the glistening 40- and 50-storey office and residential towers, and pinch yourself to remember that when Kai Tak airport closed its runway in September 1998 there was no building on the peninsula above 14 floors. At street level, you seldom notice. But from the air, courtesy of *Over Hong Kong*, the profoundness of the change becomes clear – all the more so as this edition for the first time manages to juxtapose so many "then" and "now" images alongside each other.

Hong Kong as a massive and highly pollutive manufacturing hub has come and gone, to be replaced by one of the world's most dynamic services hubs focused on the headquarter operations of international companies peering into the Mainland, and Mainland companies looking out to the world. A community of anxious refugees with an eye on onward migration has been transformed into an affluent middle class that regards Hong Kong as long-term home. Neglectful and paternalistic British colonial oversight has been replaced by a Chinese sovereign that has opened up and confounded the world, and has put Hong Kong at the heart of its strategy to open to the world.

Yet through all of this change, the rambunctious charisma of Hong Kong remains unchanged. As I wrote in *Over Hong Kong* back in 1995: "Hong Kong is a paradox. Maybe even a contradiction in terms. So many people ought not to be able to live in such a handful of square miles. So few people ought not to have been able to build so huge a trading power. They ought not to have savoured such stability during a century of almost unprecedented chaos just a dozen miles to the north. And such a wealthy place ought not to be home to so many pockets of poverty. (This) is a story of men's ability to bend nature to meet their needs, but at the same time a tribute to the awesome resilience of nature."

For most outside observers of Hong Kong, the assumption is that the 1997 transition of sovereignty must be the most significant source of change. But that assumption is wrong. All those who thought strident anti-capitalist officials would enter Hong Kong and take a wrecking ball to its colonial institutions have, 20 years on, been proven quite mistaken. Search for the true forces behind the changes that have reshaped Hong Kong over the past three decades, and you will find they sit with Deng Xiaoping and his decision in 1979 to re-engage with the outside world. After decades of surviving in spite of a closed and chaotic China, Hong Kong began to thrive because of a China that had changed its mind. After decades of surviving with its back to a closed and xenophobic China, Hong Kong turned, moved a large part of its manufacturing economy into the Mainland and began to reinvent itself as one of the world's most dynamic services economies.

Don't get me wrong – the transfer of sovereignty to China was deeply significant. But it was significant in ways few anticipated. In the transition period after the signing of the Sino-British Joint Declaration in 1984, Hong Kong shifted into a 13-year period of "20:20 foresight": all government attention was focused on management of a smooth transition. It was only on July 1 1997 as the Chinese flag rose over Hong Kong for the first time, that Hong Kong rejoined the rest of the world with "a normal uncertain future".

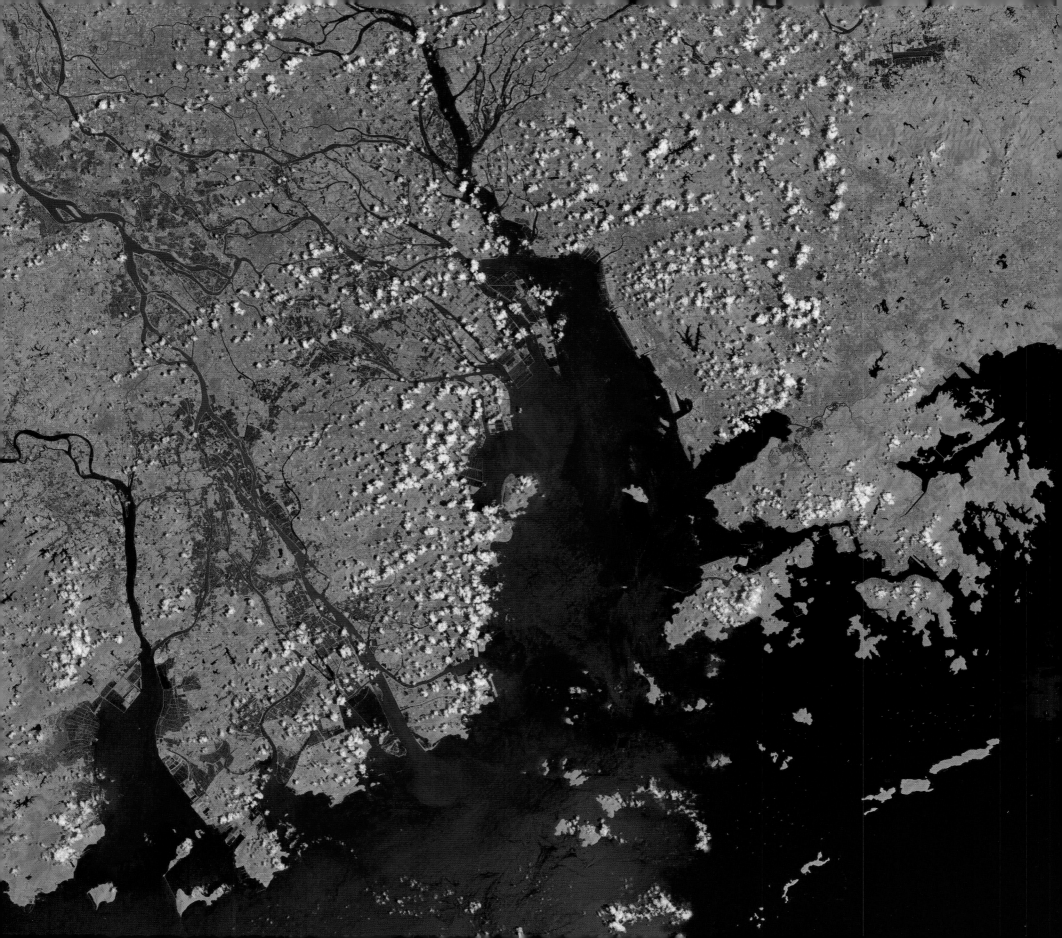

The big difference after July 1 was not that Chinese soldiers poured in, or that Mainland officials began slyly to subvert Hong Kong's westernised free market institutions. Rather the big difference was that Hong Kong shifted from a century of benign neglect as a distant and insignificant spot on the edge of a large global colonial empire, to being a critically important springboard from which the long-cloistered Chinese economy could learn about, and reengage the world economy. China knew it needed Hong Kong, and needed it to perform well in this world-linking role, whereas Britain had barely noticed Hong Kong, let alone acknowledged it needed Hong Kong in any way. Hong Kong started life in 1841 as a barren rock, and from the point of view of most British politicians was little more than a barren rock a century and a half later. But for China, at the time of the 1997 transition, Hong Kong's economy accounted for virtually 20 per cent of China's GDP – a clear measure of its importance as China emerged from its hermit years.

The tragic irony is that even though the world's commentariat were wrong in predicting that China would stride in and defile Hong Kong, and despite the best intentions of both the outgoing British administration and the new Chinese sovereign, Hong Kong crashed into a deep recession less than a year after the transfer of power – courtesy of the Asian Financial Crisis. As a single measure of how hard the crash was, in 1998, home prices fell dramatically from their levels in 1997.

Through no fault of Beijing, Hong Kong has since 1997 struggled to keep the spring in its step. From the 1998 Asian Financial Crisis, Hong Kong was hit by Avian Influenza in 1999, the dot.com crash in 2001, and SARS in 2003. Just as it was getting properly back into its stride, along came the 2008 Great Recession, with Hong Kong being hit as hard as anywhere in the world. Today, 20 years after the transition to Chinese sovereignty, many

Hong Kong families are earning no more than they were in 1997. Morale has been sapped. All evidence of hubris has evaporated. But from the air, *Over Hong Kong* shows that these setbacks have done little apparent harm.

Perhaps this is due to another – perhaps the most important – effect of the 1997 transition. The massive emigration flows that had marked the early 1990s, which persuaded many thousands of Hong Kong families to seek safe haven passports in countries like Canada, suddenly halted and reversed. A refugee mindset that had characterised many Hong Kong people before 1997 was rapidly replaced when families who recognised that China was not going to inflict wilful harm decided they could make Hong Kong their long term home.

This proved to be a massive metamorphosis. For the first time, ordinary citizens began to take a serious interest in political engagement. A commitment to civic engagement surged. Willingness to spend money on improving the environment soared. Politicians in 2000 for the first time agreed to introduce a compulsory pension scheme for retirement protection. This has caught local and Mainland administrators flat-footed as their anxiety to ensure a slow and steady transition has inflamed local families anxious to see change in response to rapid economic changes going on around them.

But step back and take the long view, and the reality that *Over Hong Kong* illustrates is that rapid change has continued to occur in response to fast-evolving demands. For example, many would still complain that Hong Kong's environment is unacceptably poor, but on a 20-year view, massive improvements have been seen. The migration of local manufacturing has reduced locally-sourced pollution. So too has the introduction of LPG-fuelled taxis.

The completion of a massive sewerage system along Hong Kong Island's northern shores means that 2m cubic metres of polluted waste water no longer pour daily into Victoria Harbour, and has allowed the resumption of the annual cross-harbour swimming race. Waste disposal remains a nightmarish challenge in a city so crowded,

and available land-fill sites are close to exhaustion, but it seems high-tech incineration may be introduced in time to bring relief. The photos in *Over Hong Kong* provide ample evidence of the environmental challenges being faced, but they also illustrate the robust resilience of nature, and the extent to which Hong Kong's extensive country parks remain intact and pristine. It may be alarming to swerve around wild boar crossing the road at night, or to trip over a snake on our high mountain country trails, but it is at the same time comforting to know our environment has enough wild places to sustain such critters. London's last wild boar was apparently killed by a royal hunting party over five centuries ago.

While *Over Hong Kong* provides spectacular evidence of the pace of change occurring in Hong Kong, it can only show glimpses of the biggest change of all – the explosion of the cities of the Pearl River Delta, and the extent of Hong Kong's integration with the wider region – now being called the Greater Bay Area. When I, in 1978, first stared through army binoculars across the Shenzhen River, it was to scan the riverbanks for dead bodies as rising tides trapped and drowned youngsters swimming to "freedom" in Hong Kong. On the opposite bank of the river, all you could see was occasional wooden shacks. Today, Shenzhen boasts almost as many glistening tower blocks as Hong Kong does. They rise like a gigantic wall along the banks that mark the boundary with Hong Kong.

Official figures say Shenzhen's population has now passed 11m compared with just 7.3m in Hong Kong, and its GDP is on a par with Hong Kong, with property prices coming close. Behind Shenzhen, Dongguan is home to 11m more. Combine Hong Kong, Macau and the nine municipalities that stretch along both sides of the Pearl River up to Guangzhou, making up the Greater Bay Area, and you have a metropolitan area of 66m people, with a GDP of US$1.3tr – yes trillion. That makes the region, which makes up barely 1 per cent of the land area of China, and is less than half of Guangdong Province, economically bigger than Spain, and on a par with Australia.

Left
Pearl River Delta The view of the Pearl River Delta area as seen from 700km above the earth. This region is increasingly referred to as the Greater Bay Area. In this image Guangzhou is situated at the head of the Pearl River estuary.

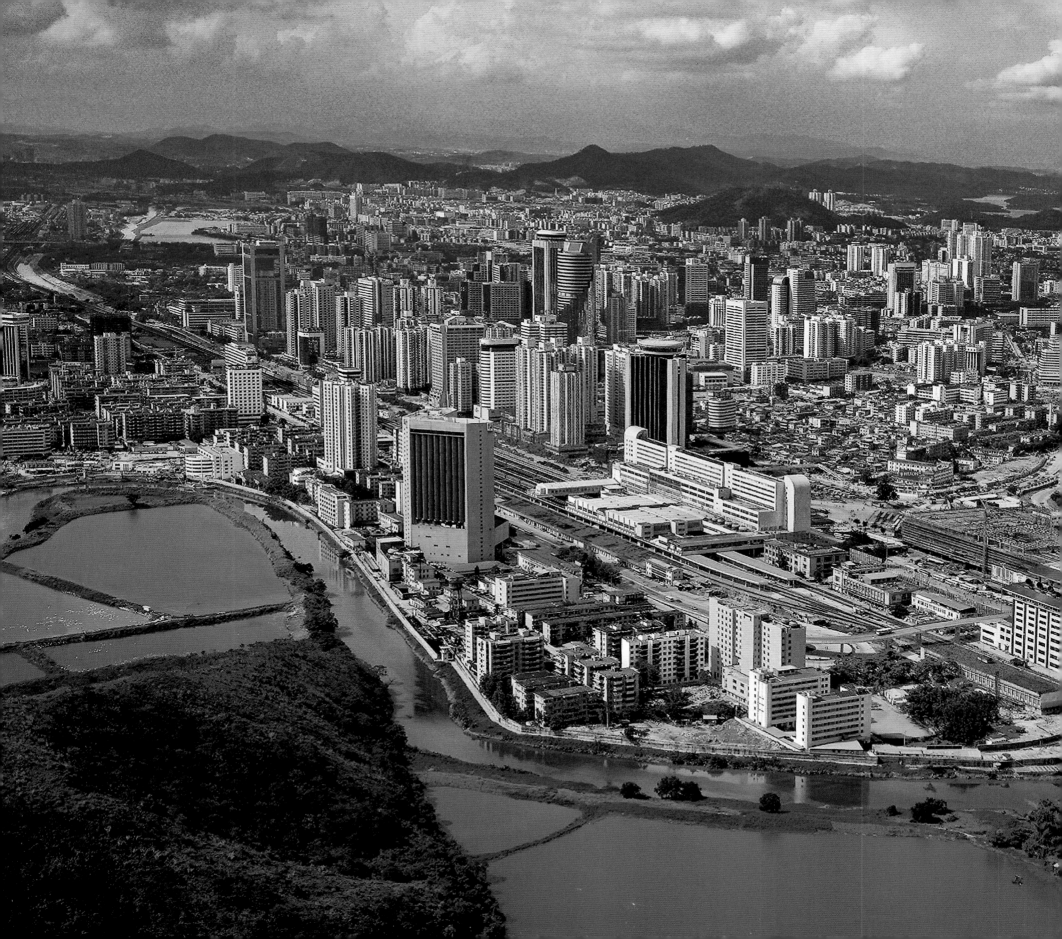

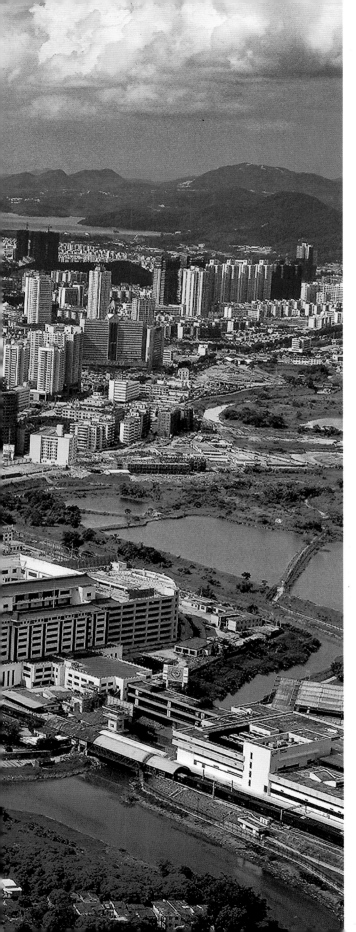

The Hong Kong that 30 years ago lived with its back to China, and thrived in spite of it, is in the process of reconnecting with its hinterland – with profoundly important results. Back in the 2002 edition of *Over Hong Kong* I predicted that by 2015 "a large proportion of the SAR's present population will be living in homes in Shunde, Panyu and Dongguan. They will be commuting to work in Hong Kong on rapid transit systems, passing through the border at high speed with "intelligent" identity cards. Their children will be attending schools that match the standards of Hong Kong. Local hospitals will offer medical services equal in standard to those in Hong Kong." As we have passed 2015, I think I jumped the gun – but not by much. The high speed rail that will open next year will get passengers from Hong Kong to Shenzhen in 14 minutes, and to Guangzhou in 48 minutes. The road bridge from Chek Lap Kok airport along the north of Lantau to Zhuhai and Macau will when it opens next year enable vehicles to get to the western side of the Pearl River in just 20 minutes. There is a huge daily cross-border flow, both ways, of children and adults for school and work.

At present, it is only the NASA satellite images that give you a glimpse of the scale of the region which has Hong Kong at its heart – and there is something awesome about being able to see the faint pencil line of the Hong

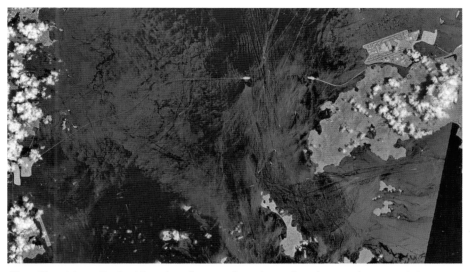

Hong Kong-Macau Bridge The enlarged section from the satellite photograph on page 8 shows very clearly the course of the bridge across the Pearl River and the two small islands where the roadway goes underwater to allow passage of ocean-going ships up-river.

Kong-Zhuhai-Macau Bridge drawn across the Pearl River from Chek Lap Kok. It is also only the satellite images that show the scale and density of the urban region that now encircles Hong Kong, and the loss of green space across the region. It is only here that you realise how important Hong Kong's Country Parks are as a "green lung" for the region, and if nothing else, *Over Hong Kong*'s breath-taking images of Hong Kong's dramatic and pristine green spaces need to remind us of how important it is to keep them safe – not just for Hong Kong, but for the whole metropolitan area around the Pearl River of which it has now become a part.

Perhaps the next step must not simply be to produce another breath-taking aerial voyage over Hong Kong, but to expand it to put Hong Kong in its proper context – *Over the Greater Bay Area*. Perhaps this is too ambitious for today, but surely sometime soon...

Left
Shenzhen By the early 1990s, Shenzhen had grown remarkably. From a few small farming or fishing villages along the border, in the space of 20 years, a vibrant city had developed. This photograph is of Lo Wu, the first border crossing point for foot passengers and also the Kowloon and Canton Railway.

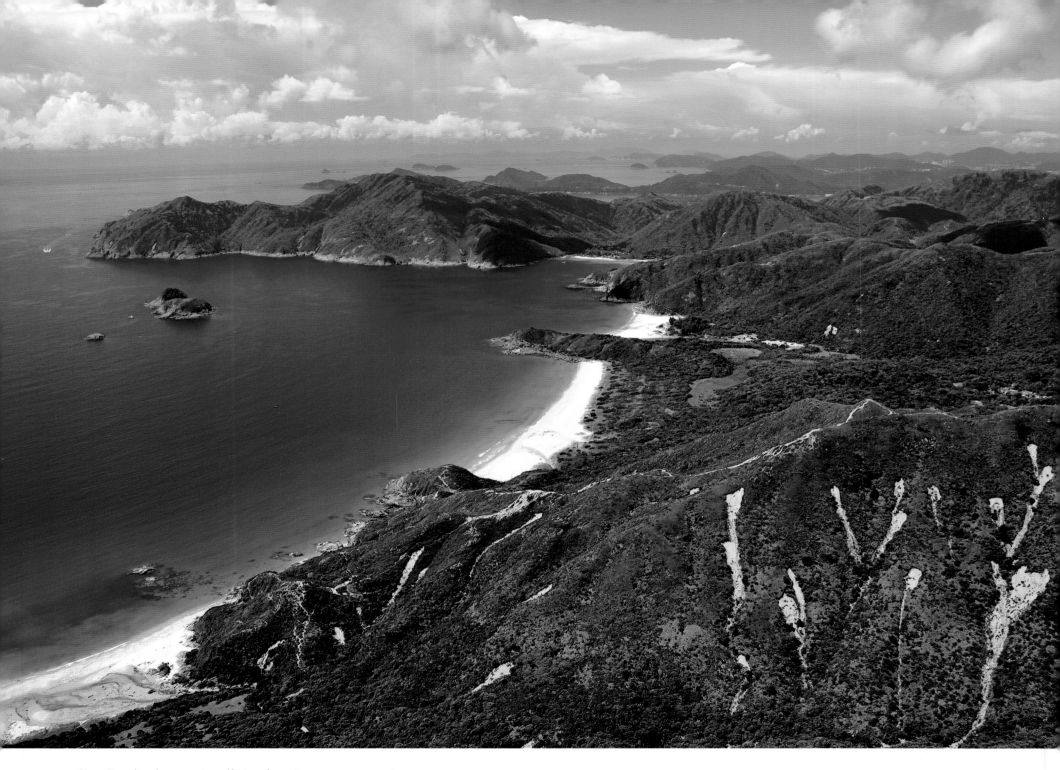

Hong Kong has the reputation of being a busy city.

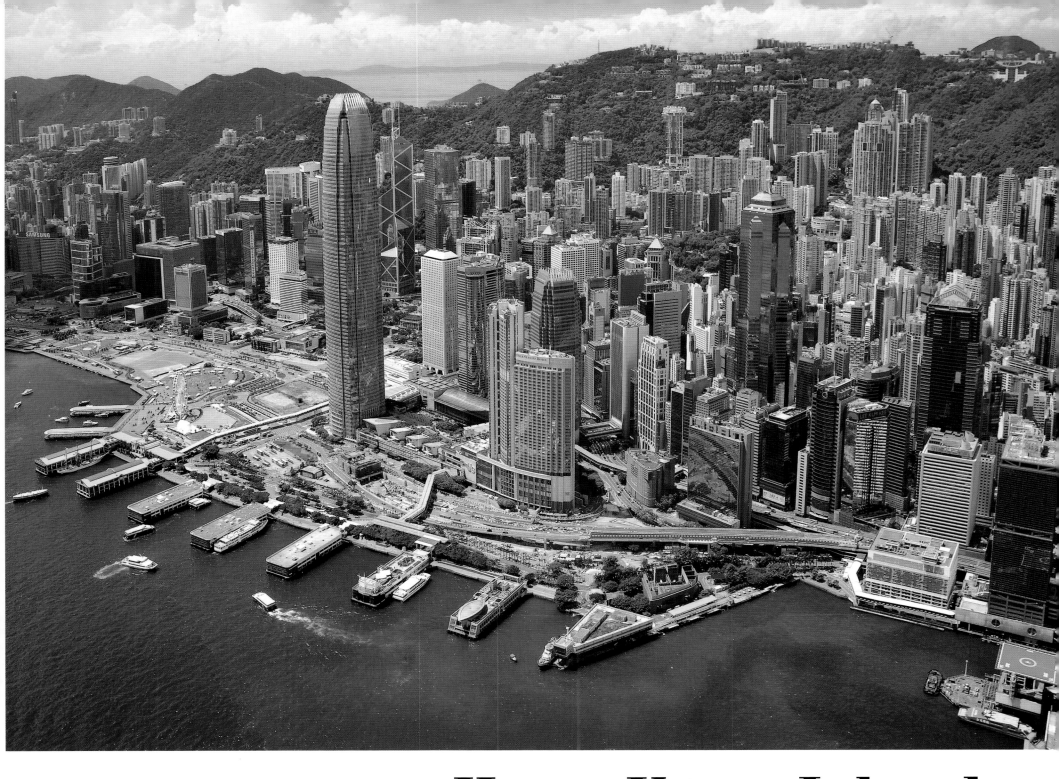

Hong Kong Island

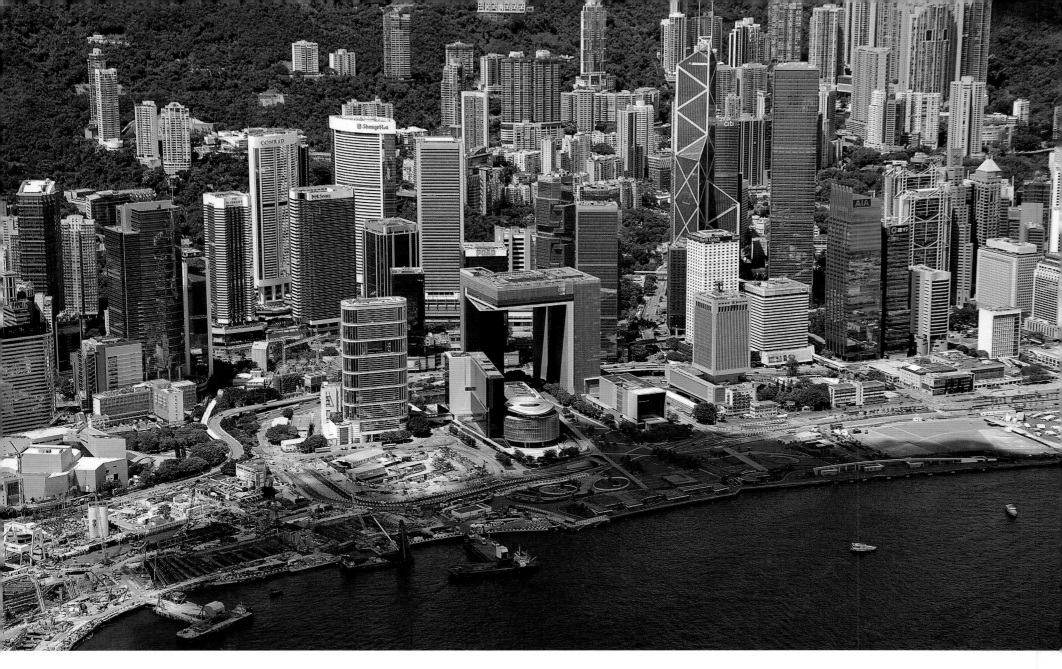

Previous page

Central Ferry Piers As befits a city bisected by the magnificent
Victoria Harbour and including over 230 islands, water transport
plays a significant part in everyday life. The major outlying
islands are served by ferries from Central Piers 2 to 6. Pier 1 (the
right-hand one in the picture) is for government use and the Star
Ferry to Tsim Sha Tsui sails from Pier 7. The Maritime Museum
occupies Pier 8 which also serves as a mooring for occasional
visiting vessels. The remaining two piers are for general public
use and overlooked by the Observation Wheel. Between the
ferry piers and Hong Kong's second tallest building, IFC2, is the
construction work for the Central and Wanchai Bypass, most of
which is underground or under the sea.

Above

Admiralty The area between Central and Wanchai, known as
Admiralty in English and *Kam Chung* (金鐘) or Golden Bell
in Chinese, was, in early colonial days, a key military area,
the Victoria Cantonment. The navy dockyard occupied the
waterfront whilst the army was based further inland. The area
was the subject of a contentious struggle for control between
the civilian and the military authorities. The government has
finally won and today the only military presence is the Peoples'
Liberation Army base. The rest of the HMS Tamar site is now
occupied by the Central Government Complex, designed by
Rocco Yim on the principle "The Door is Always Open", hence
the post-modernist appearance of the main building.

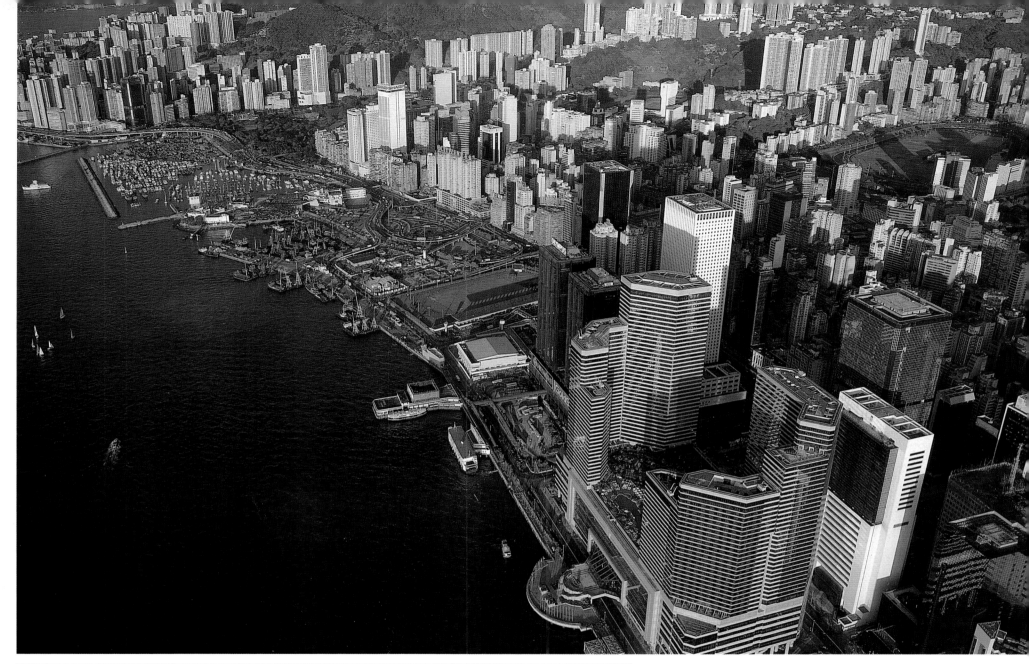

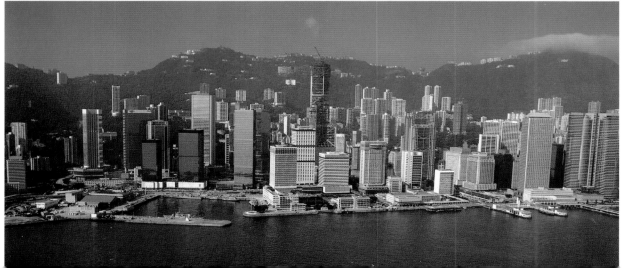

Above
Wanchai to Causeway Bay Looking east from Wanchai to
Causeway Bay in 1990, the first phase of the Convention and
Exhibition Centre stands on the foreshore of new reclamation.
Further east, a cargo handling area still operates and the
Causeway Bay Typhoon Shelter is full to capacity.

Bottom
Central The Central waterfront in 1988 with the new Bank of
China Tower, designed by I M Pei, under construction. Over
300m and 70 storeys high when completed, it became Hong
Kong's tallest building – a crown it has now had to relinquish.

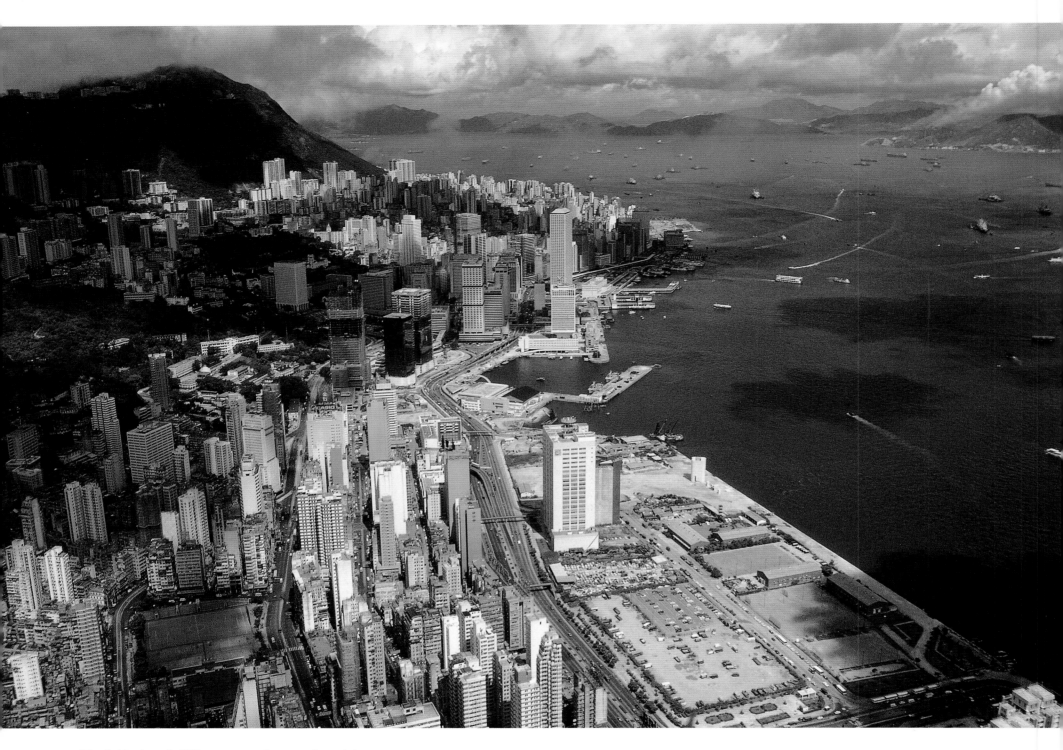

Wanchai In the early 1980s extensive reclamation changed the profile of Wanchai. Telecom House and the Hong Kong Arts Centre were the first to be built north of Gloucester Road. In Central, Jardine House is by far the tallest building.

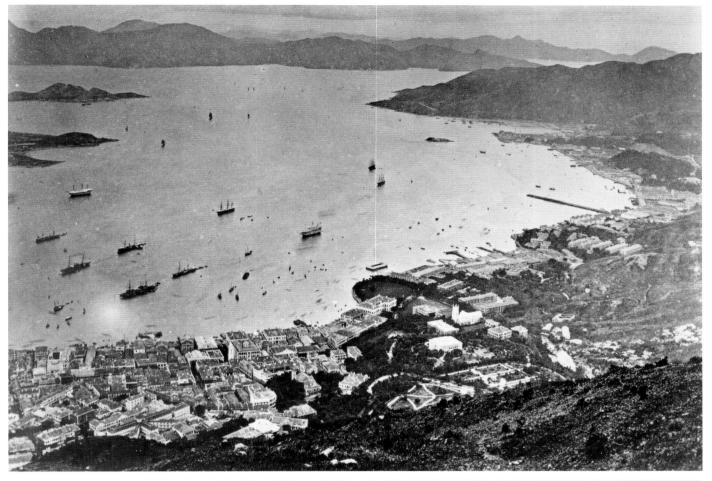

Left

City of Victoria In 1880 Victoria Harbour was much more extensive than today. The trading hongs built their godowns on the praya of what was known as the City of Victoria, now Central. The gothic-style tower of St John's Cathedral sits almost as a watchdog on the border between Victoria and the military cantonment.

Bottom

Victoria Harbour These two photographs show the difference 35 years makes. The left picture was taken in 1945 with HMS Tamar on the left edge. In 1982, we can see that quite a lot of reclamation has occurred with the two Star Ferry piers, the L-shaped Blake's Pier and the four Outlying Islands piers being prominent.

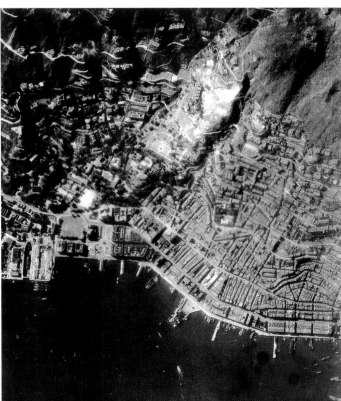

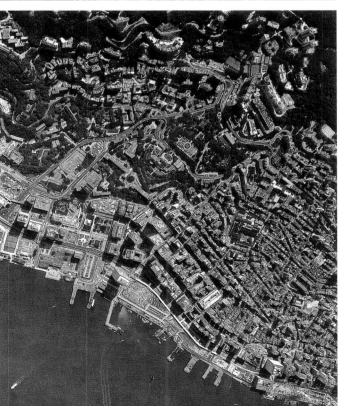

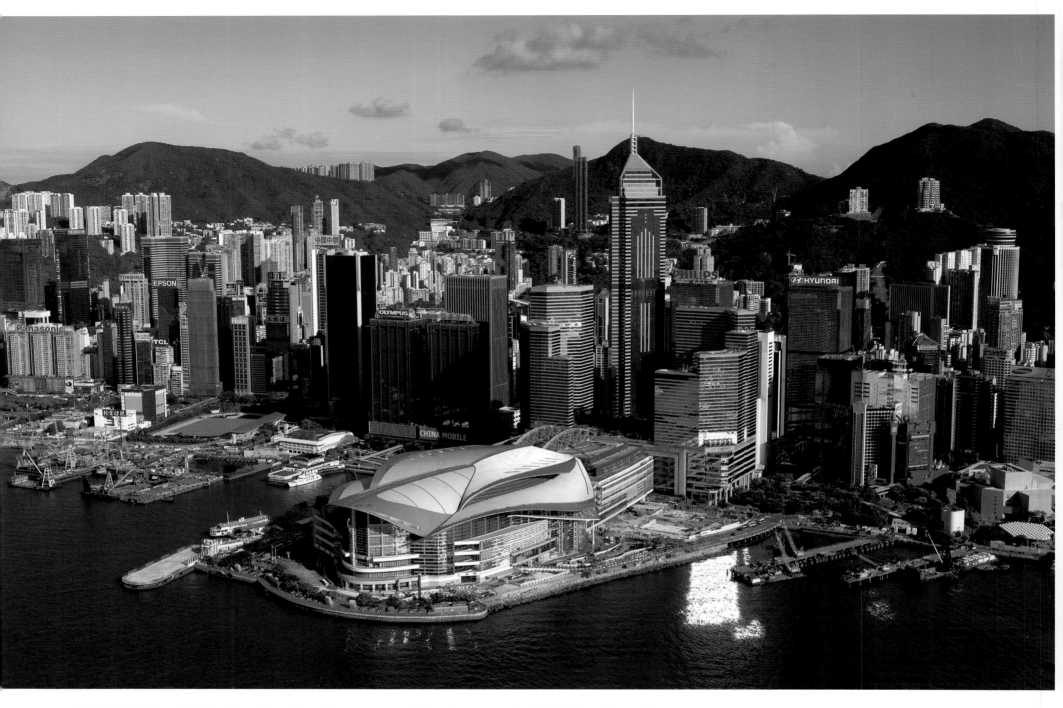

HKCEC The design of the Hong Kong Convention and Exhibition Centre is intended to create the illusion of a bird's wings in flight though unkind critics liken it more to a turtle. No matter, it is a minor wonder of modern engineering. It was created in a mere 48 months from reclamation of the artificial island to completion, just in time for its role as the centre-stage of Hong Kong's return to China, the Handover in 1997. Look carefully at the eastern end of the building and you will see the two tall flagpoles in Bauhinia Square where every day the Chinese and Hong Kong flags are ceremonially hoisted. The centrepiece of the Square is the Golden Bauhinia just visible on the edge of the shadowline. The six-metre high Bauhinia flower, the city's symbol, was the welcoming gift of the Chinese people to mark the Handover.

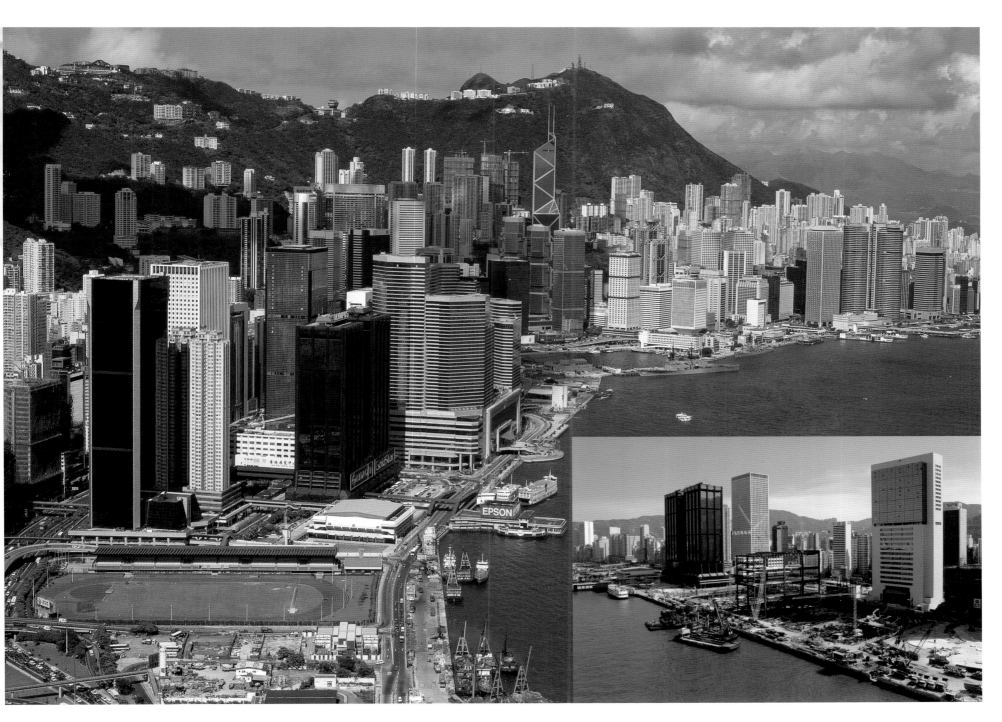

Above
Wanchai and Central A view from the east of the Wanchai and Central harbour-front in 1991. Phase one of the Convention and Exhibition Centre is complete and, in the distance, the Bank of China Tower is the tallest building in Hong Kong.

Inset
Wanchai It's hard to believe that the construction work here would, some 10 years later, blossom into the building on the opposite page. The white edifice behind is the Wanchai Tower. The China Resources Building and the twin towers of the Great Eagle Centre rise on the left.

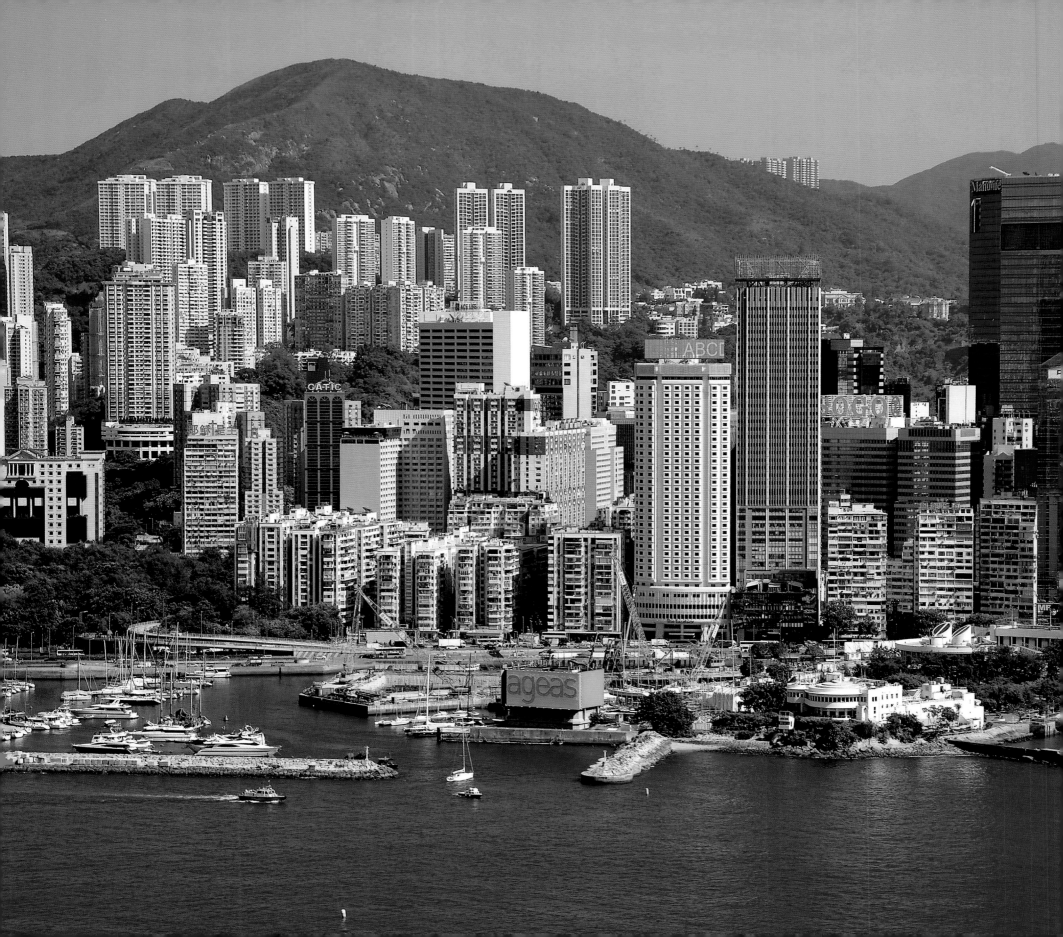

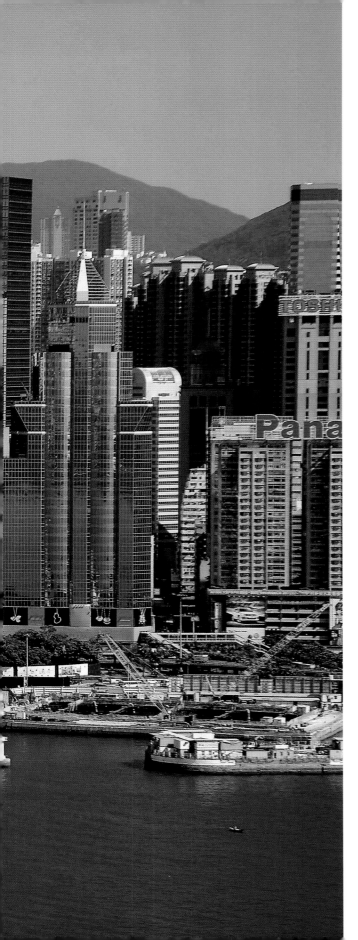

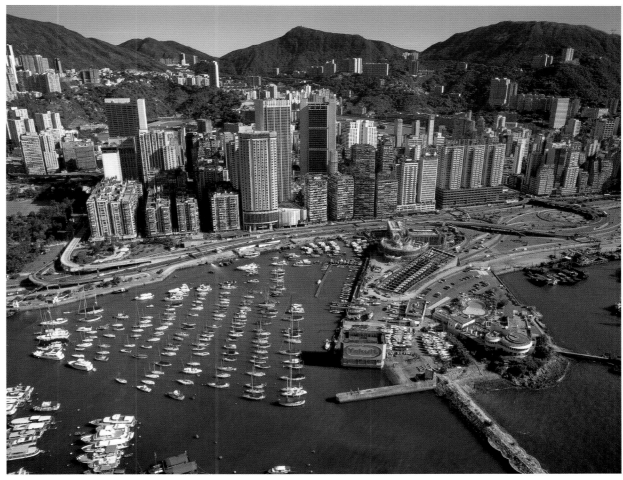

Left
Causeway Bay Confusingly, the area now recognised as
Causeway Bay was originally called East Point and Causeway Bay
was the area around Victoria Park. Street names in what was East
Point give a clue to the fact that much of the land in the area
was sold in the early 19th century to Jardine Matheson. Indeed,
Jardine's still maintain the custom of firing the Noon Day Gun
every day close by the typhoon shelter. Kellett Island (though
no longer an island) was originally a fort for the protection of
the harbour and later an ammunition storage magazine. Now it
provides a home for the Hong Kong Yacht Club and the Hong
Kong entrance to the Cross-Harbour Tunnel. Causeway Bay itself
is the premier shopping area of the city with correspondingly
high rentals.

Above
The Royal Hong Kong Yacht Club Sampans cluster in the
corner by the Police Officers Club in 1986. The Royal Hong
Kong Yacht Club occupies the prime position on Kellett Island
and, between the two, the roadway disappears into the Cross-
Harbour Tunnel. Behind are the buildings of the shopping heart
of the city.

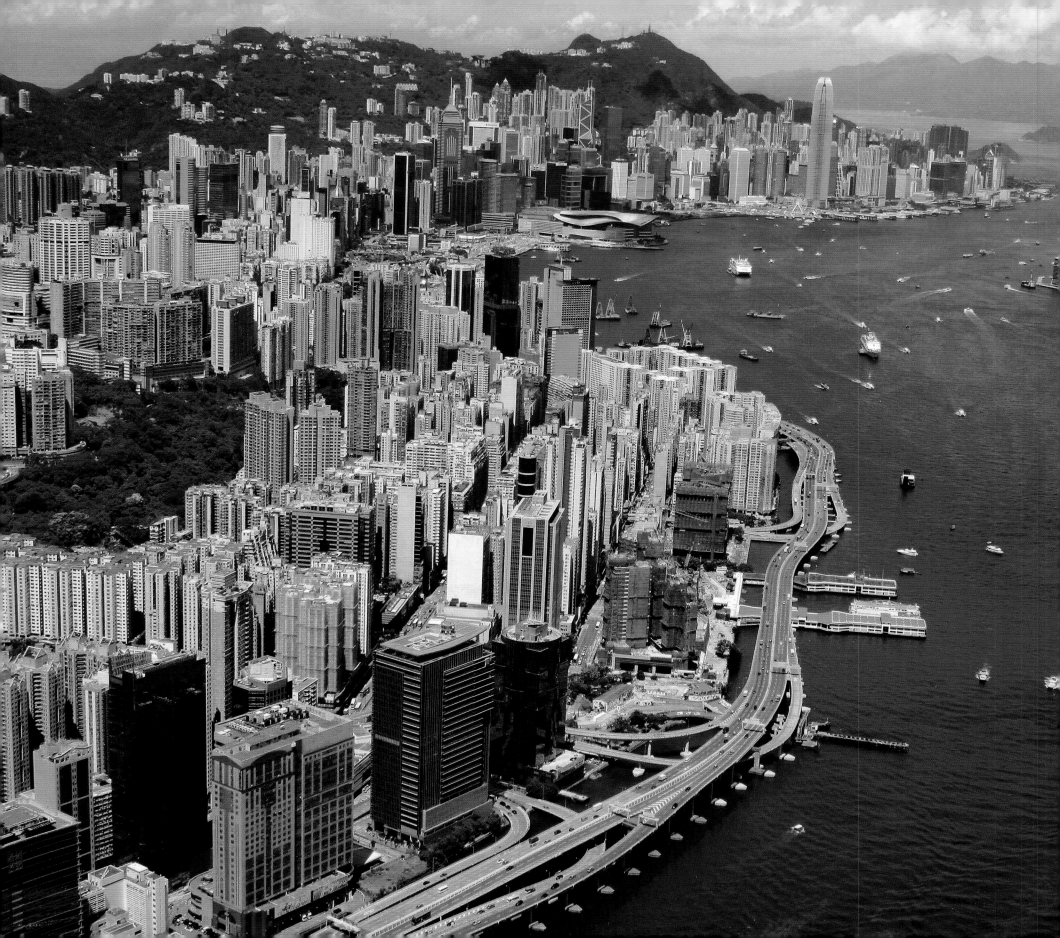

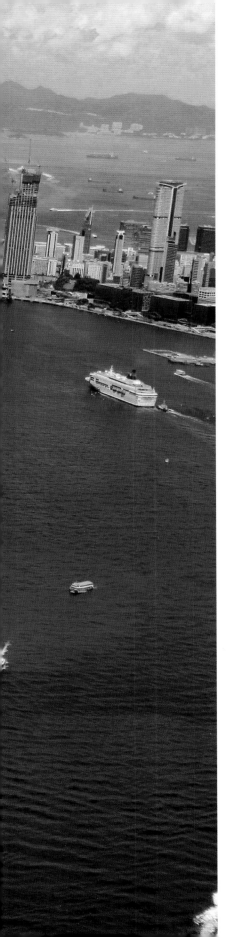

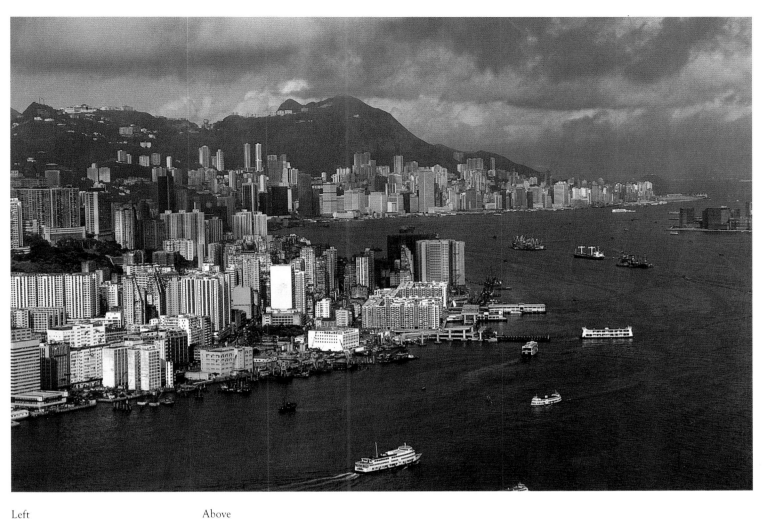

Left

Victoria Harbour Looking west along the north shore of Hong Kong Island to Central with the Island Eastern Corridor snaking round. IFC2 is in the middle distance and Lantau Island on the far horizon. Above Central and Wanchai, The Peak and Mount Cameron form a green backdrop to the city. In the foreground are the North Point Ferry Piers. With the building of three road tunnels linking the Island with the Kowloon Peninsula, cross-harbour passenger and vehicle ferries have assumed a less important role. However, as the mix of cruise ships, lighters and small craft demonstrates, Victoria Harbour is still a very busy waterway.

Above

Island Eastern Corridor A similar view to the picture on the left from the early 1980s when the construction of the Island Eastern Corridor was just beginning.

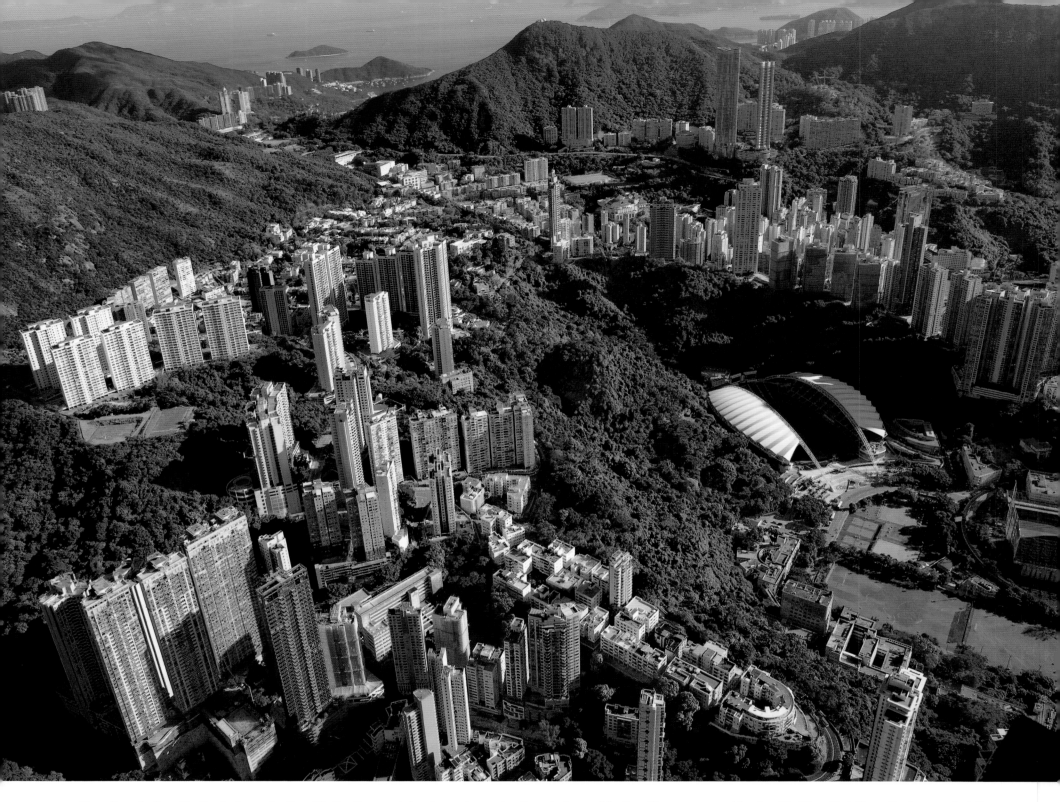

Hong Kong Stadium Nestling in the small valley of So Kon Po, close to Happy Valley, is the city's premier sporting venue. With a seating capacity of 40,000, the stadium is currently Hong Kong's largest outdoor multi-purpose recreation and sports arena. It is best known internationally as the home of the Hong Kong Rugby Sevens. The hill to the left is Jardine's Lookout, so named because it was where a watch was kept for the first sighting of the arrival of Jardine Matheson's clippers coming from India and London. The Wong Ngai Chung Gap between the hills gives access from the north side of the island to Deep Water Bay and Repulse Bay.

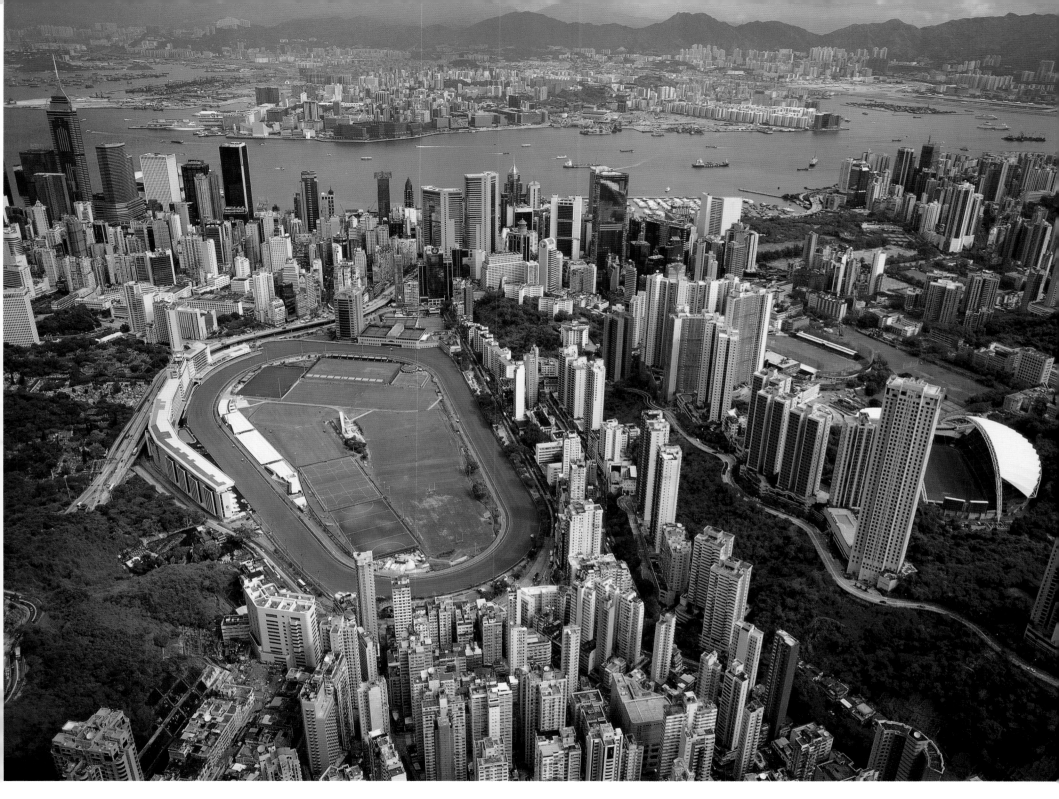

Happy Valley The first horse races in Hong Kong were held in 1846 on land reclaimed from a malaria-infested swamp in Happy Valley. Every Wednesday evening during the racing season the stands on the left in this mid-1990s picture are packed, making horse-racing the city's most popular spectator sport. The Hong Kong Jockey Club holds the franchise for all legal gambling and a portion of its turnover is dedicated to charitable purposes.

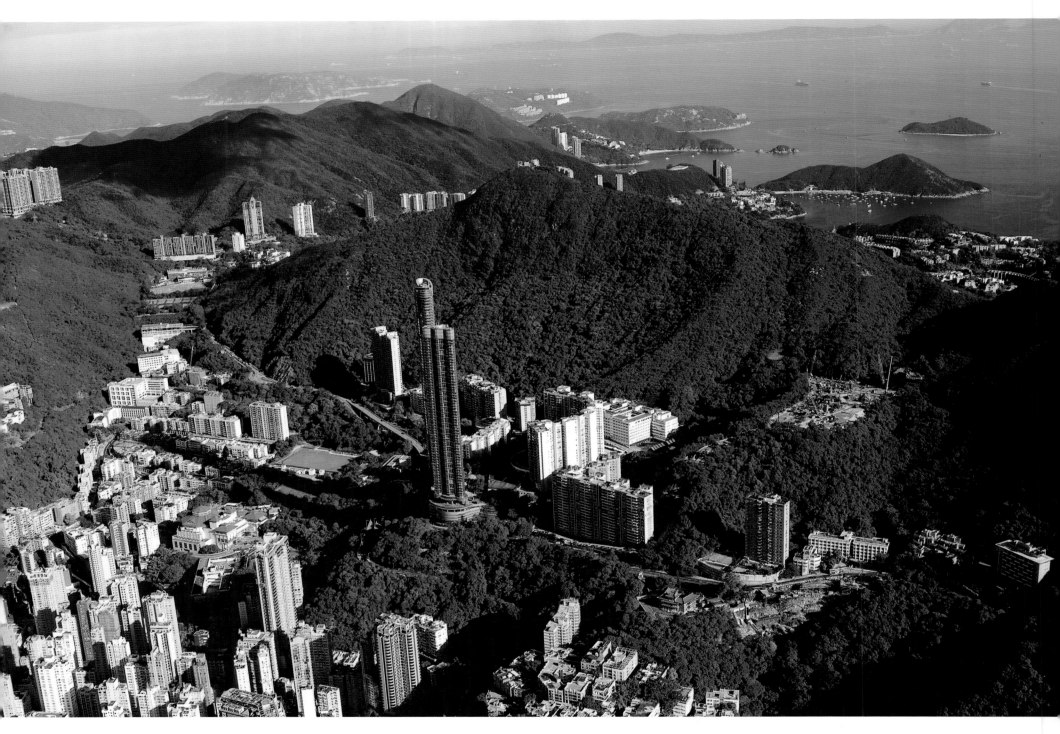

Above

Hong Kong Island The Wong Ngai Chung Gap Road, between Mount Nicholson and Jardine's Lookout, leads up to the watershed between the north and south sides of Hong Kong Island. At the crest of the gap is Hong Kong Cricket Club's ground and Hong Kong Tennis Centre with the luxury residences of Black's Link off to the right of them. Occupying a prime position on the edge of Tai Tam Country Park is the fortress-like Hong Kong Parkview. The two tall buildings centre-stage are The Summit and Highcliff with the Adventist Hospital close by. In the distance the coastline of Island South stretches from Shouson Hill on the right to Stanley Peninsula.

Right

Victoria Peak In the 19th century, Victoria Peak was the exclusive retreat of wealthy European taipans and, today, it remains an expensive and much-sought-after residential area. Ordinary people do get a look-in, The Peak, seen here in 2003, is one of the city's top tourist attractions.

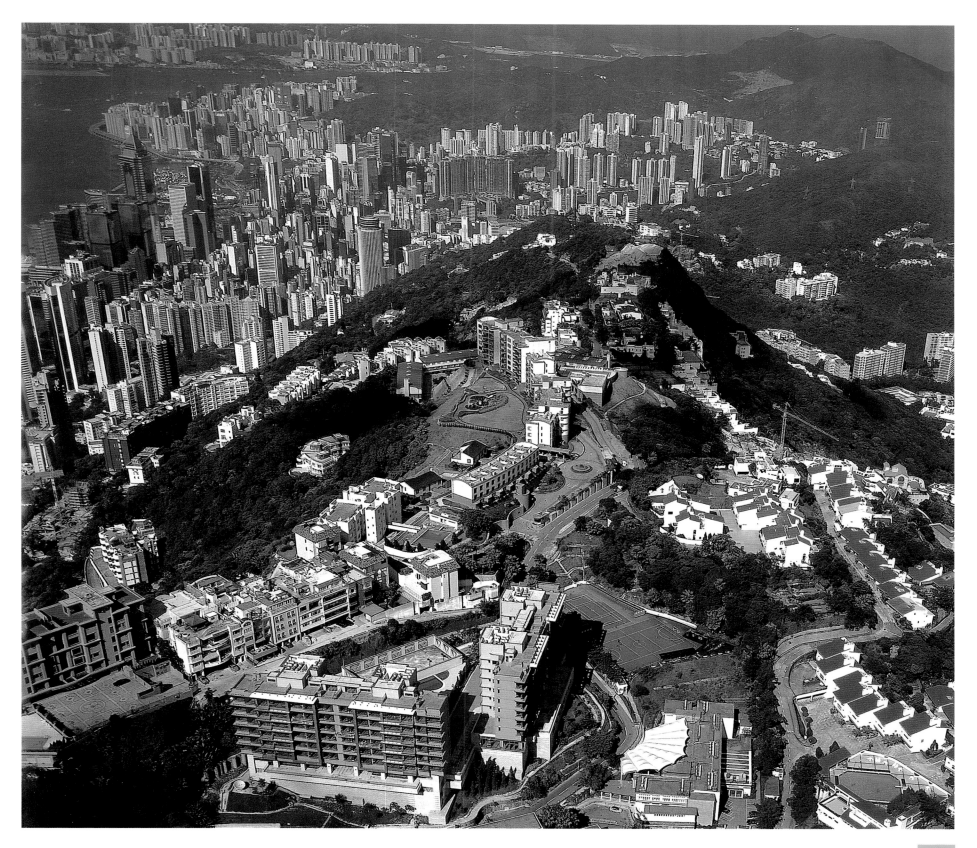

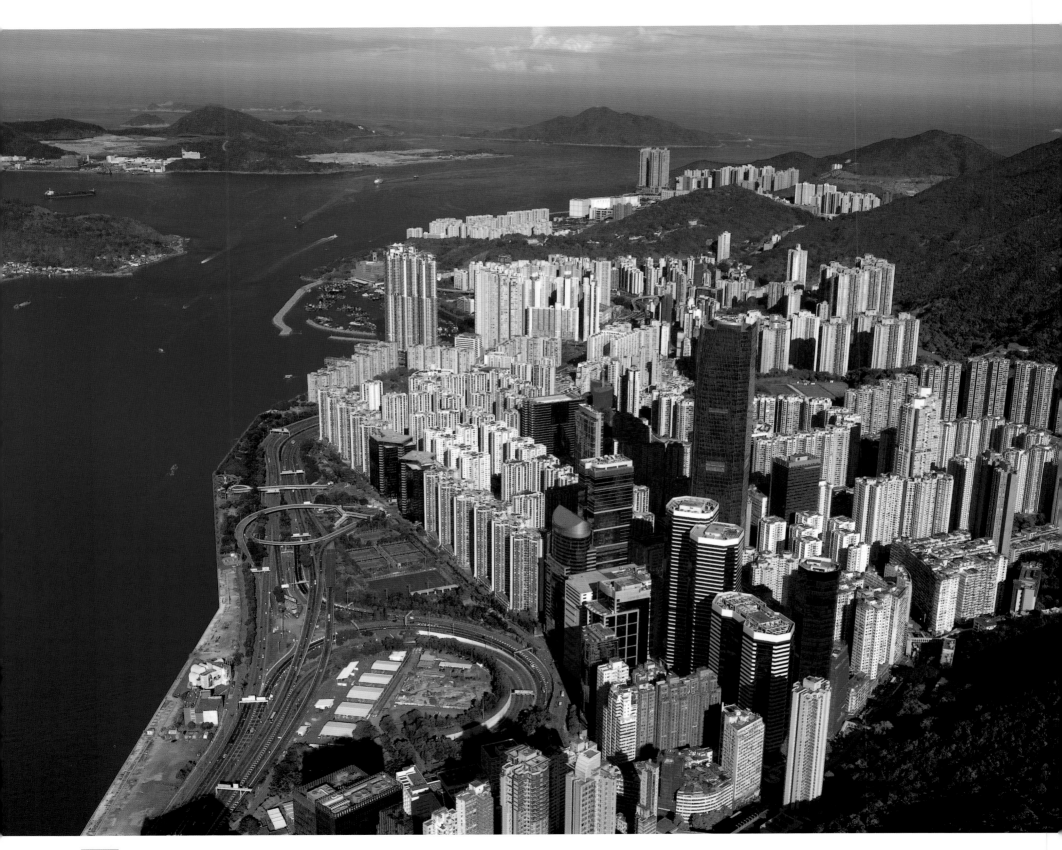

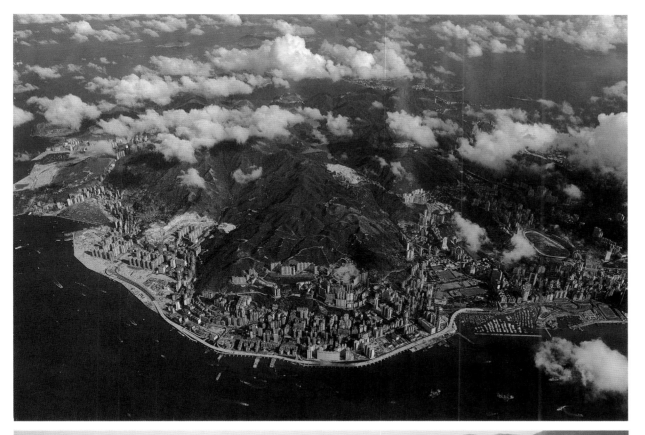

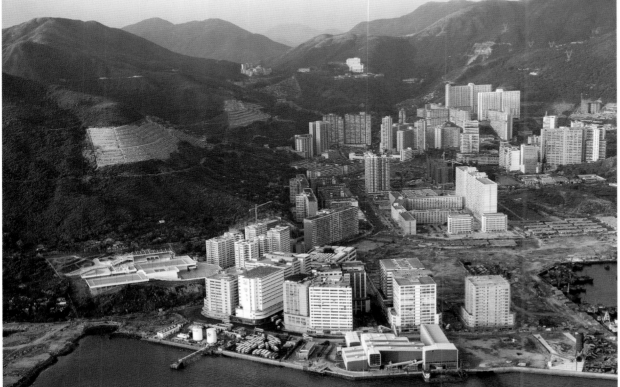

Opposite page
Quarry Bay to Lei Yue Mun The narrow passage between
Lei Yue Mun on the left and Pak Sha Wan on the right is the
eastern entrance to Victoria Harbour. Because of its enormous
strategic importance, the British built concealed gun batteries
to protect it. The fortified complex has now been converted into
the Museum of Coastal Defence, just visible on the far side of
Shau Kei Wan Typhoon Shelter. Confusingly, the sea passage,
the fort on Hong Kong Island and the village on Kowloon side
are all called Lei Yue Mun. The housing estate centre left is one
of the city's earliest private residential estates, built on the site of
the former Taikoo Dockyard which closed in 1972. The circular
roadway in the foreground is the access to the Eastern Harbour
Tunnel, the second of the three road tunnels connecting Hong
Kong Island with Kowloon.

Top left

Hong Kong Island A magnificent high-level panorama from the
mid-1980s of the eastern end of Hong Kong Island from Wanchai
in the west to Chai Wan in the east and Stanley in the south.
Especially in the east, new reclamation works are apparent.

Bottom

Chai Wan A dawn view of a thriving industrial development in
Chai Wan in the early 1980s. During the Ching Ming festival in
Spring, the roads up the hill are jam-packed with people visiting
the cemeteries on the hillside to pay respects and make offerings
to their ancestors.

Following pages
Shek O Tucked away in the south-eastern corner of Hong Kong
Island is the village of Shek O. The name means "rocky bay" and
as one can see, the location of the village on a rocky outcrop
justifies the name. On the other hand, the magnificent beaches
are well supplied with sand. The relatively isolated position and
limited means of access to Shek O ensures that the area remains
fairly quiet and peaceful although summer weekends can be busy.
The surrounding area is one of Hong Kong's designated country
parks where the Dragon's Back, above the village, is the city's
only paragliding site. The beaches are popular with surfers and
Big Wave Bay, seen beyond the Shek O Country Club golf course,
is renowned for its waves–as its name suggests.

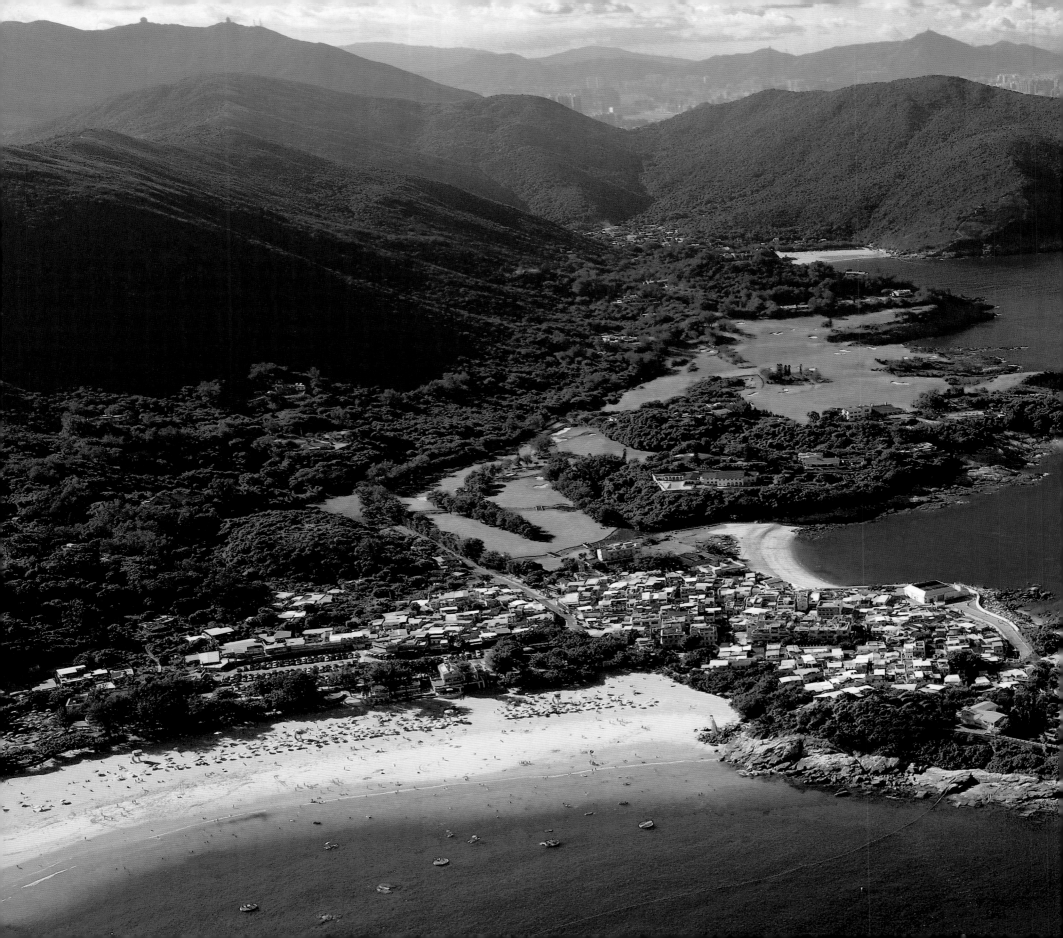

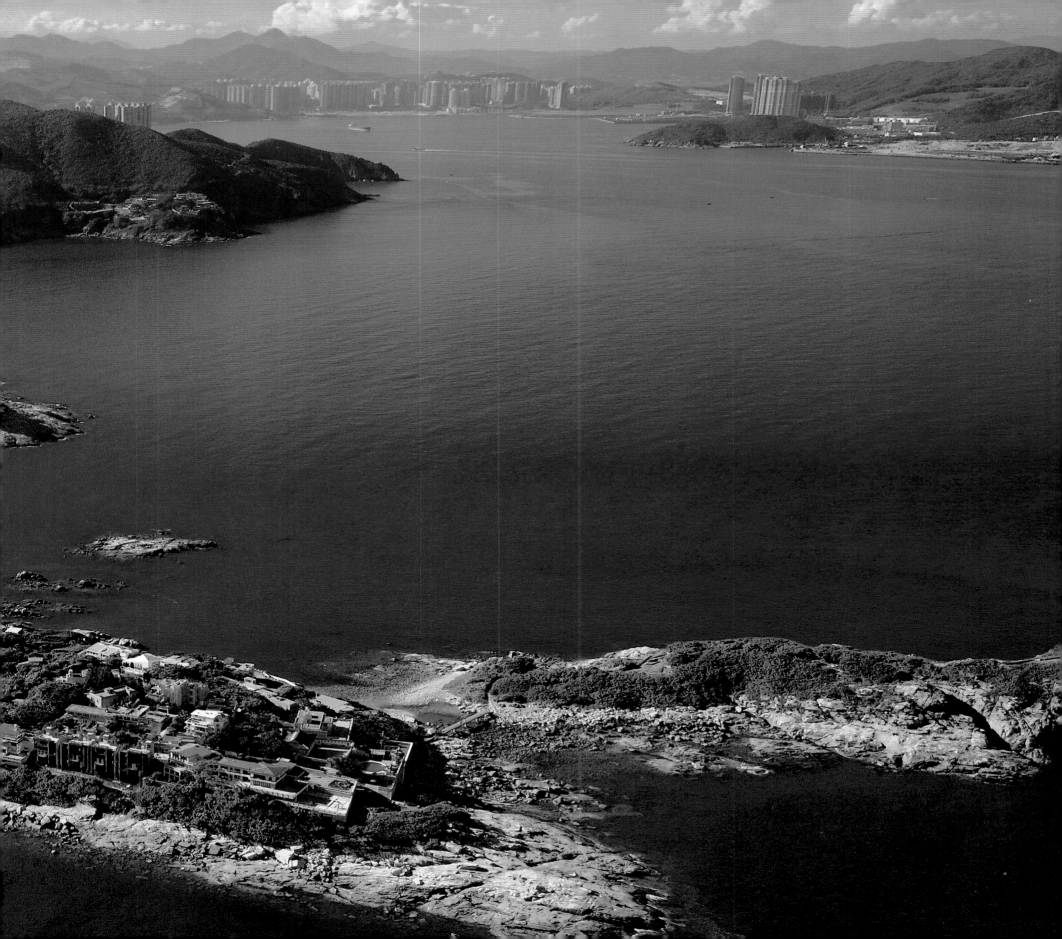

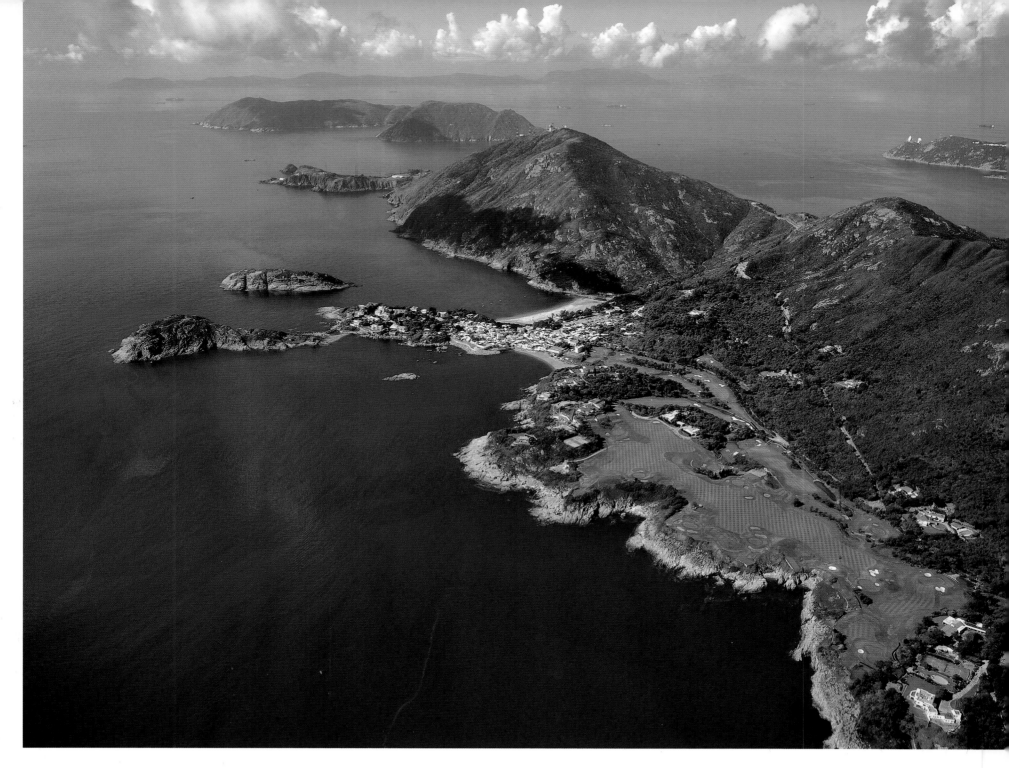

Above
Shek O Shek O Country Club membership is one of the most highly sought-after in Hong Kong. When the club was founded in 1921, there was no road to the area and members reached it by boat to Stanley and then on foot or horseback. The luxurious and spacious houses overlooking the magnificent 19-hole golf course are taipan territory.

Right
Red Hill Controversy surrounded the construction of this luxury residential development at Red Hill in the 1980s on a once-beautiful and secluded peninsula. Across Turtle Cove in this early 1990s photograph is Stanley and, in the far distance, the East Lamma Channel and Lamma Island.

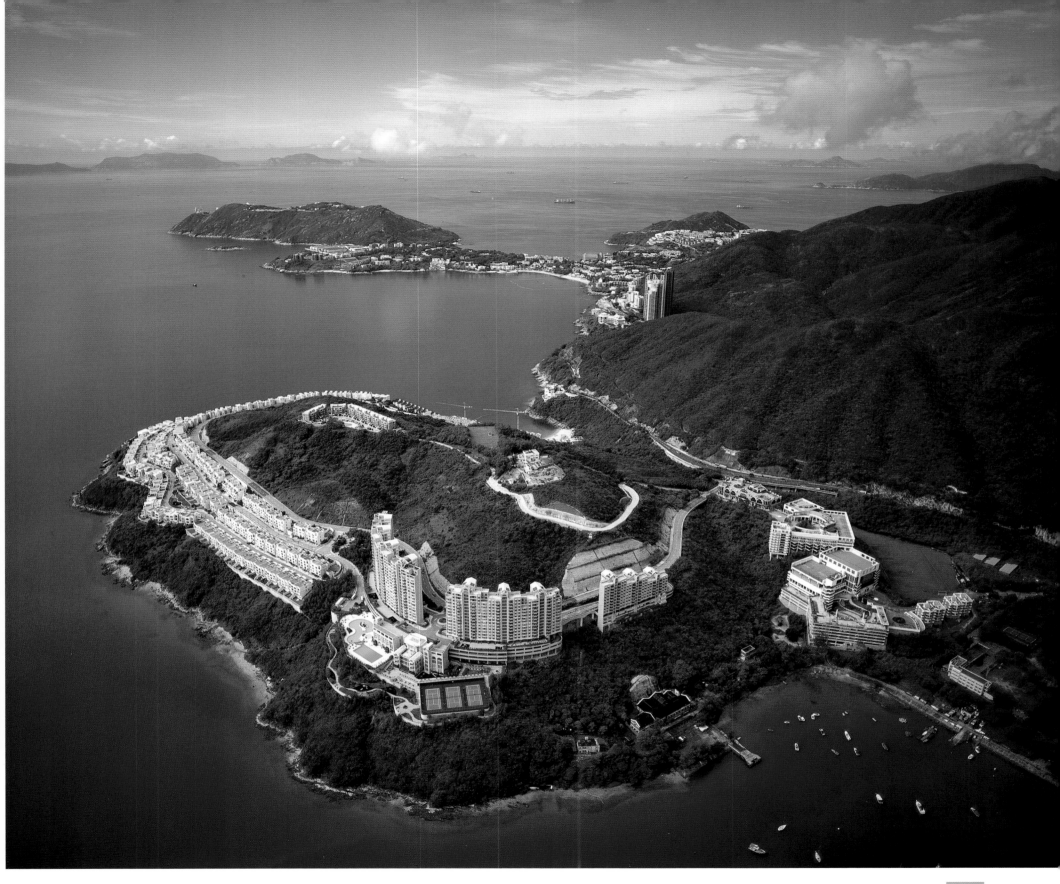

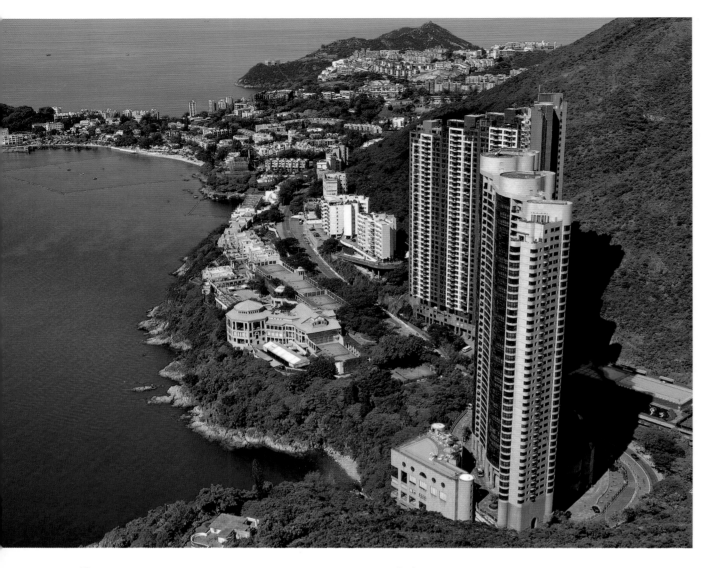

Above
Tai Tam Country Park Complementing the Town Club, the
country facility of the American Club claims a prime position in
Tai Tam overlooking Turtle Cove in this late-1990s photograph.
The surrounding area is Tai Tam Country Park, the largest park
on the island.

Right
Stanley The view across Stanley and Tai Tam Bay to Redhill
Peninsula and, in the distance, the hills of Shek O Country
Park. The near side of the isthmus is Stanley Promenade, curving
round left to the pier and the rectangular block of Murray
House. This building began life as an army sergeants' mess in
Victoria Cantonment (better known as Admiralty), and when the
area was re-developed, the decision was made to preserve Murray
House as an excellent example of colonial architecture. It was
painstakingly dismantled stone-by-stone and re-erected on its
present site. Stanley itself is notable not just for the Promenade
but also Stanley Market and Stanley Beach on the far side of
the isthmus. The market is a very popular bargain-hunting
ground for tourists and the beach as the venue for a variety of
watersports from dragon boating to windsurfing.

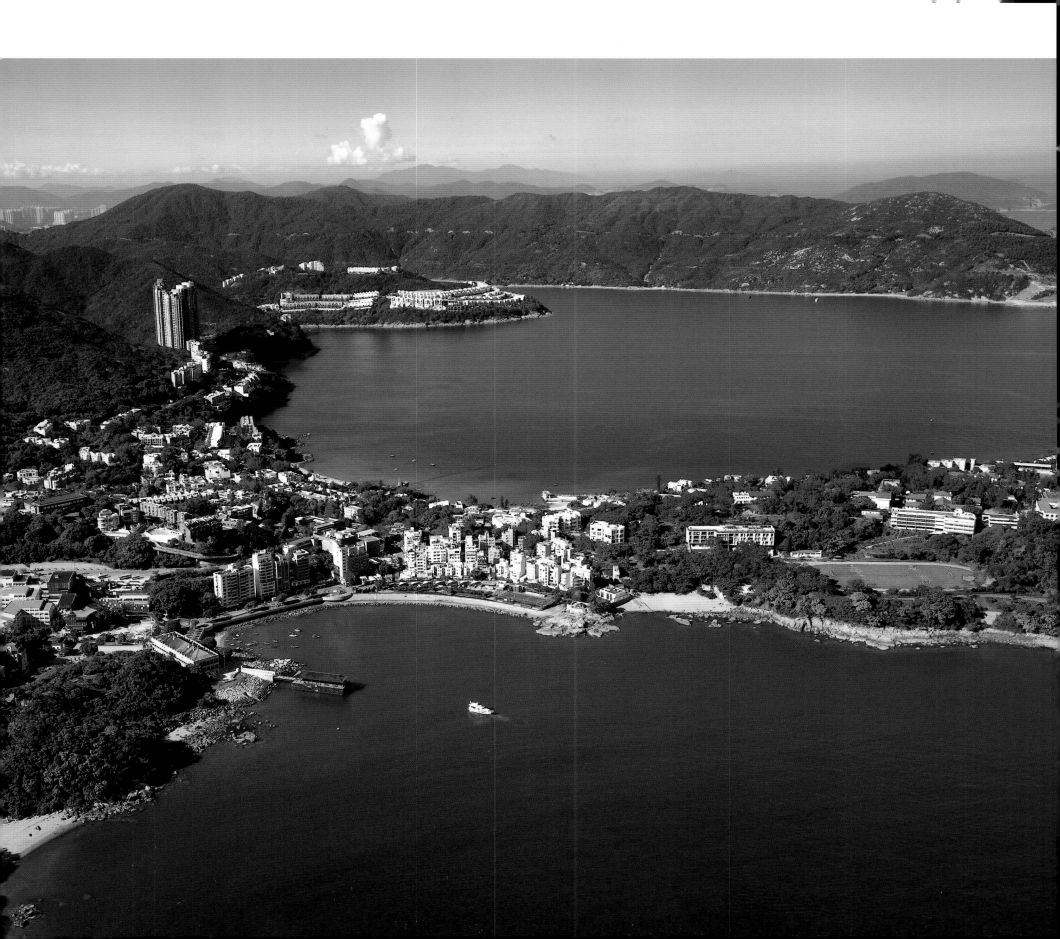

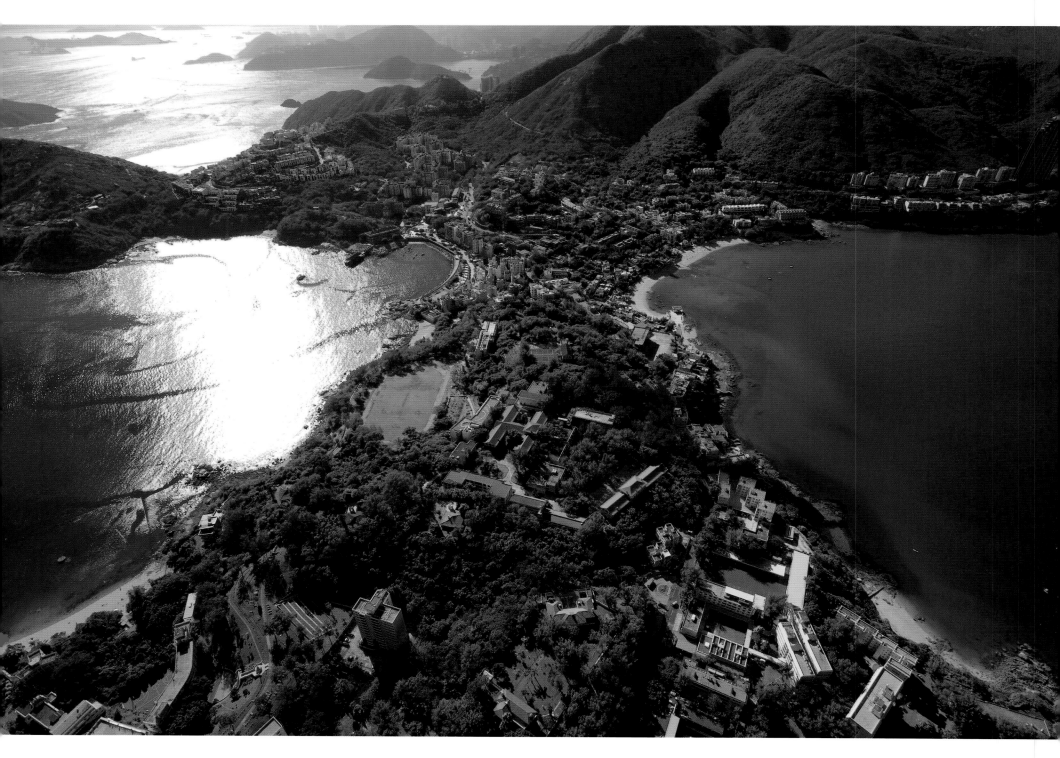

Stanley Stanley Village from the south. Just off the bottom of the picture is Stanley Prison and the staff quarters can be seen in the bottom right corner. To the left of this are the red roofs of part of St Stephen's College, the largest secondary school in the city. The rest of the college campus occupies the area between that and the sports ground to the left. During the Battle of Hong Kong during World War 2 this was the scene of very heavy fighting. To the left of the main village is the curve of Stanley Promenade leading to Murray House with Chung Hom Kok in the distance. On the other side is Stanley Main Beach, a popular watersports venue.

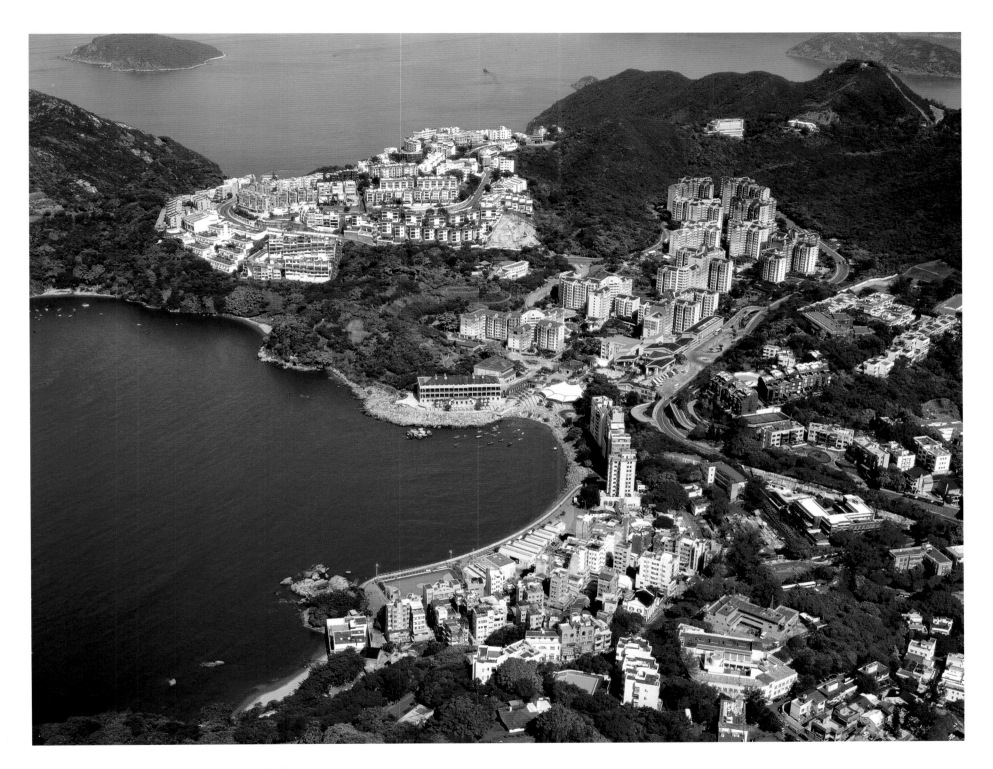

Stanley and Chung Hom Kok Perched on the headland above
Stanley is the luxury estate of Chung Hom Kok. In Stanley
itself, the Murray Building, transplanted stone-by-stone from
the former military cantonment in Admiralty, adds a touch of
Edwardian architectural grandeur to Stanley Promenade.

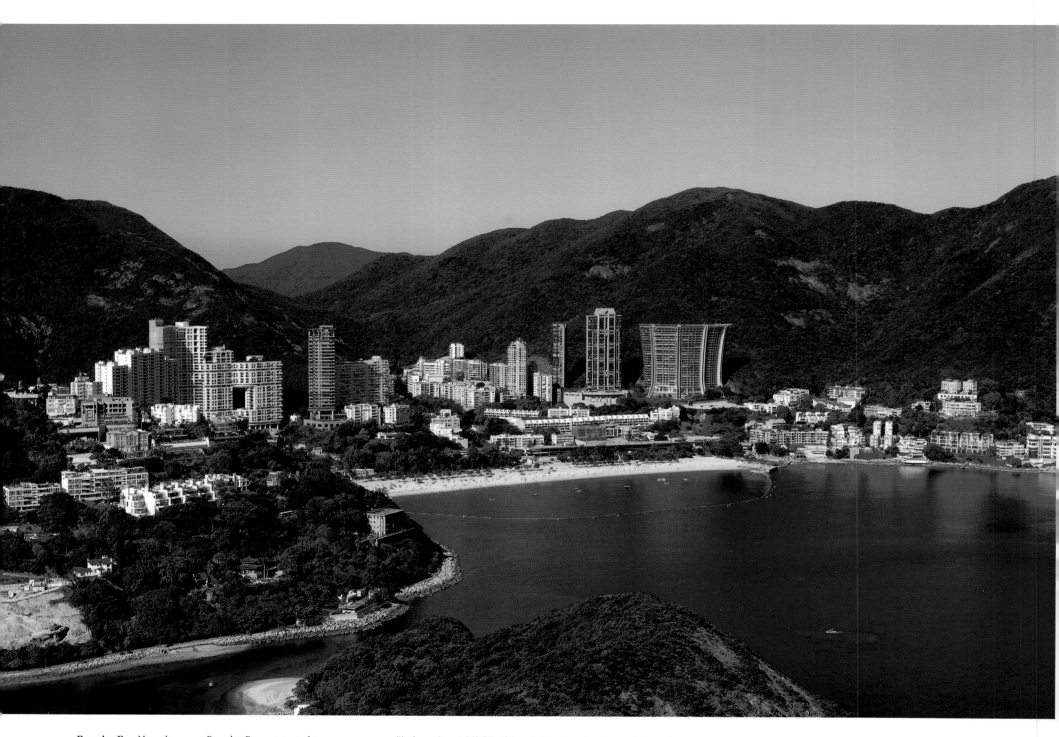

Repulse Bay How the name Repulse Bay originated is a mystery that has several explanations, none of which can be regarded as definitive. Indeed, until the 20th Century British Admiralty charts inaccurately named it as Chonghom Bay. It has long been one of Hong Kong Island's more fashionable areas and is one of the most expensive housing areas in the city. The distinctive "hole-in-the-middle" building is The Repulse Bay and is on the site of the colonial Repulse Bay Hotel which was demolished in the 1970s and 1980s. The beach, now protected by a shark net, has been, since 1910, popular in summer with Hong Kong people wishing to find relief from the summer heat and the bus route from Central to Repulse Bay is one of the city's oldest.

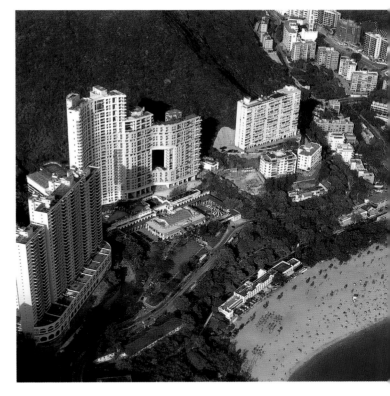

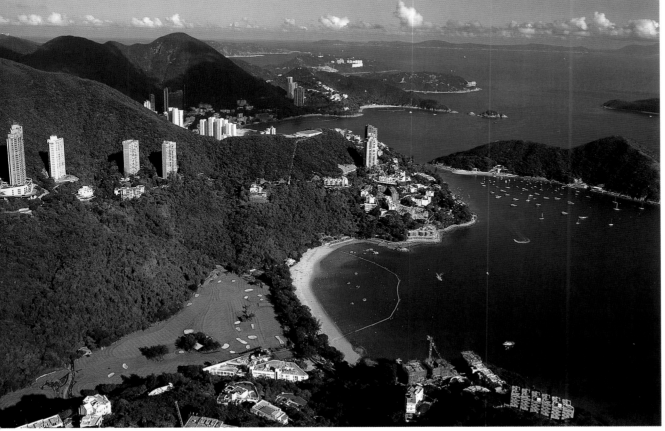

Top left
Repulse Bay Hotel This photograph of the original Repulse
Bay Hotel with its open-air verandah, was taken in 1982, shortly
before it was demolished.

Top right
Repulse Bay Hotel The original hotel was a haunt of the rich
and famous and it played a bit part in the film *Love is a Many
Splendoured Thing*. The apartments that replaced it were built
according to *feng shui* principles, hence the hole in the middle
to allow the local dragon free access between mountain and sea.
Public outcry at the loss of the hotel resulted on a 9/10th scale
replica being built.

Bottom
Deepwater Bay Deepwater Bay is one of Hong Kong's most
attractive beaches and behind it is the 9-hole course belonging to
the Hong Kong Golf Club. On Middle Island (to the right) both
the Royal Hong Kong Yacht Club and the Aberdeen Boat Club
have club facilities and moorings.

Right

Aberdeen and Ap Lei Chau One of the earliest RAF reconnaissance photographs of
Aberdeen and Ap Lei Chau, this was taken from a height of 21,000 feet in 1924. Aberdeen
is still a small fishing village although the majority of the fishing boats are moored, in
straight lines as today, off Ap Lei Chau. The breakwaters have yet to be built that will
create a proper typhoon shelter. A few sampans can be seen, a small harbinger of the
sampan city that will fill the harbour from the 1950s on.

Bottom right

Wong Chuk Hang Any photograph of the Aberdeen and Ap Lei Chau area is inevitably
dominated by the harbour with its mass of small boat moorings. The backdrop to the
amateur sailors' paradise in this picture is Nam Long Shan or Brick Hill where Ocean
Park is situated. A cable car on the other side of the hill connects the main entrance
in Wong Chuk Hang with the main part of the park seen on the seaward end of the
bluff. On the left of the picture is Wong Chuk Hang, the English meaning of the name
is "Yellow Bamboo Ditch". The area was originally an isolated farming area until, in
the 1960s, it developed into an industrial centre with a public housing estate built to
accommodate the workers. Now industry has moved on, the housing estate demolished
to be replaced by the MTR South Island Line and factory buildings re-purposed into art
galleries, restaurants, hotels and the like.

Bottom left

Aberdeen In contrast to the 1924 photograph above, by the mid-1980s, the population
has obviously blossomed. High rise apartment blocks have been built to accommodate
the sampan dwellers who were being gradually moved from water to land. A bridge
connects the two sides of the harbour, the island is being prepared for more
development, and pleasure craft are becoming more numerous. The chimneys of the
old power station are at the far end of Ap Lei Chau.

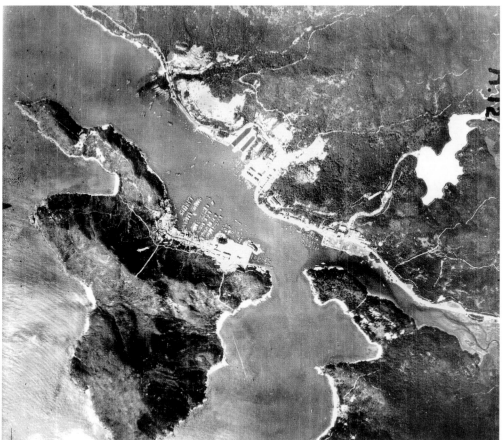

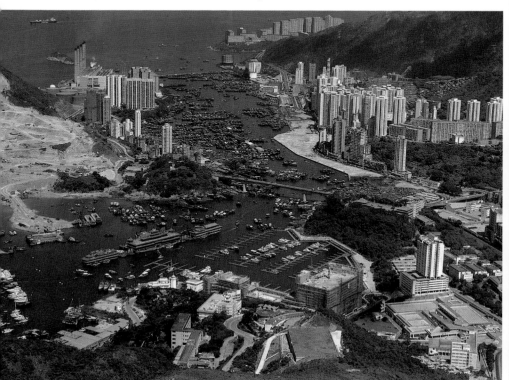

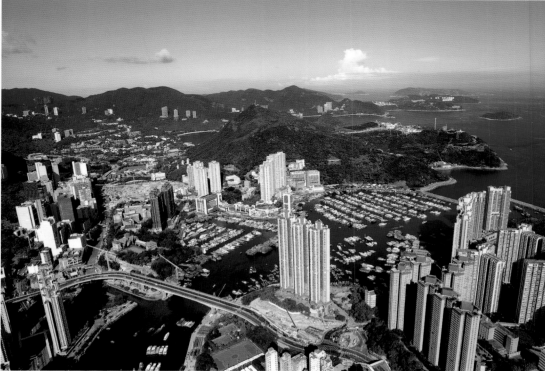

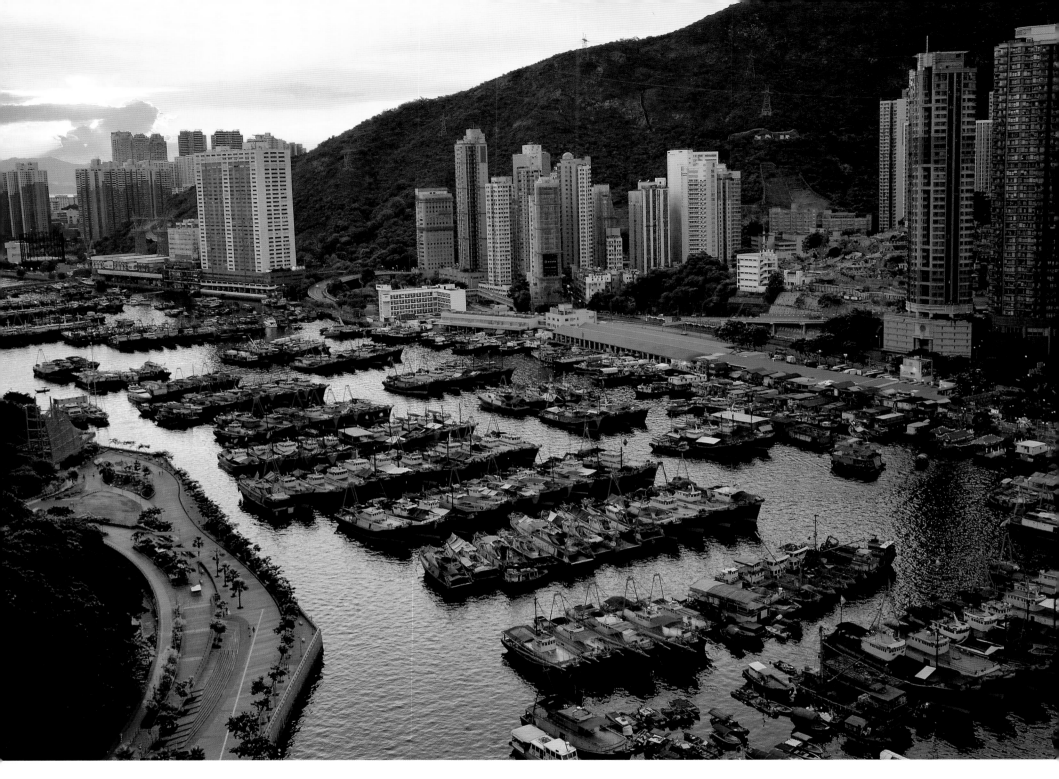

Aberdeen Harbour The view on a summer evening in Aberdeen when the fishing fleet is taking its mandated break from trawling the South China Sea. Not a true aerial shot but taken from a sufficiently high view as to almost qualify and certainly a worthy picture. The area in the bottom left corner is part of what is officially known as Aberdeen Promenade but was more properly called Aberdeen Praya. Praya is an interesting word that has been adopted into Hong Kong usage. The Chinese equivalent means literally "next to the sea". The word is originally from the Portuguese, rather succinctly meaning "the broad stone-faced road that runs parallel to the harbour in front of the city".

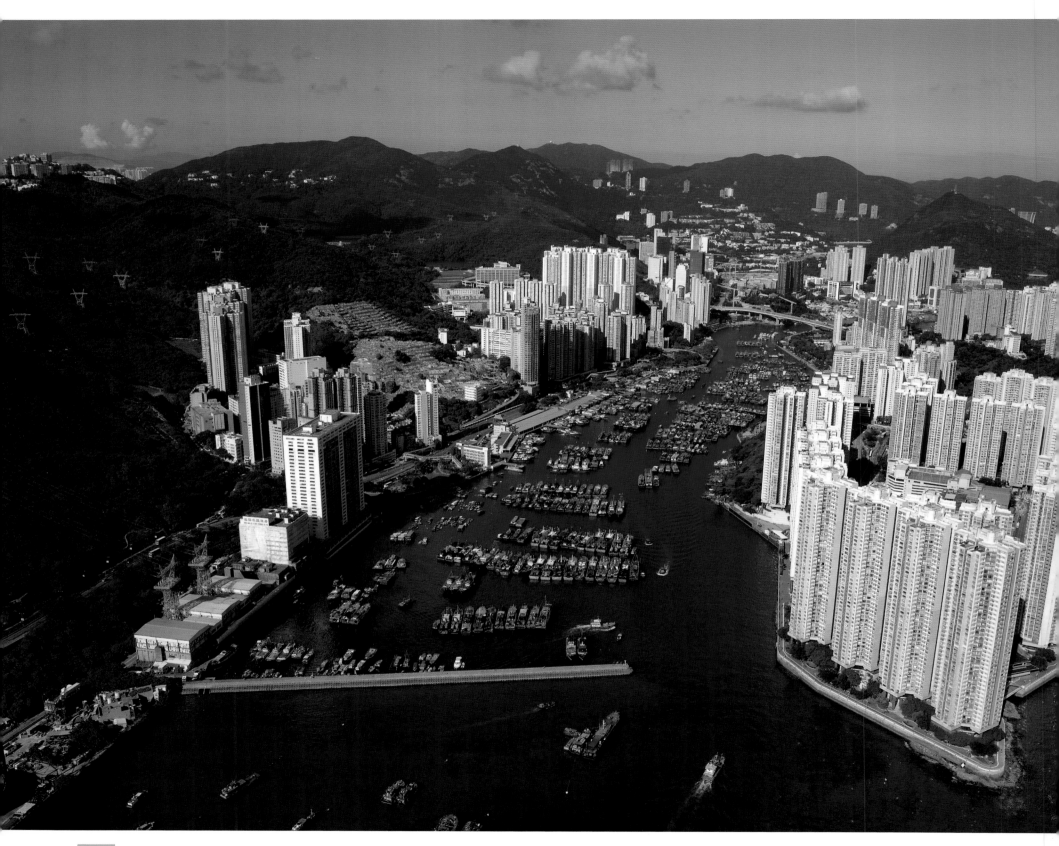

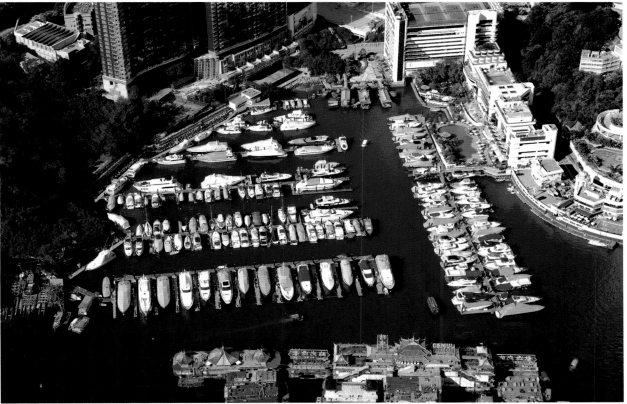

Top
Aberdeen Marina Aberdeen Marina is the place to find luxurious, and very expensive, yachts moored. It is under the control of Aberdeen Marina Club, founded in 1984, whose premises are the buildings on the upper right of the picture. At a more down-to-earth level, the three small piers at the top of the picture serve ferries to Jumbo Floating Restaurant and for sampans providing tours of the harbour. This corner of Aberdeen Harbour illustrates one of those contrasts that abound in Hong Kong, the luxury lifestyle in close proximity with the workaday world.

Bottom
Ocean Park First opened 40 years ago, Ocean Park is the largest theme park in Asia. On Nam Long Shan headland is The Summit which has a mix of animal-related attractions, such as Marine World, and traditional amusement park activities.

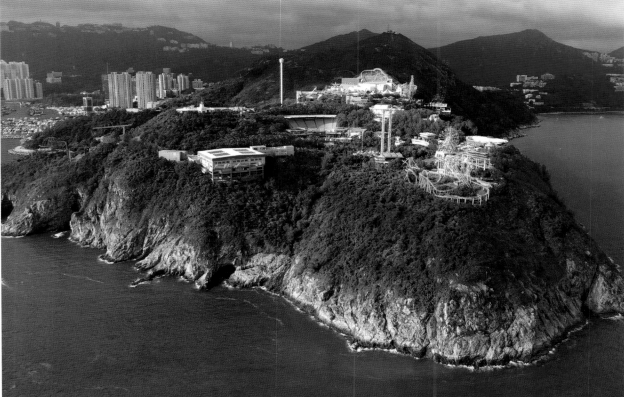

Opposite page
Aberdeen and Ap Lei Chau Aberdeen was the original "Fragrant Harbour", so-called because it was the home of incense makers, but now it is the primary fishing port of Hong Kong. The anchorage is well sheltered and these days busy with commercial and pleasure craft. In the summer months there is a ban on commercial fishing and so the harbour in this picture is unusually full of fishing vessels. Not too many years ago it was a floating sampan village whose Tanka inhabitants now live in the high-rise buildings either side of the harbour. The private development estate at bottom right on Ap Lei Chau is the site of what was Hong Kong Electric's power station.

Cyberport A container ship sails up the East Lamma Channel past the residential development Residence Bel-Air in the Cyberport business park. By contrast, to the right of Bel-Air is part of Wah Fu Estate. The estate was inaugurated in 1968 and marked a new chapter in the history of public housing in Hong Kong with the provision of better facilities and services. Flats were small, between 300 and 430 square feet, but unlike earlier public housing, each had its own shower and toilet. The concept was an early attempt to build a self-contained community of 50,000 people and the architecture was designed to foster a sense of community.

HK Island West The western side of Hong Kong Island borders the East Lamma Channel. At the left-hand edge of the picture is the enormous Pokfulam Chinese Cemetery and just above it, Queen Mary Hospital. The hills above are part of Pokfulam Country Park. Along the waterfront is Hong Kong University's sports grounds. To their right is Cyberport which was developed by the Hong Kong government with the intention of creating a place where information technology and multimedia start-ups could be nurtured. By happy coincidence the site chosen, Telegraph Bay, has a historical connection with communication technology. It is where international submarine telephone cables come ashore.

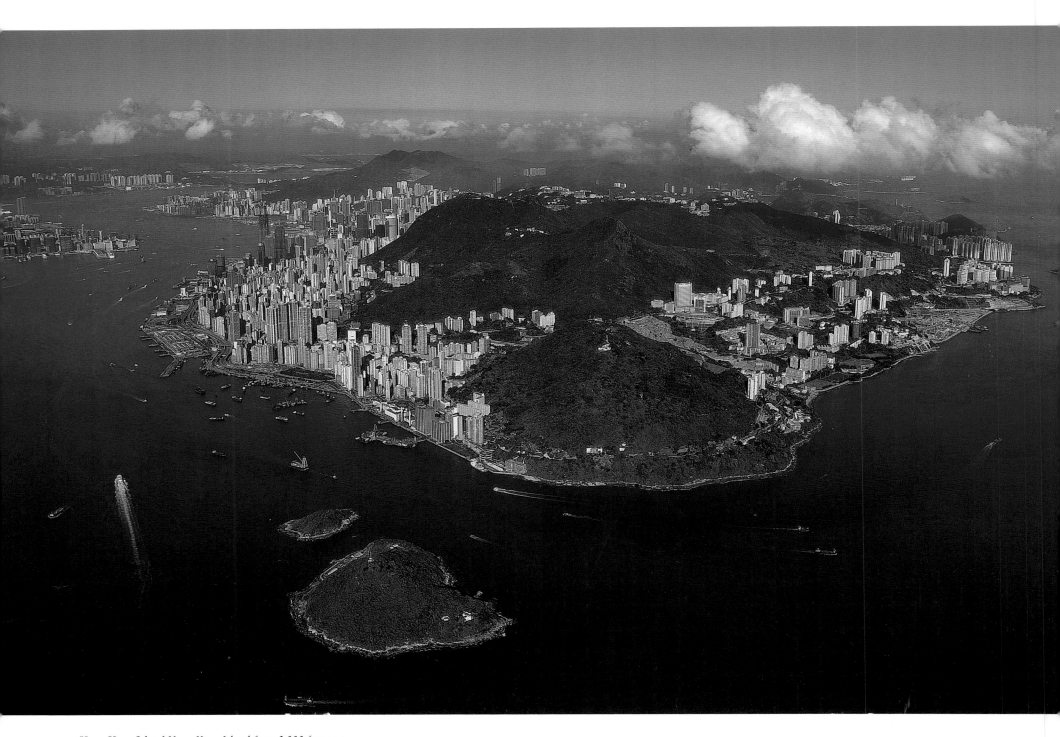

Hong Kong Island Hong Kong Island from 3,000 feet on a bright day, in 2002, is an amazing example of man's triumph over inhospitable terrain. It was because of the magnificent sheltered harbour that ships first anchored here in the 19th century and created a base for trade with China. Land suitable for building was scarce and the conurbation on the island's north shore, seen here from Western to Chai Wan, is mostly on reclaimed land.

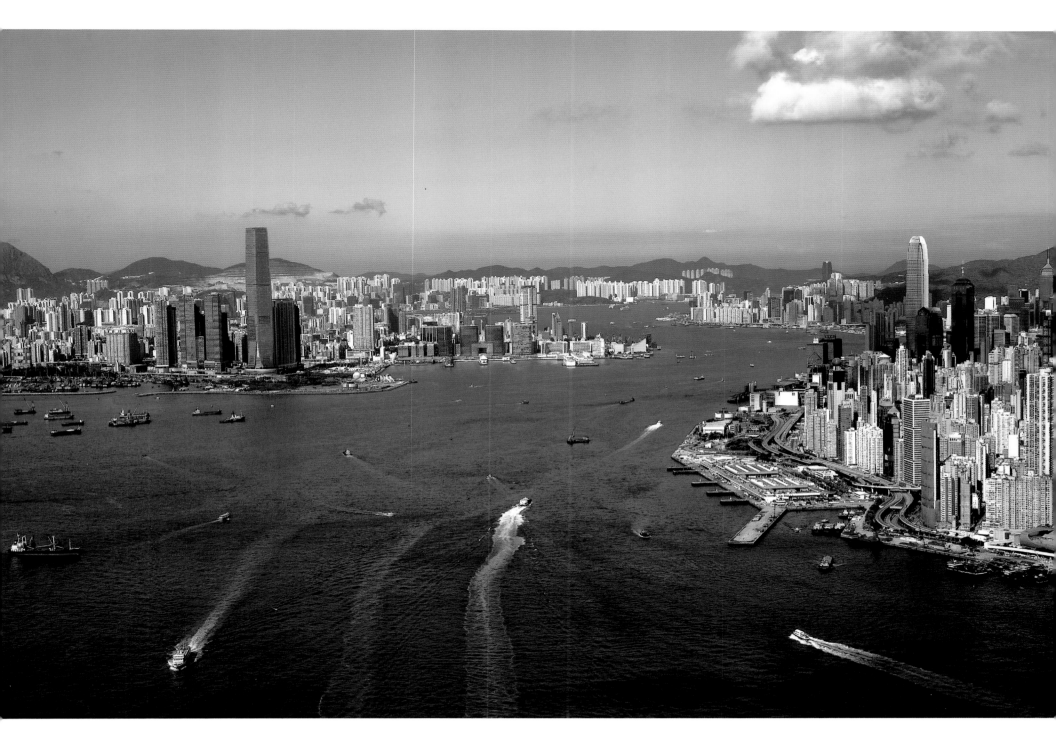

Victoria Harbour from the west From whichever direction,
this one is from the west over Belcher Bay, Victoria Harbour is
a pleasing sight. But the blue-roofed Central Wholesale Food
Market, the many cargo wharves along the shoreline and the
merchant ships at anchor remain a reminder that the life-blood
of Hong Kong has always been trade.

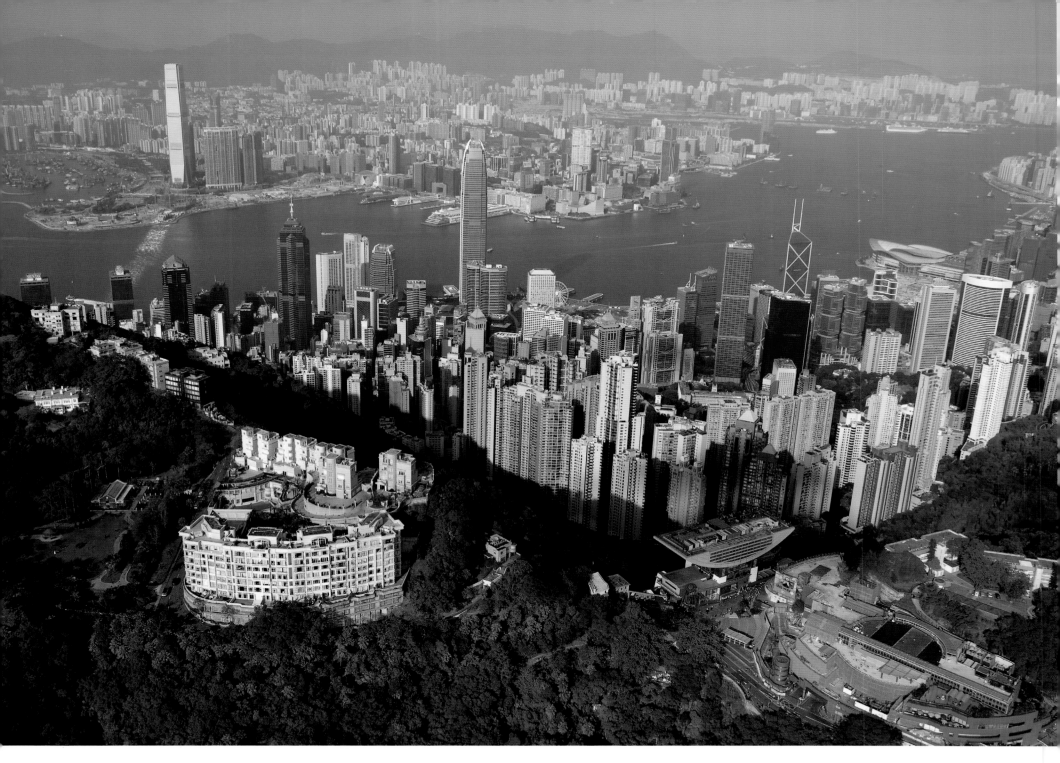

Across the harbour Traverse the roads of Mid-Levels on Hong Kong Island and you will keep finding viewpoints that offer stunning vistas. This photograph, taken in November 2017, from the air above Victoria Peak, rather than a road, is high-lighted by the two tallest buildings in the city, International Commerce Centre and International Finance Centre, whose names are a stark reminder of what is important to Hong Kong – trade and finance. In the right foreground is The Peak Tower below which is the conglomeration of high-rises in Central District.

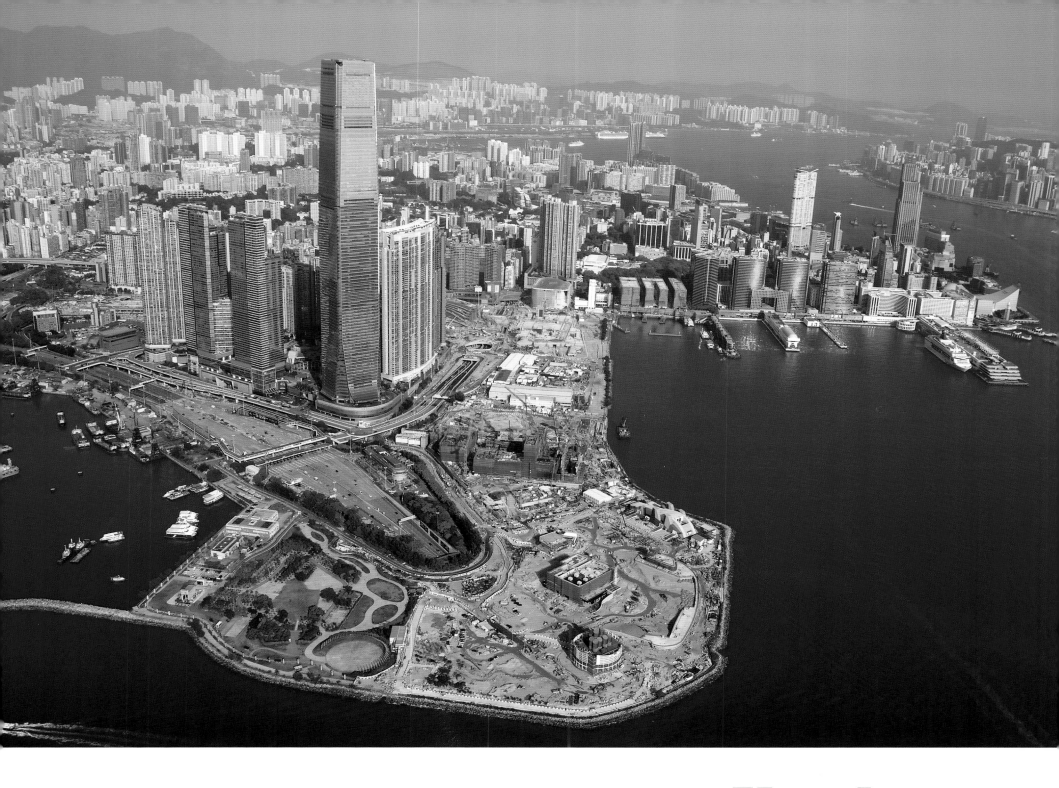

Kowloon

Previous page

West Kowloon In the middle distance it is possible to see the runway of what once was Kai Tak airport. When Kai Tak was still operating there was a strict height restriction on buildings in the Kowloon peninsula. Since the closure of that airport, the restriction has been lifted, making possible such structures as the 490-metre tall, International Commerce Centre. The area around the ICC is currently a huge construction site for the high-speed railway terminus and the long-planned facilities of the West Kowloon Cultural District.

Right

Tsim Sha Tsui Once upon a time it was possible to get off the Star Ferry from Hong Kong Island and catch a train that would take one (with changes, of course) all the way to the westernmost part of Europe. Where the Cultural Centre now stands used to be the Kowloon and Canton Railway's Kowloon station, the only remainder of which is the Clock Tower. The two Star Ferry piers continue to provide a cross-harbour passenger service to Central and Wanchai which the company has done since it was founded in 1888.

Bottom left and right

Tsim Sha Tsui Two views of the Tsim Sha Tsui waterfront in 1930s when the area was the centre of warehousing for cargo ships unloading alongside or in the harbour. Reclamation and development has brought big changes to the area.

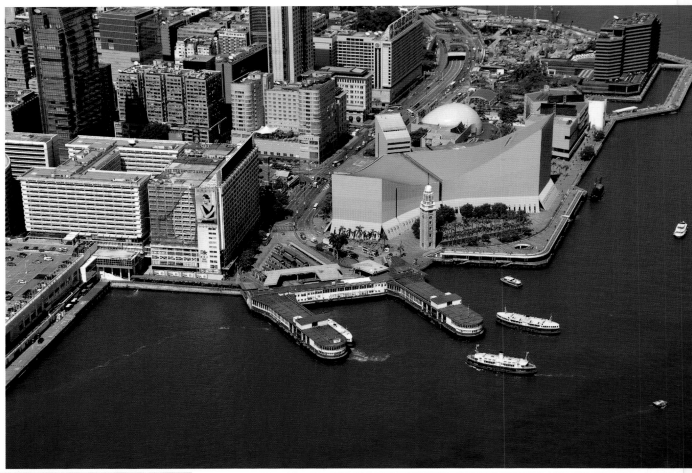

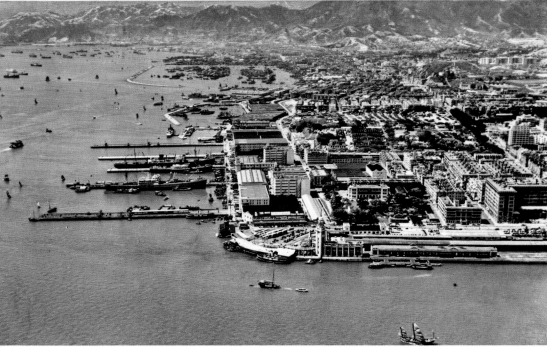

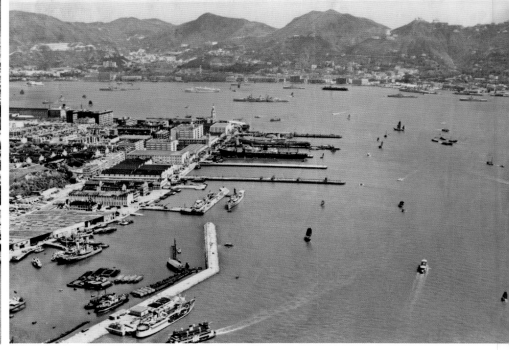

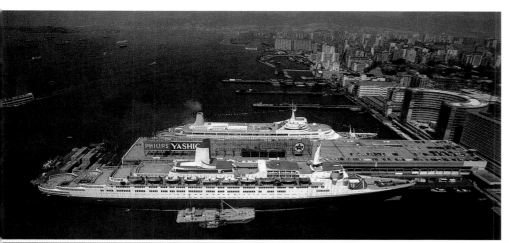

Left

Two Queens of the Sea A rare picture of two great liners, *Queen Elizabeth 2* and *Canberra* moored at Ocean Terminal while visiting Hong Kong in 1977.

Below

Tsim Sha Tsui In this night-view from the roof of the Sheraton Hotel c1976, the Kowloon-Canton Railway's Kowloon Station still stands. Beyond are the bright lights of Hong Kong Island at a time when the Connaught Centre (Jardine House as it is today) still dominated the Island's skyline.

KCR's Kowloon Station was closed in 1975 when the terminus was moved to Hung Hom and the government of the day determined that the site would be used for a cultural centre. Various campaigns by local organisations tried to prevent the demolition of the 1910-built station but were unsuccessful. Finally, a petition to the Queen, in 1978, was turned down, and within 48 hours, the wreckers moved in. Only the Clock Tower remains on the site.

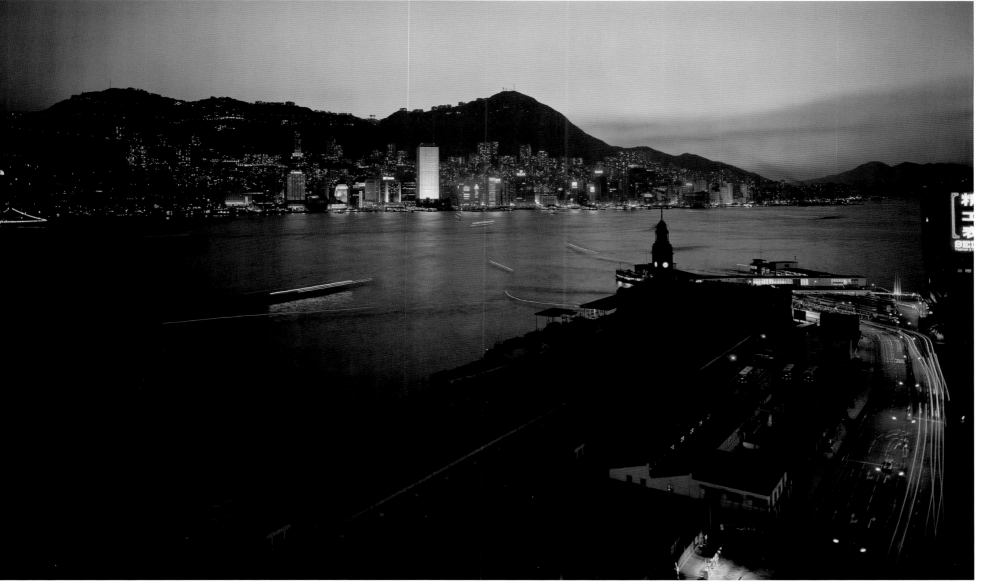

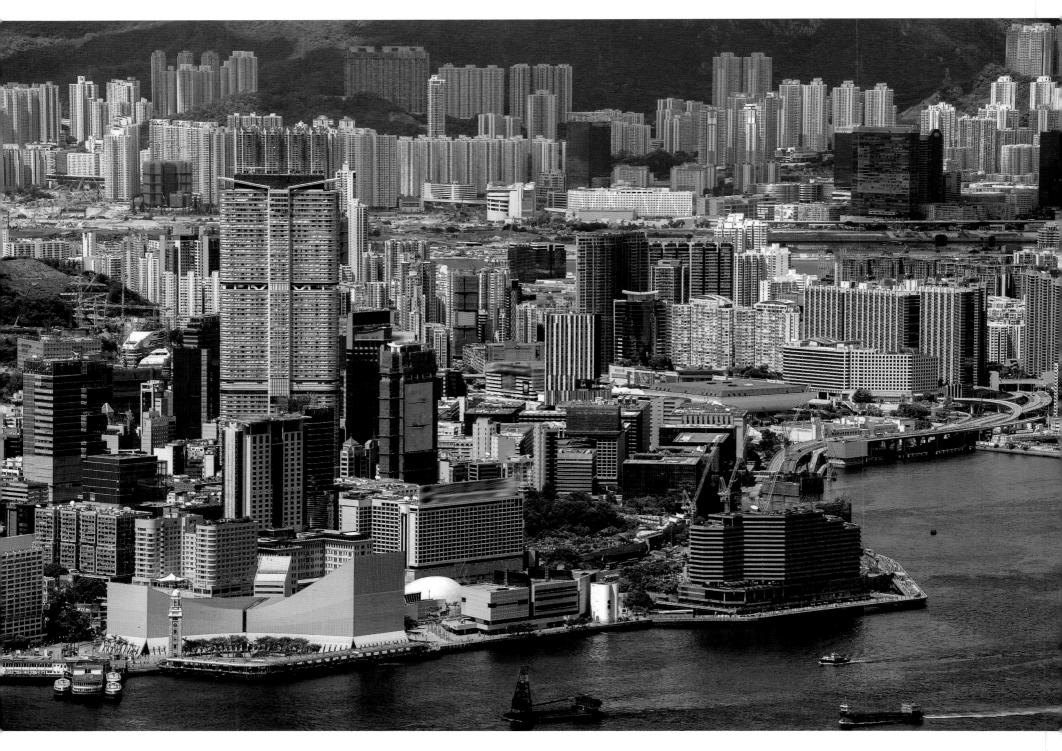

Tsim Sha Tsui Instead of trade, culture features on the Tsim Sha Tsui waterfront these days. The railway station has been replaced by the Cultural Centre with the Space Museum and Museum of

Art alongside. The Regent Hotel has become the Intercontinental and in front of it all is the Avenue of Stars that pays tribute to the city's film industry.

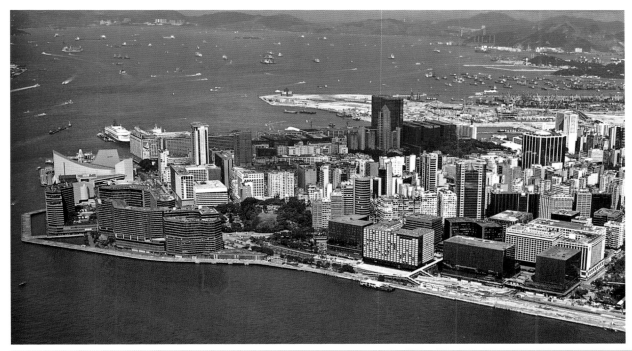

Left

Tsim Sha Tsui The waterfront of Tsim Sha Tsui in the late 1990s before the explosion of high-rise buildings following the closing of Kai Tak airport. What is always amazing, especially when seen from the air, is the amount of waterborne traffic.

Below

Hung Hom One of the city's leading concert venues, Hong Kong Coliseum, is the grey and white, square-shaped building in the centre of the picture. Alongside Tsim Sha Tsui Promenade, the Hung Hom By-pass snakes past the extension of the promenade with the Hung Hom ferry pier.

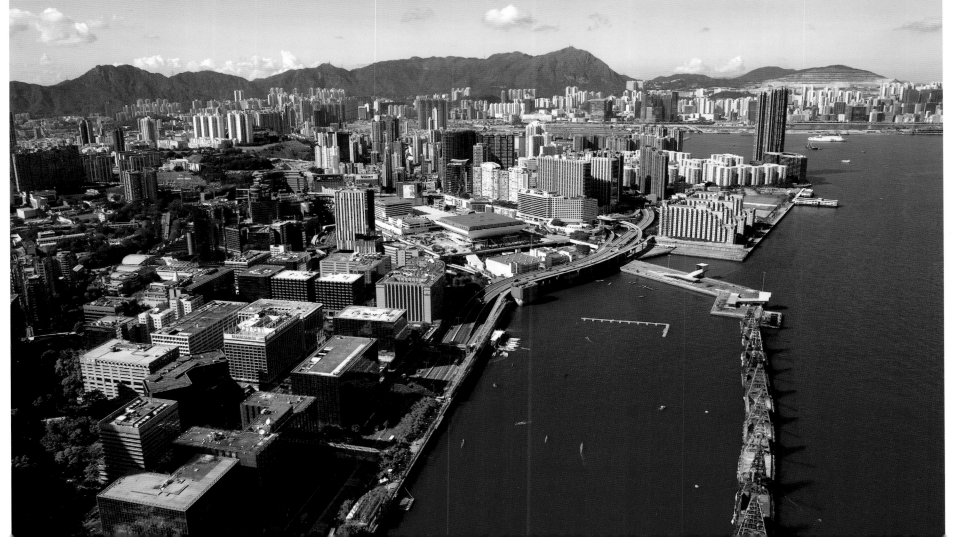

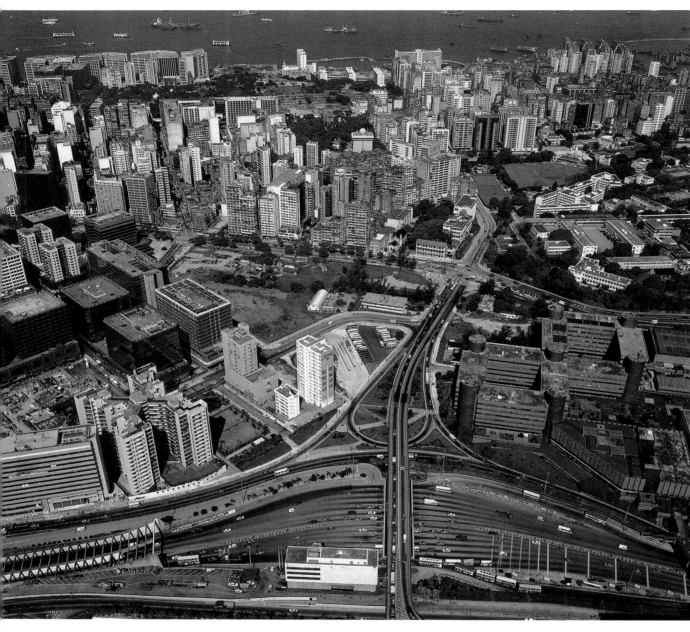

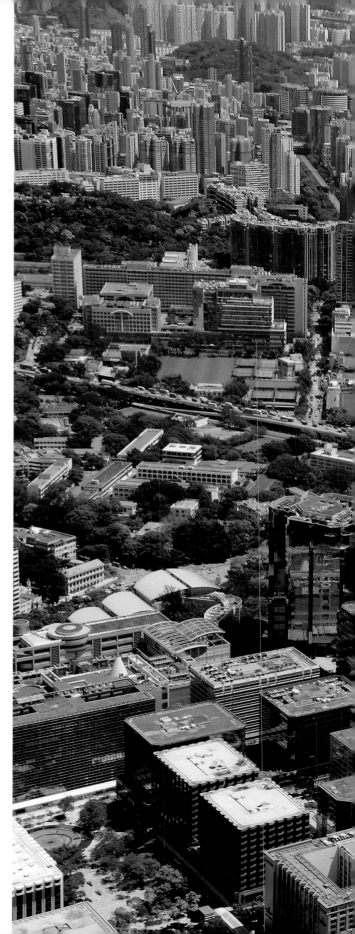

Above
Tsim Sha Tsui East In this early 1980s photograph, the toll plaza of the Cross-Harbour Tunnel is remarkably free of traffic and the road system adequate for the number of vehicles, quite a different picture to today. At the right are buildings of what was then Hong Kong Polytechnic (now a university) and above them the white buildings of Gun Club Hill Barracks, now a Peoples' Liberation Army base.

Right
Kowloon The view looking north from Hung Hom towards Kowloon Tong and the beginning of the New Territories. It is surprising how much of the urban area is technically in the New Territories. In the foreground is the Hong Kong Coliseum with Hung Hom railway station between it and the Kolwoon-side entrance to the Cross-Harbour Tunnel. To the left of where the toll plaza narrows is Hong Kong Polytechnic University. Compared to the picture on the left, the tunnel traffic is now much heavier.

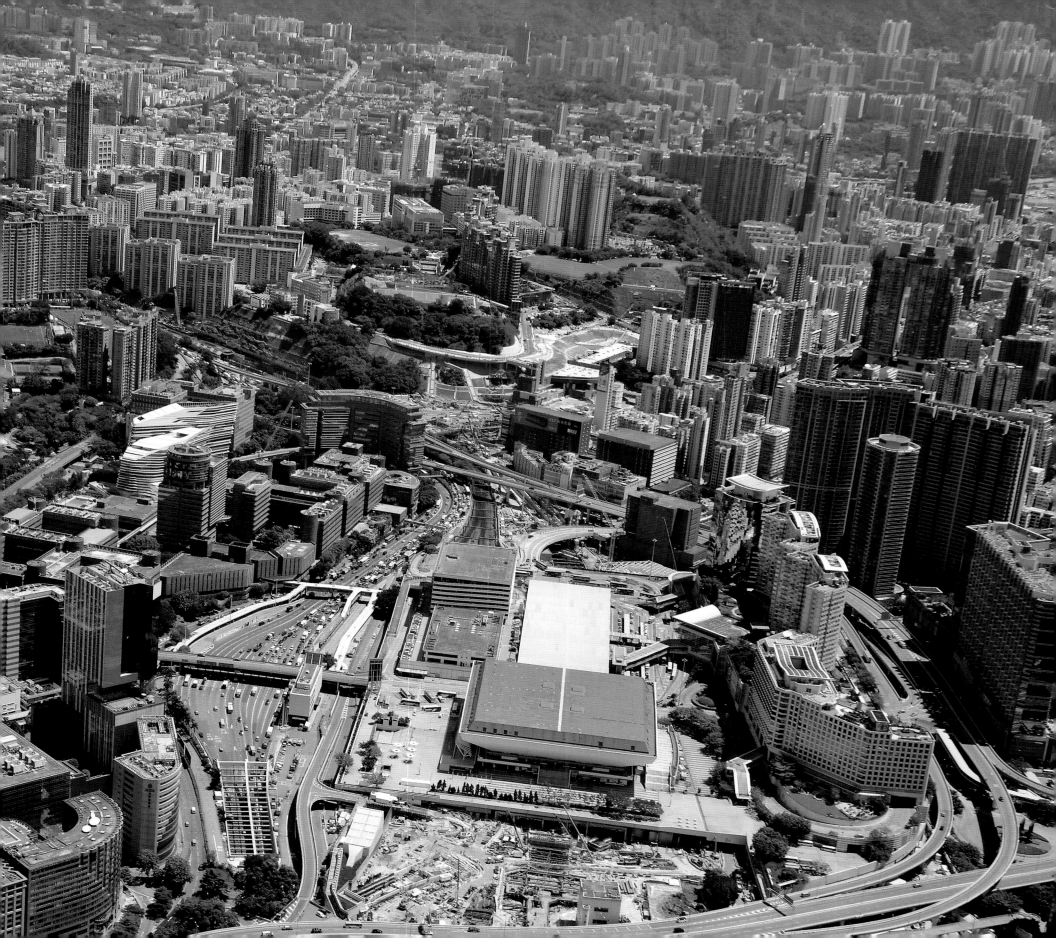

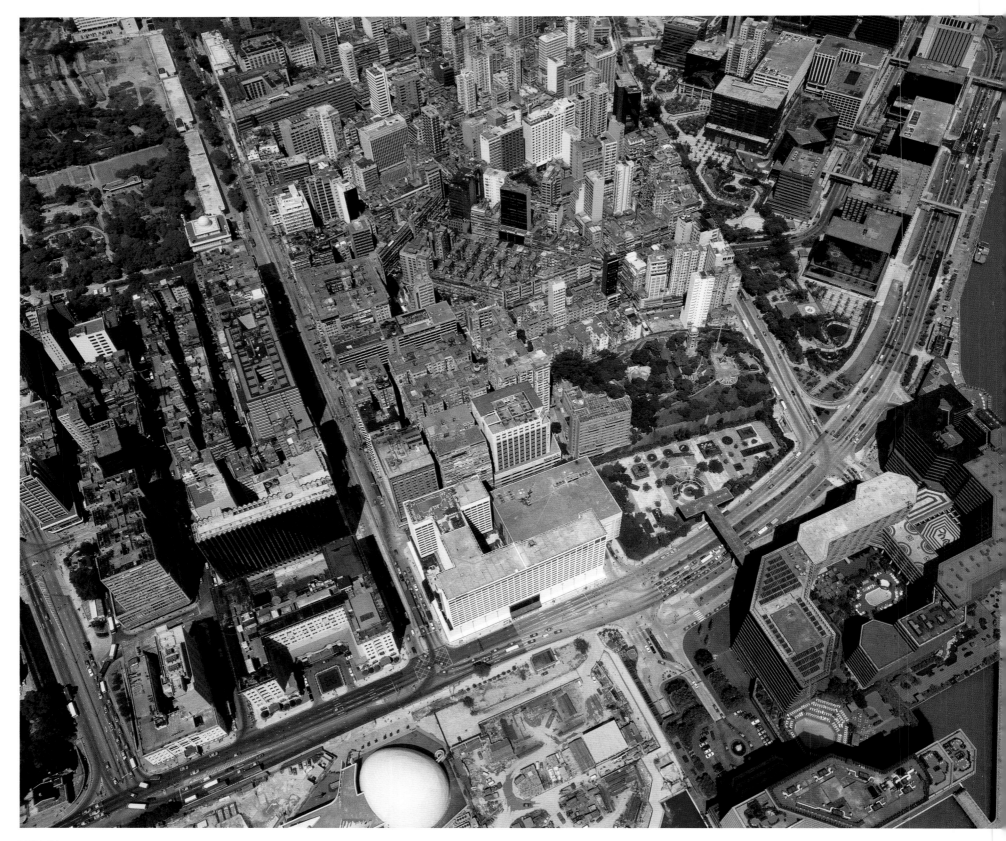

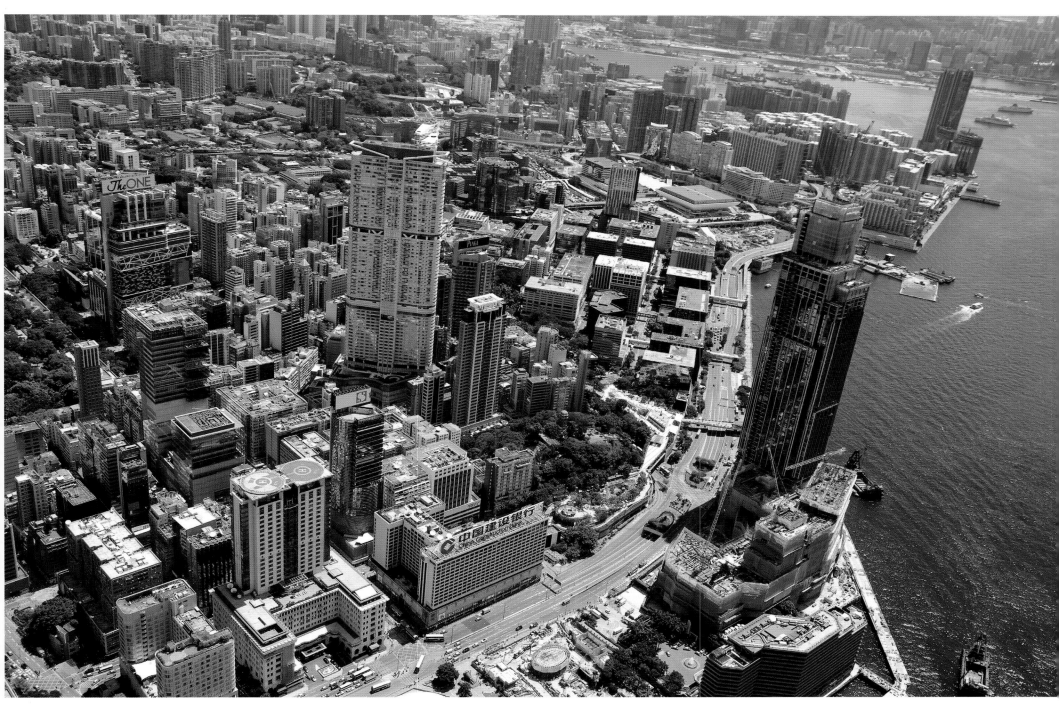

Left
Blackhead Point then In this near-vertical view from 30 years ago, the green area marks the original shoreline at Blackhead Point and is now known as Signal Hill Garden. The brick signal tower, restored in 1970, was, from 1908 to 1933, the location of the Observatory's Time Ball used daily by ships to check the accuracy of their chronometers.

Above
Blackhead Point now The same area as the opposite picture today. The building under construction at the right is the New World Tower and even the venerable Peninsula Hotel, in the foreground, has grown extra storeys.

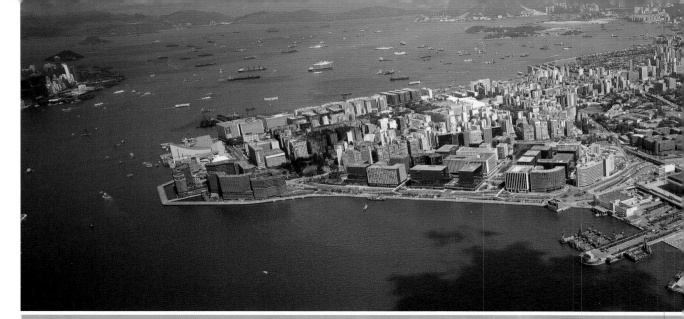

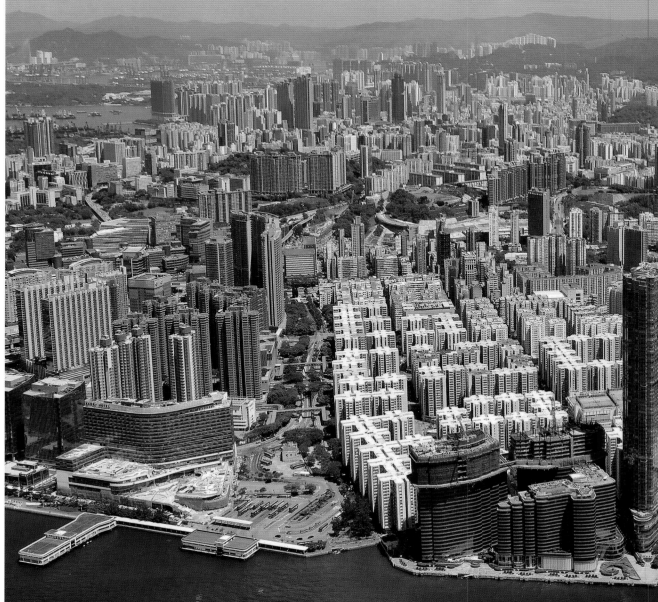

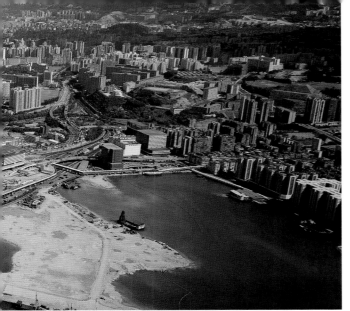

Kowloon In the early 1990s, reclamation of Hung Hom Bay continued apace as can be seen in this photograph looking west over the Hong Kong Coliseum and Polytechnic University towards Yau Ma Tei and Ho Man Tin.

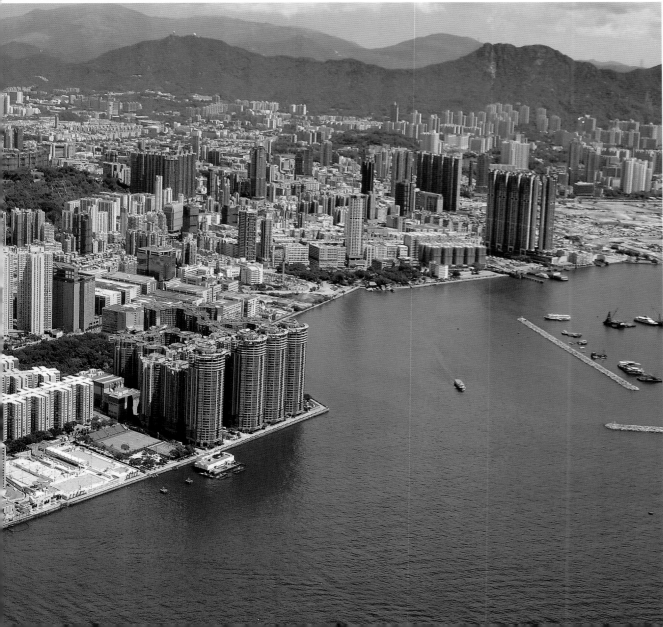

Whampoa Kowloon Docks, alternatively known as Whampoa Dock, founded in the 1860s facing Hung Hom Bay. The dockyard closed in 1985 and the area converted into a private residential development that took the name Whampoa Garden. A curious feature of the estate is a shopping mall in the shape of a ship as a tribute to the original dockyard. Further reclamation has enabled the development of Hung Hom Promenade with part of the ferry pier just visible at the left edge of the picture.

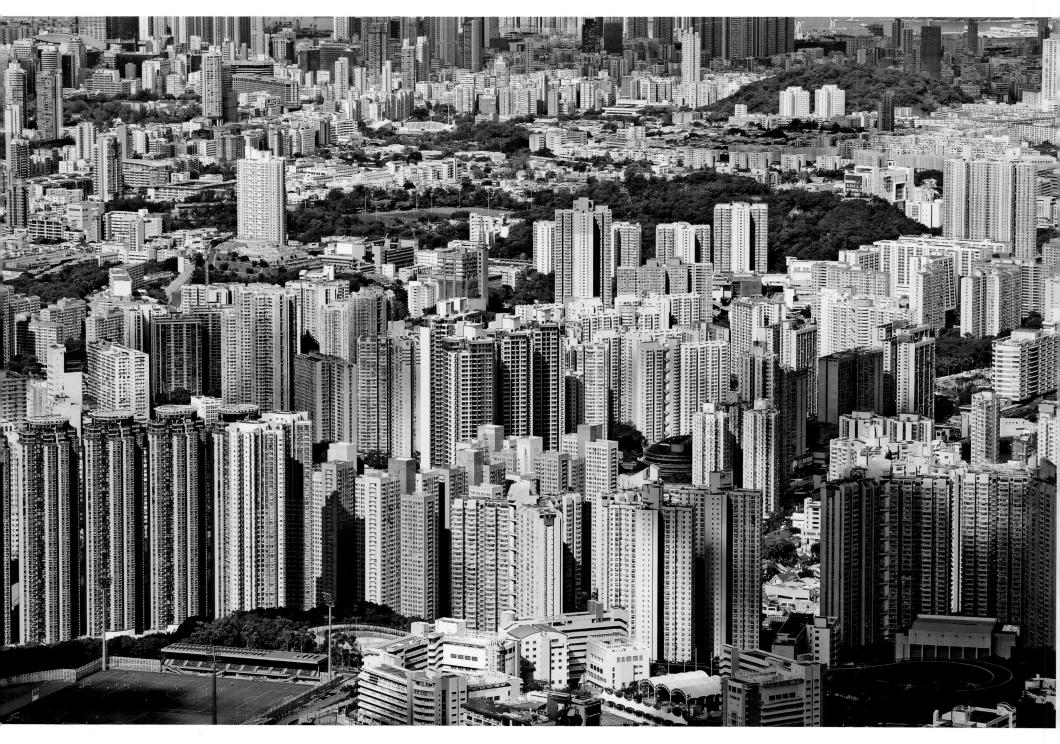

Pak Tin Serried ranks of high-rise blocks in Pak Tin avoid monotony with splashes of colour. Just beyond them, Shek Kip Mei was the scene of a disastrous squatter area fire on Christmas Day 1953 which gave birth to the public housing programme that has now made the Hong Kong Government the biggest housing landlord in the world.

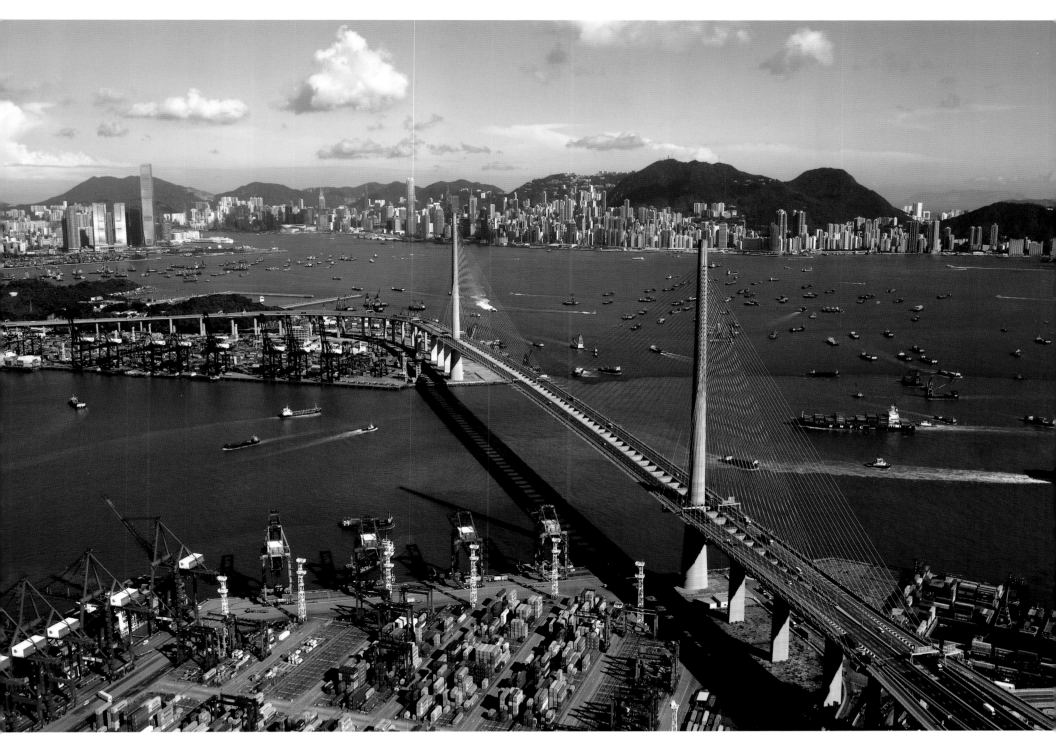

Stonecutters Bridge Stonecutters Bridge forms a gateway to the container port area. The bridge connects Stonecutters Island (no longer technically an island) with Tsing Yi Island and links eventually to Hong Kong International Airport. With a main span of 1,018 metres and total length of 1.6 km, it is currently the third longest cable-stayed bridge in the world.

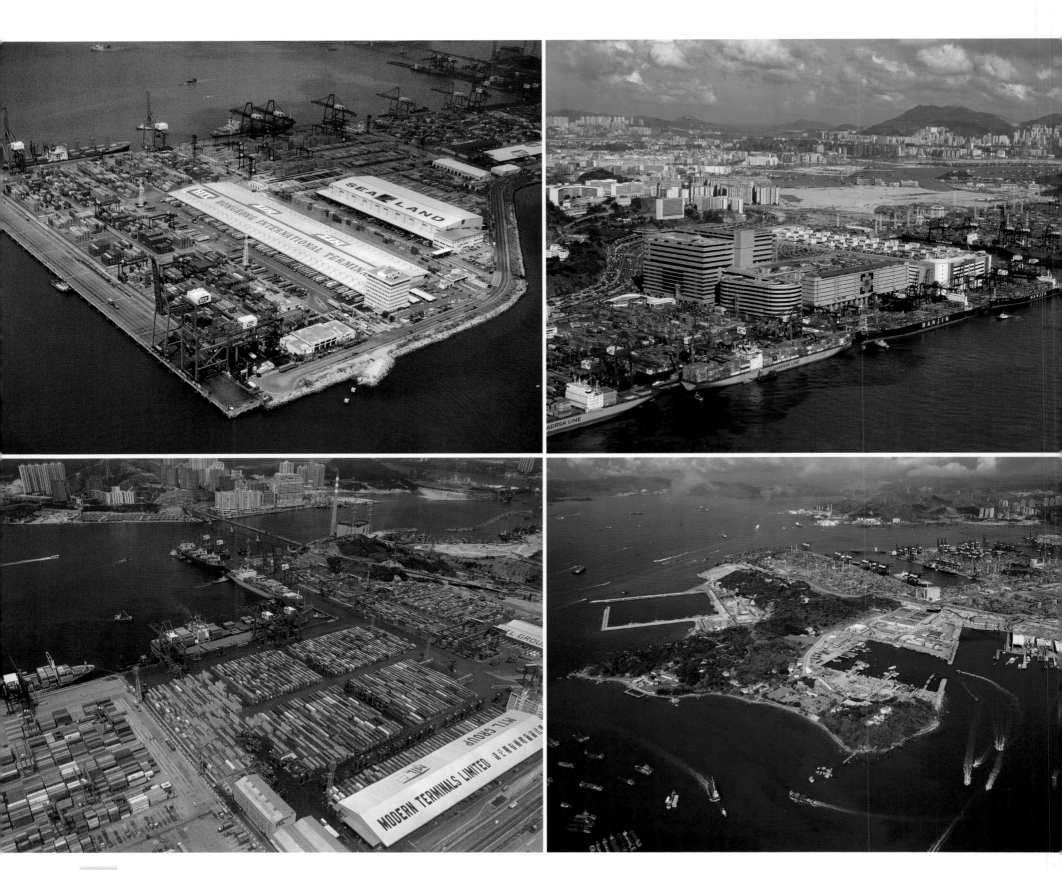

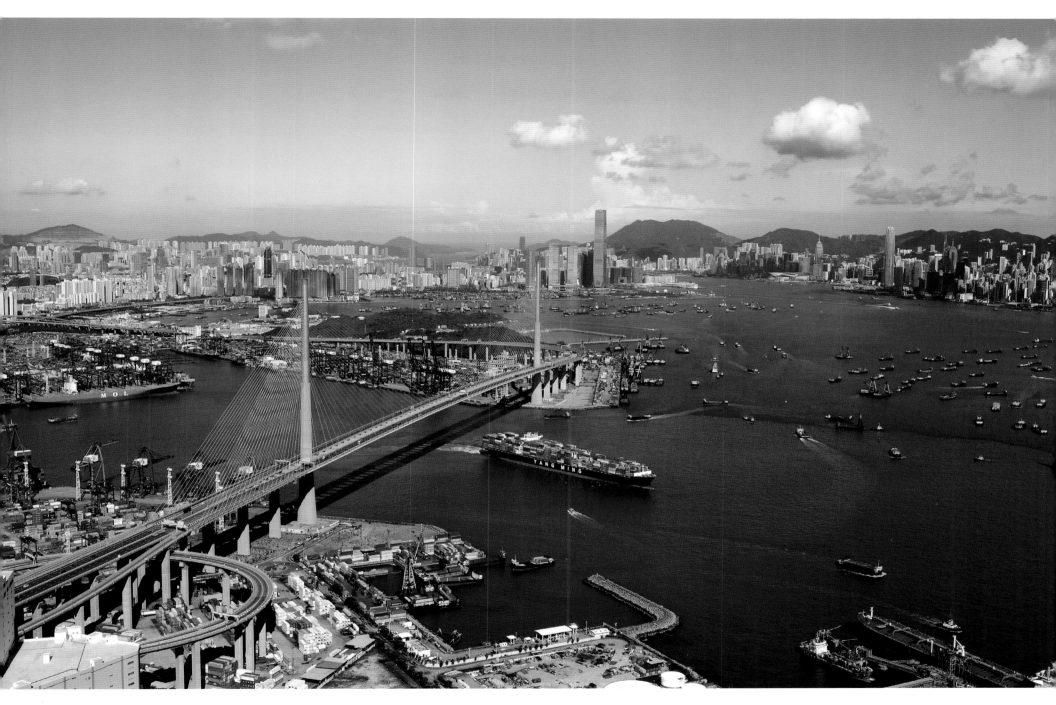

Left page
Kwai Chung A sequence of the development of the Kwai Chung container port area in the Rambler Channel from the early 1980s to 1999. The building in the photograph at top right rivalled the Pentagon as the building with the largest floor area in the world. In the photograph at bottom right, Stonecutters Island is no longer an island.

Above
Rambler Channel A ship departs the container port through the Rambler Channel and under Stonecutters Bridge. The number of small vessels in the open water of Victoria Harbour is a reminder of just how busy this port is. Underneath the spit of land to the right of the nearest bridge tower lie the remains of the liner *RMS Queen Elizabeth* which caught fire and sank, in 1972, while being renovated.

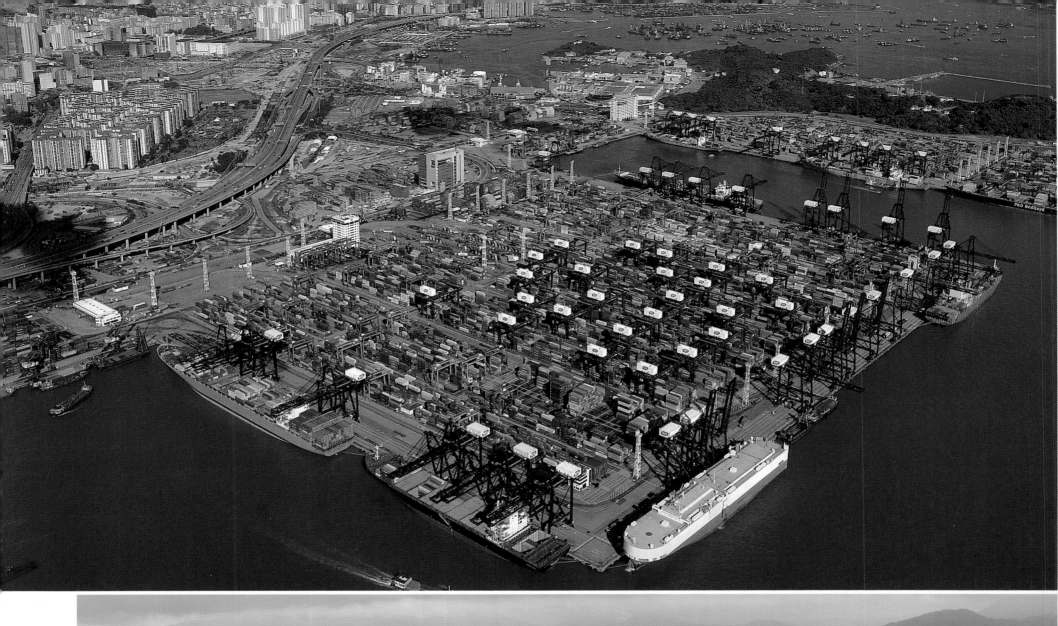
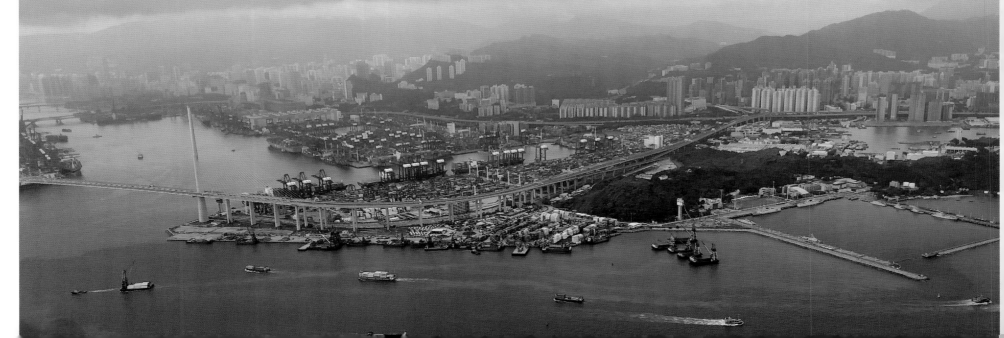

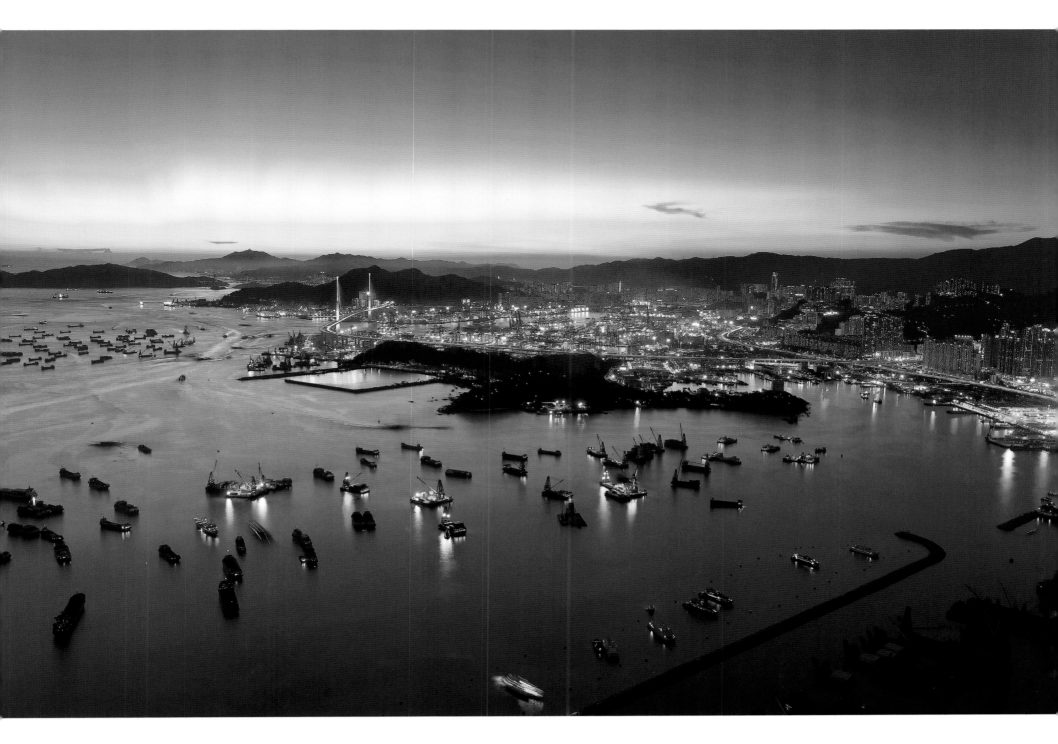

Left
Kwai Chung With so many boxes, how do they keep track of
them all? Twenty years ago (top) or today (bottom) the port is
always busy.

Above
Kwai Chung Sunset over the container port; the workaday world
transformed into a romantic image.

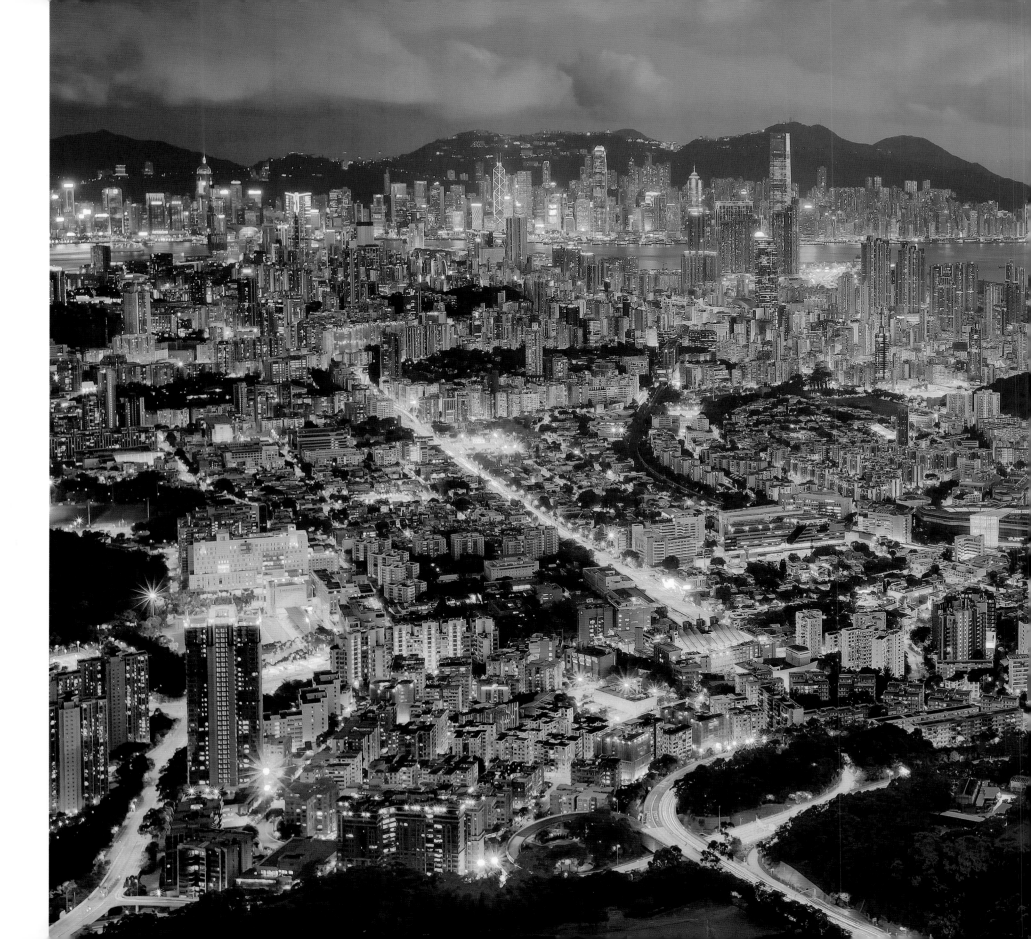

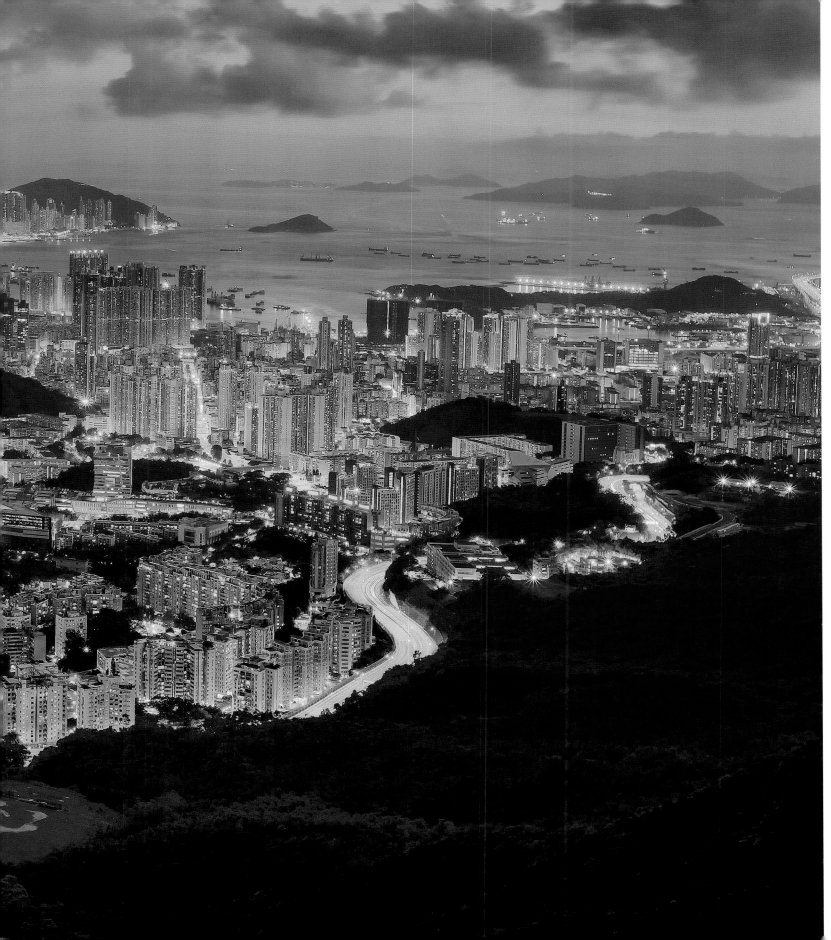

Golden City The golden glow of the city looking south over the Kowloon Peninsula towards Hong Kong Island. It is a graphic and beautiful illustration of just how crowded the city is. The viewpoint is from Lung Yan Road in the hills above Shek Kip Mei. City University is in the near foreground.

Following pages
Urban Geometry In close-up, high-rise buildings create almost-abstract geometric patterns of urban beauty.

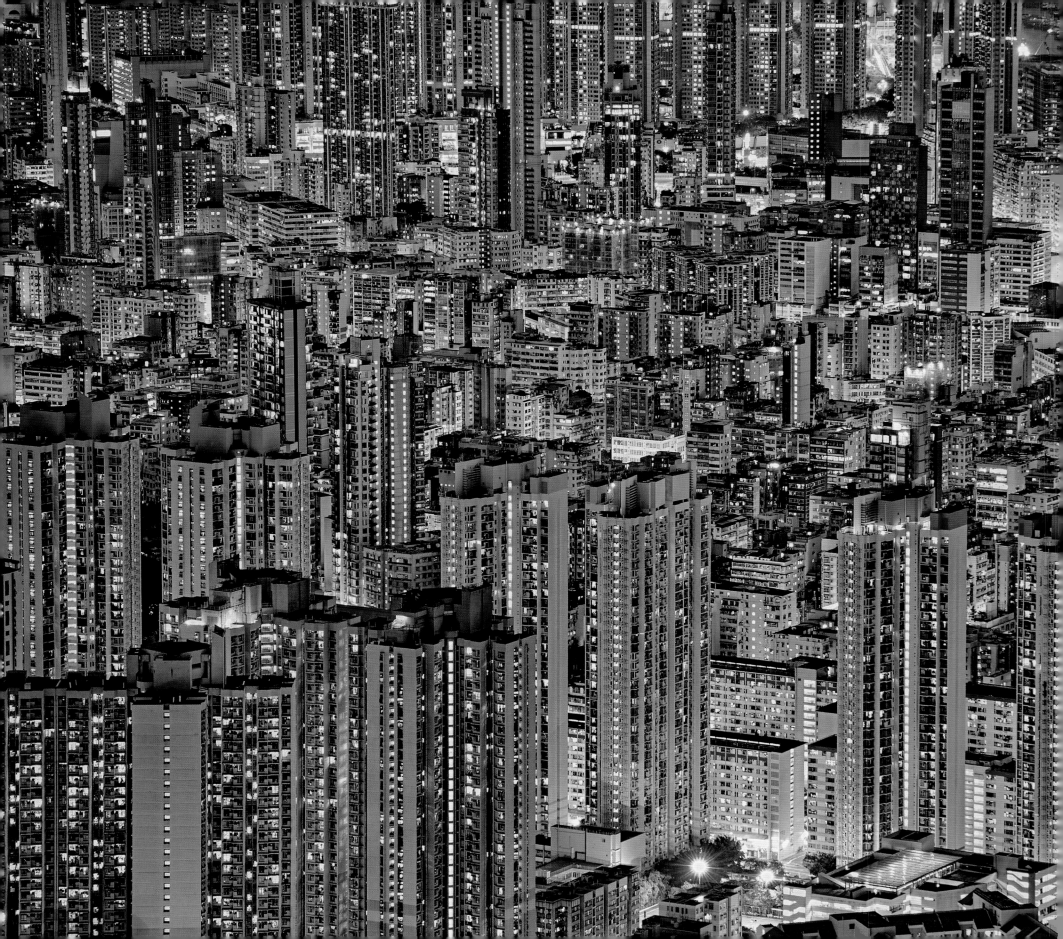

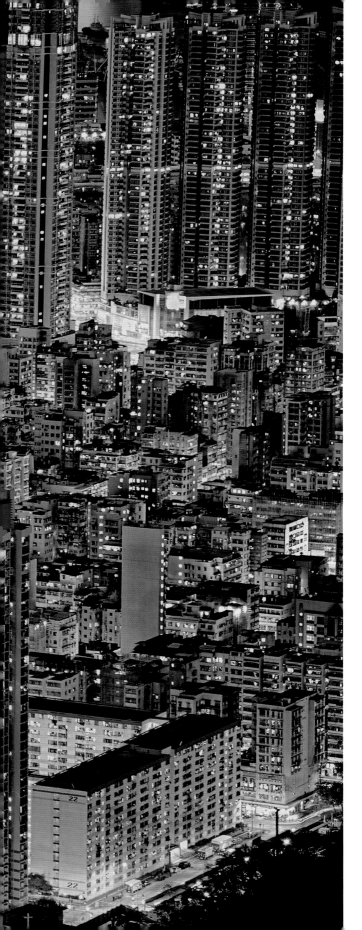
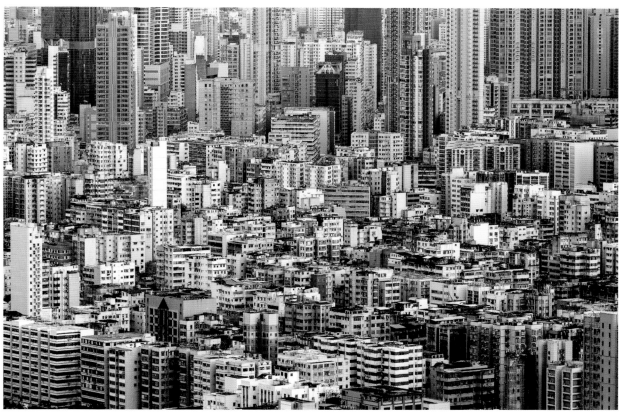
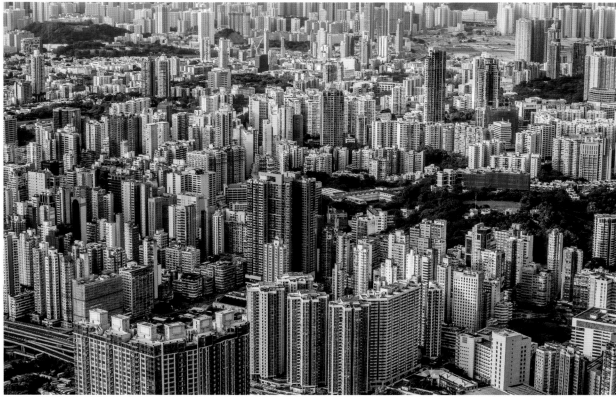

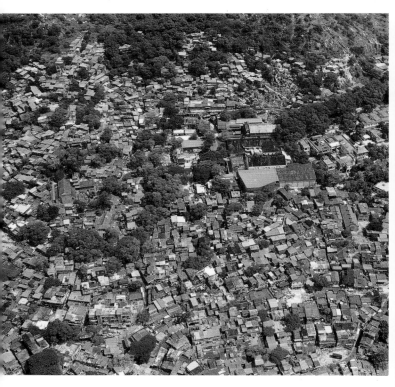

Above
Diamond Hill In the 1980s Diamond Hill was a mass of squatter settlements with a host of social problems, health and fire hazards that unplanned settlement entails. At the peak the population of the area was more than 50,000. Gradually, the squatters were moved as more public housing became available for re-settlement though the last area remained until 2001.

Right
Chi Lin Nunnery Chi Lin Nunnery was founded in Diamond Hill in 1934 as a retreat for Buddhist nuns and rebuilt in the 1990s in traditional Tang Dynasty style. When the last of the squatter camps was cleared, the Nunnery and the government cooperated to establish Nan Lian Garden on the site, also designed as a traditional Tang-style garden. Considering they are in the middle of a busy city area, the Garden and the Nunnery are surprisingly calm and peaceful places.

Far right
Kowloon City Kowloon City, near the old airport, has become famous for its restaurants, especially those serving Thai cuisine. This view of the streets was familiar, though perhaps a little scary, to air travellers arriving at Kai Tak as the aircraft made the infamous approach to landing on runway 13.

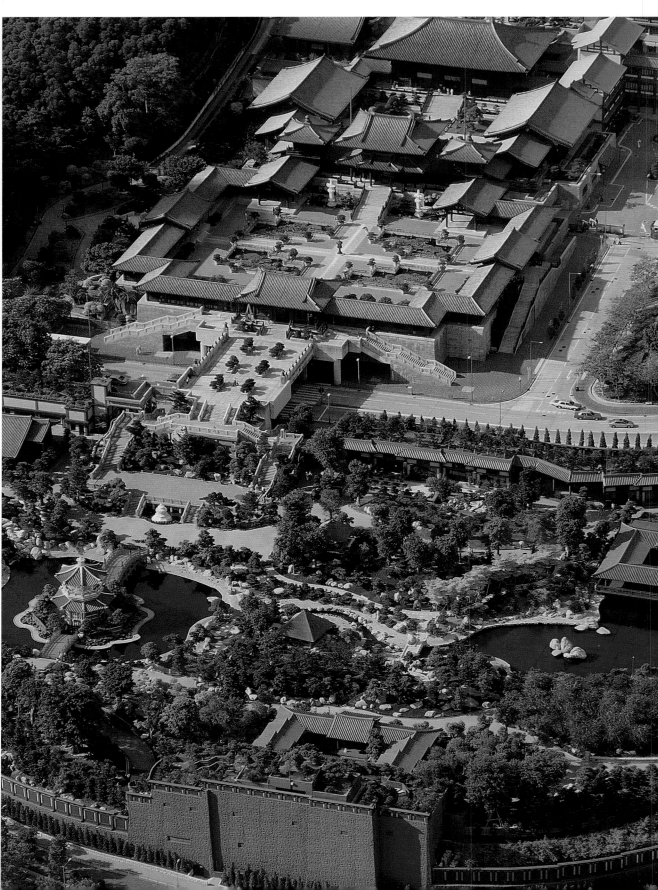

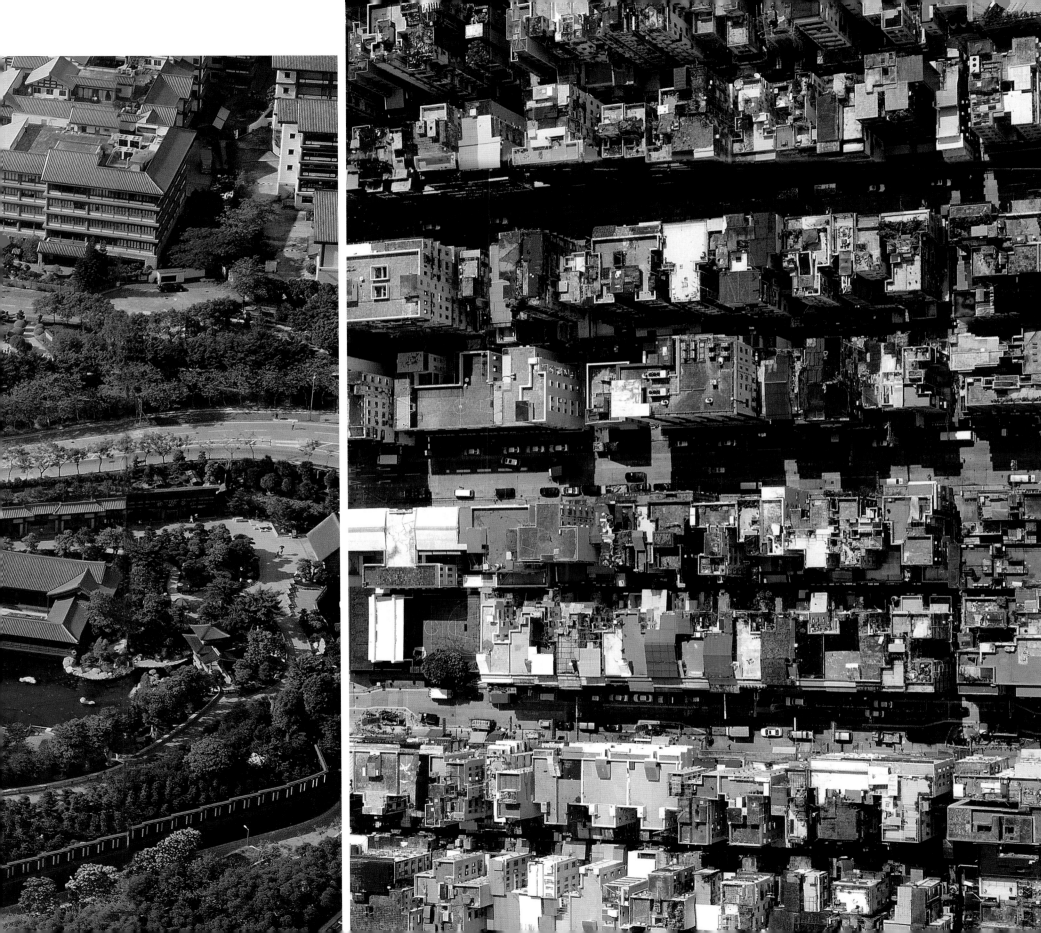

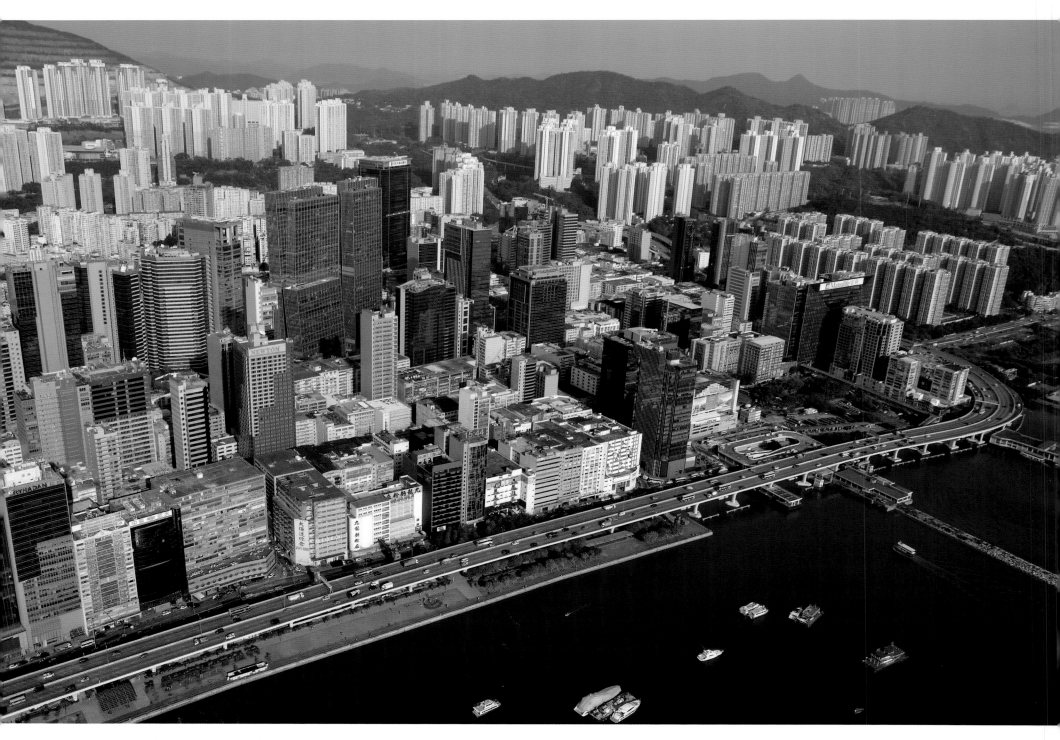

Kwun Tong Back in the Song Dynasty (960–1279), Kwun Tong was the centre of the salt production in the area and was known as Koon Tong or Mandarin Pond. In the 1950s, it began to develop as an important industrial area and the local inhabitants alledgedly took a dislike to the word Koon, which smacked of officialdom, and persuaded the government to change the name to Kwun Tong.

Now, in the city's post-industrial age, the area is taking on a new role as a commercial and financial centre. The old, polluting factories are disappearing and the housing stock is being replaced or rehabilitated to improve local peoples' quality of life.

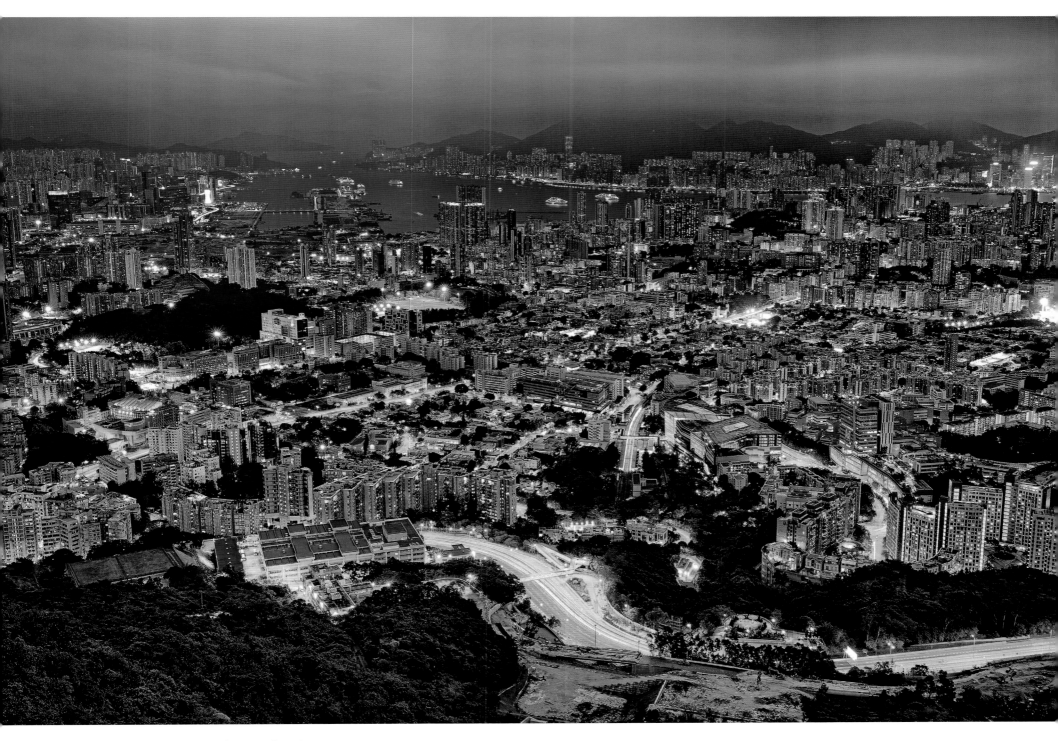

Kowloon City The magic of dusk transforms Kowloon City into
a lava flow of lights.

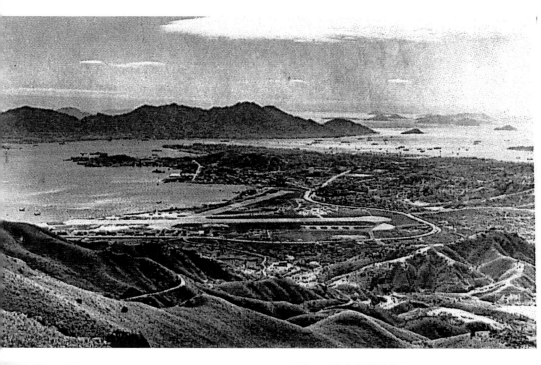
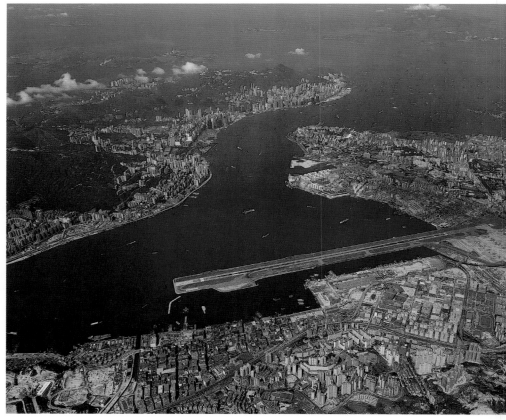
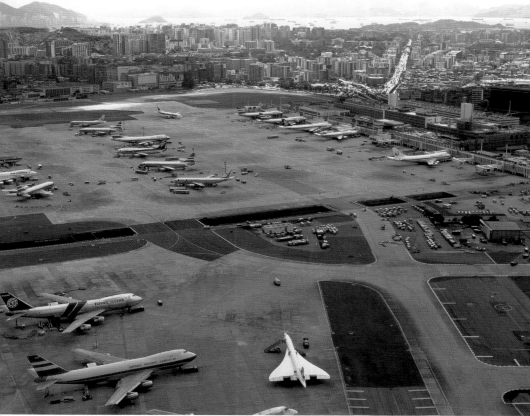
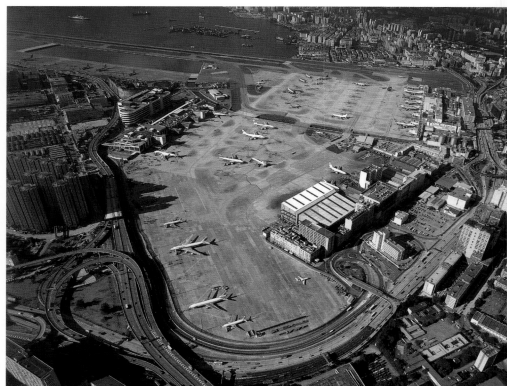

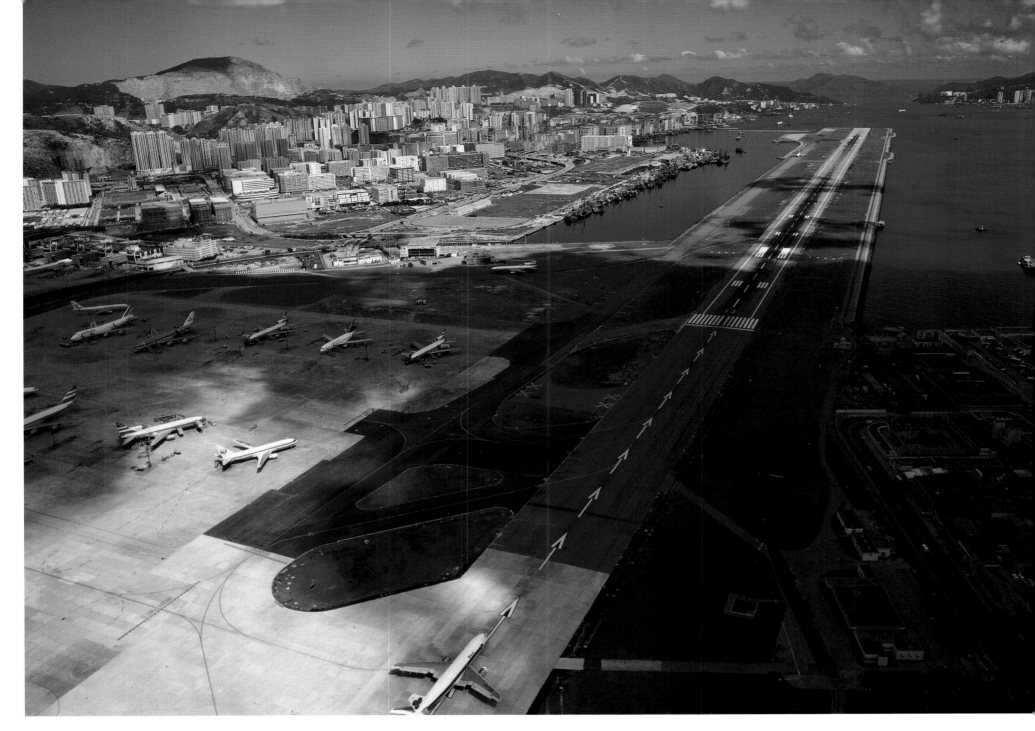

Upper left
Kai Tak During World War Two, Kai Tak developed from a grass strip into a two-runway aerodrome. This photograph dates from the 1940s.

Lower left
Kai Tak With limited air-bridges, aircraft were parked on the apron and passengers bussed to and from the terminal. At the lower edge of the picture is the distinctive shape of Concord. The road at upper right is Boundary Street, the dividing line between the colony and the New Territories.

Upper right
Kai Tak The demands of modern jet aircraft for ample take-off and landing space eventually required a new runway extending some three kilometers into the harbour.

Lower right
Kai Tak This photograph was taken shortly before the airport closed. The area just below the green patch marking the nullah, occupied by four aircraft, is the extent of Kai Tak when it first opened in 1925.

Above
Kai Tak A pilot's eye view, in the 1980s, of the final turn on to runway 13, though, for real, he would (in pilot-speak) be just a bit hot and high, too close in and hoping the brakes were in good order.

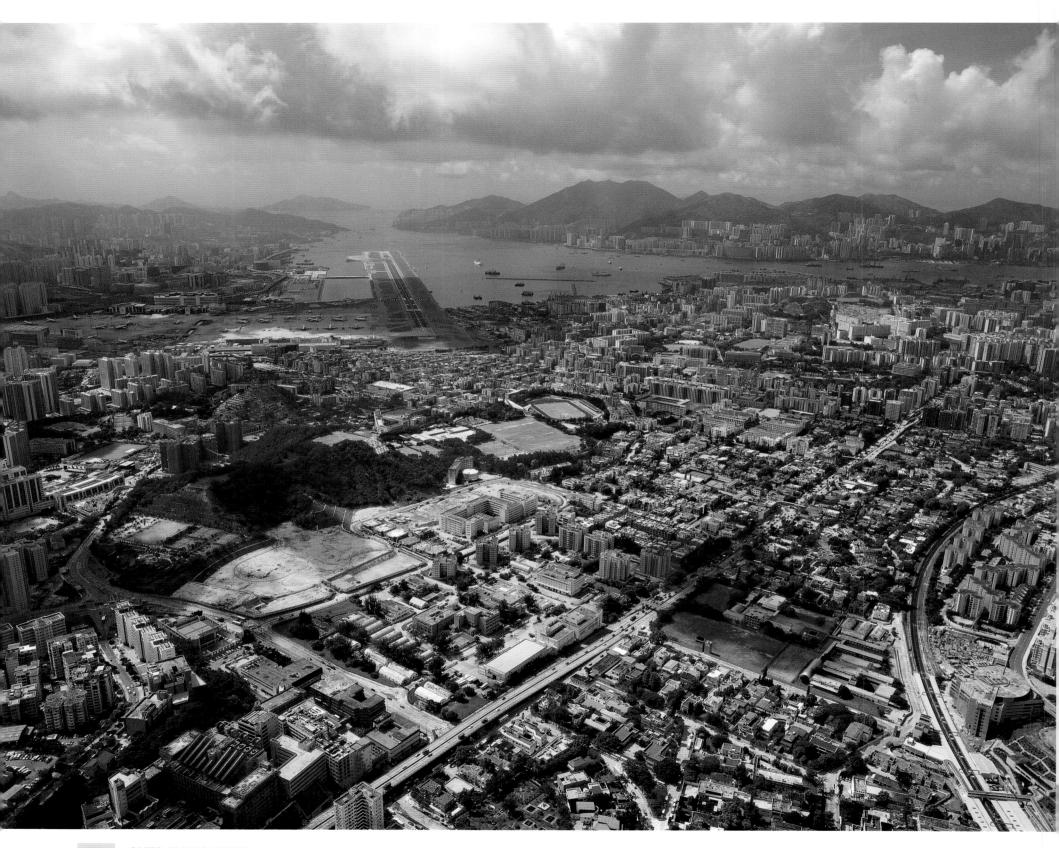

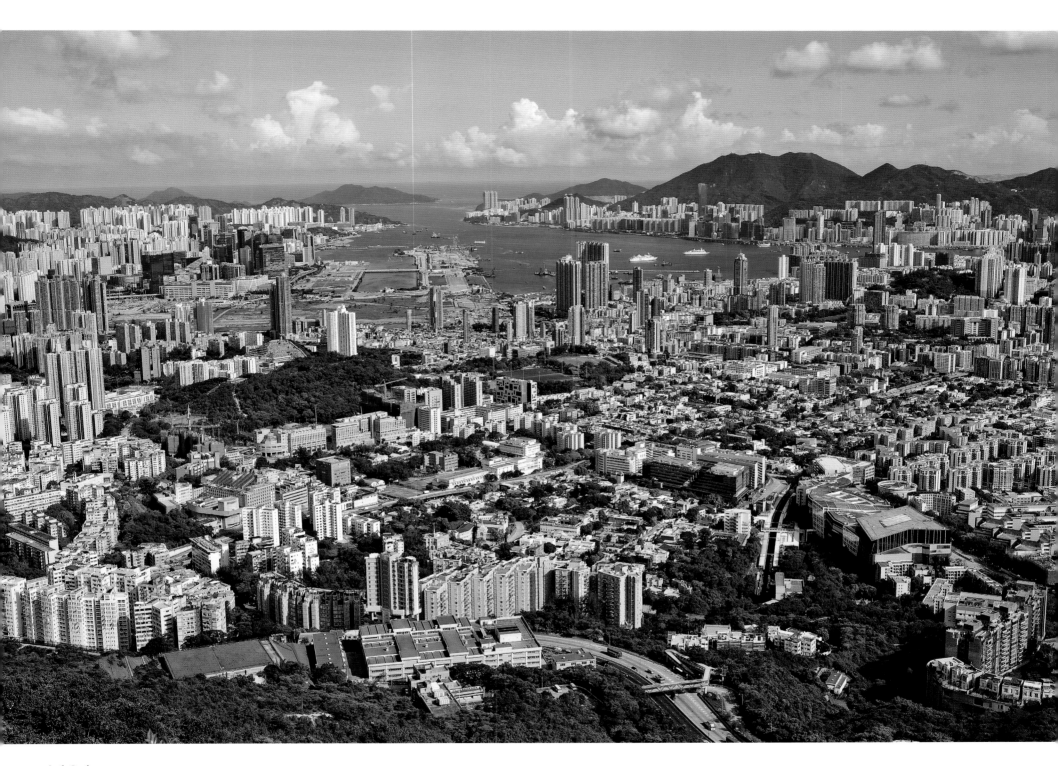

Left & above
Kai Tak A big difference in the cityscape between the time that
Kai Tak was active and now. Then, the height of buildings was
strictly limited for flight safety reasons. Now, the sky isn't quite
the limit, but high rise construction has taken off.

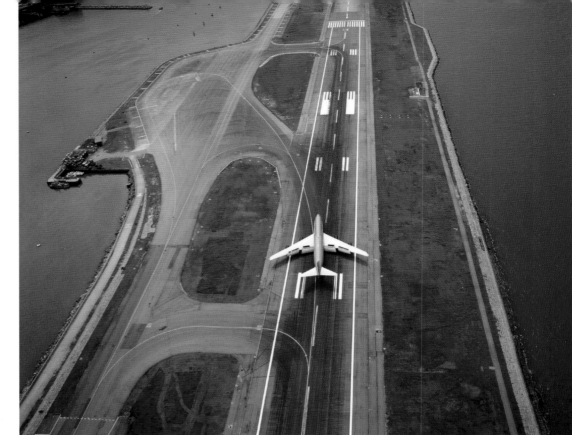

Right
Kai Tak The end of runway 13 for aircraft.

Bottom
Kai Tak The end of runway 13 for cruise liners.

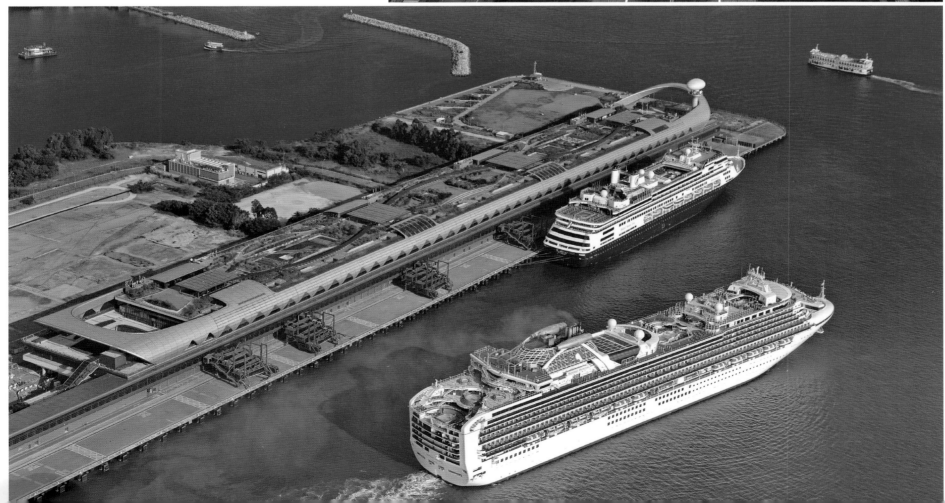

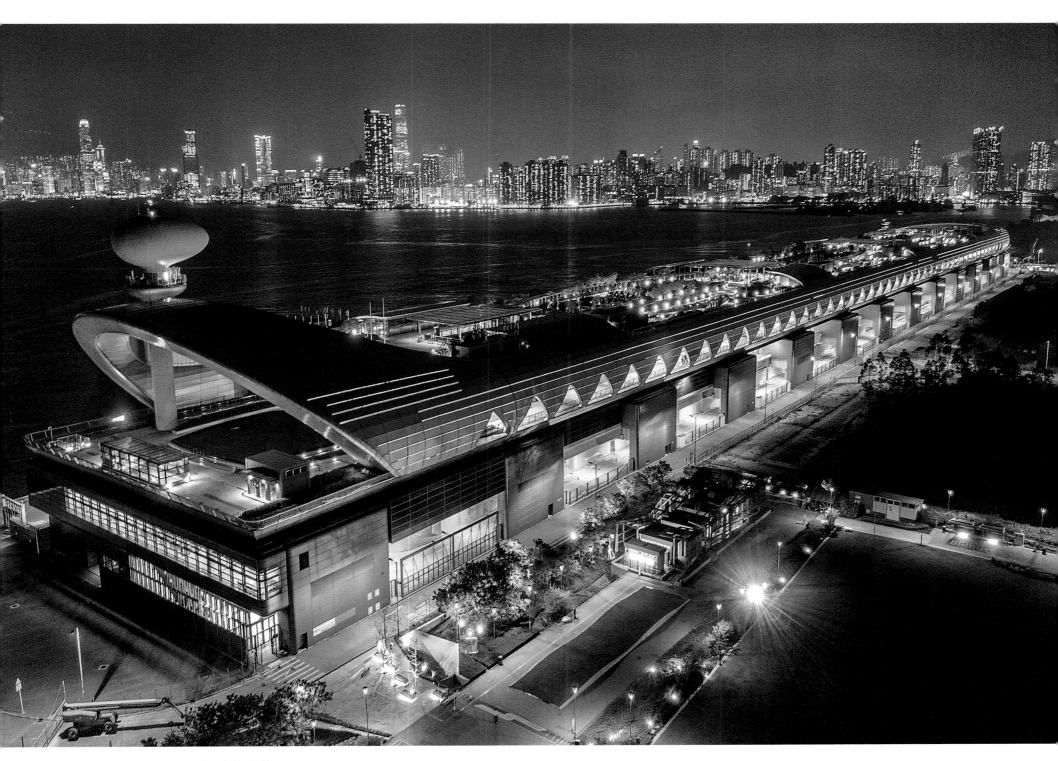

Cruise Terminal When Kai Tak closed the challenge was to
find a use for a three kilometer concrete strip sticking out
into the harbour. The solution, a grand terminal that can
accommodate even the largest cruise liners which Ocean
Terminal was unable to do.

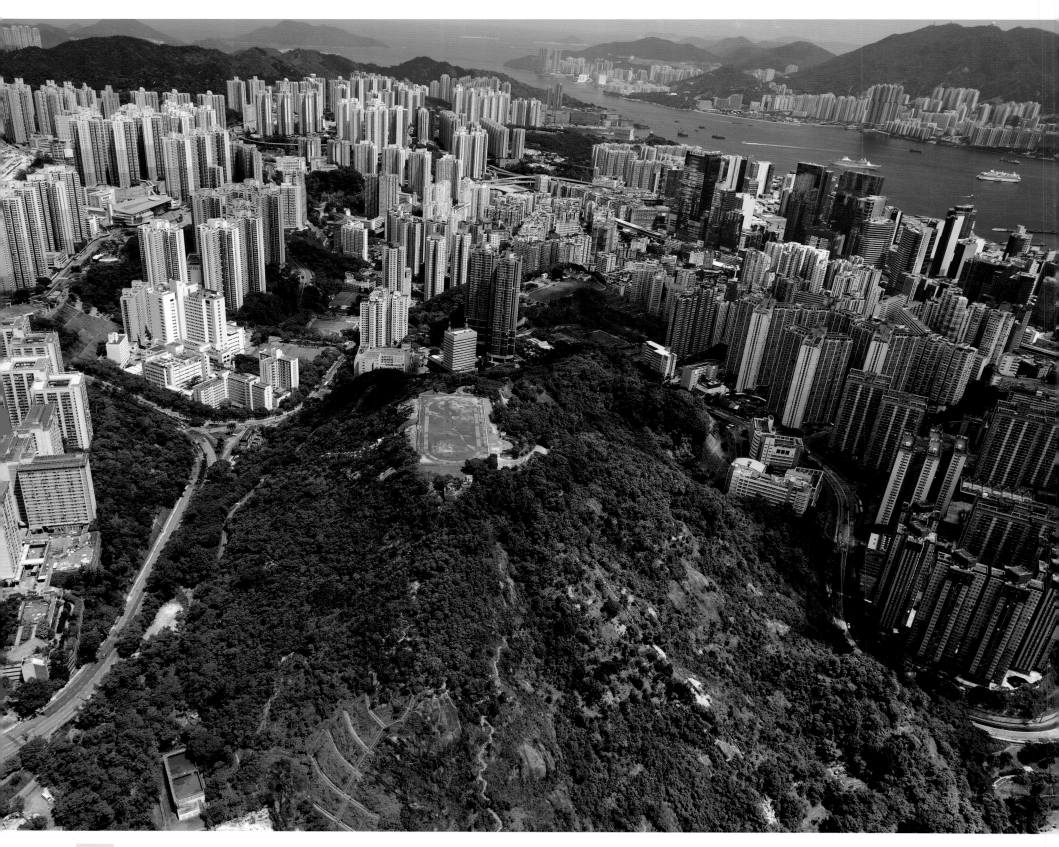

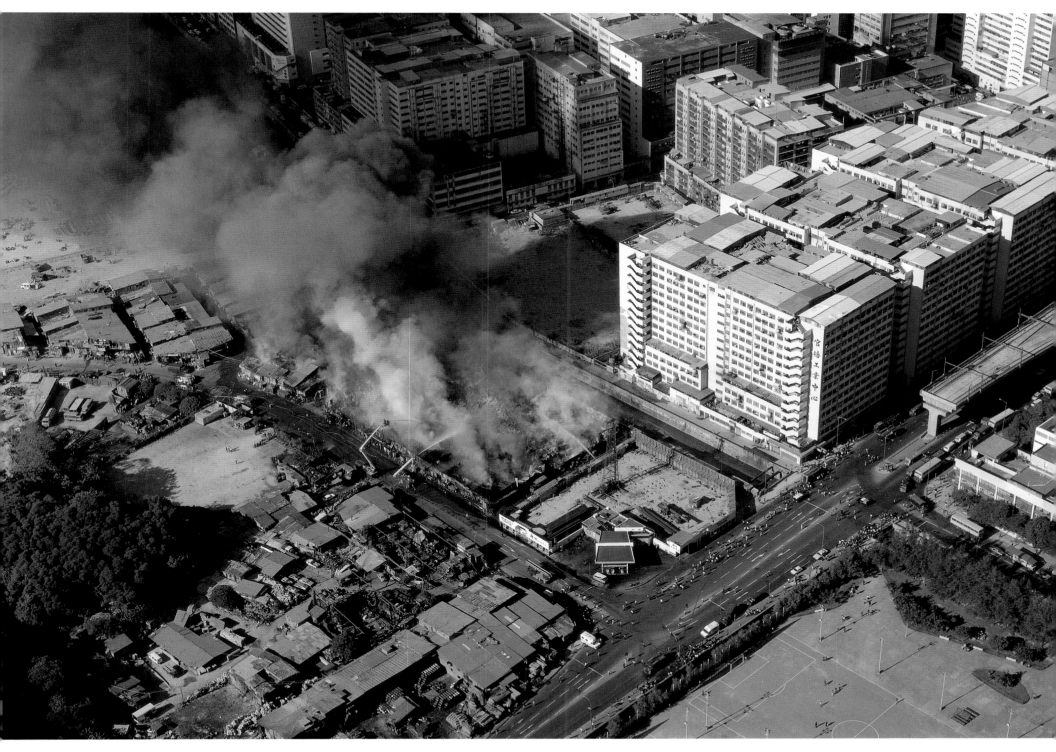

Left
Kwun Tong The view from above Jordan Valley towards Kwun Tong with Ngau Tau Kok on the right. What appears to be a curiously laid-out running track, in fact, covers the Kwun Tong high-level reservoir.

Above
Kwun Tong A squatter area fire in Kwun Tong in the early 1980s. Particularly in cold weather serious fires in squatter areas were common, usually as a result of spilt kerosene for heaters.

Top
Hang Hau Hang Hau in Junk Bay, is better known now as part of Tseung Kwan O new town. The ship with its bow onshore is the *Huey Fong*, notorious for bringing the first wave of Vietnamese refugees to Hong Kong in December 1978. It was nearly a month before it was allowed into harbour to discharge its 3,318 passengers and this marked the start of the flood of what became known as Boat People.

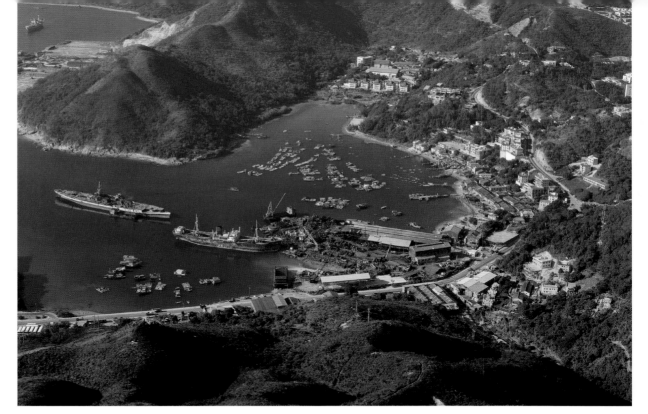

Bottom
Junk Bay A high level, late-1980s, view from above Tai Tam across to Junk Bay and the New Territories. The light brown patches mark the reclamation for what will become the new town of Tseung Kwan O.

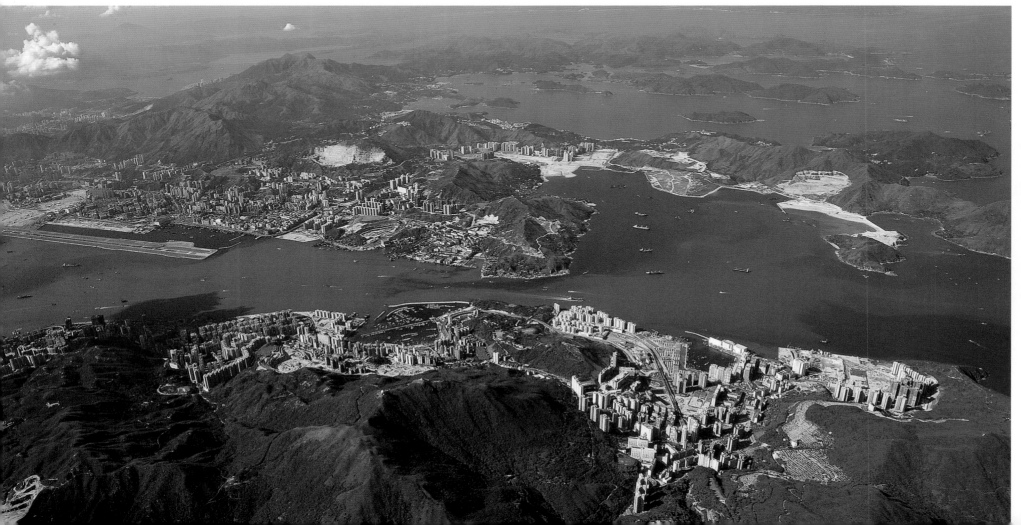

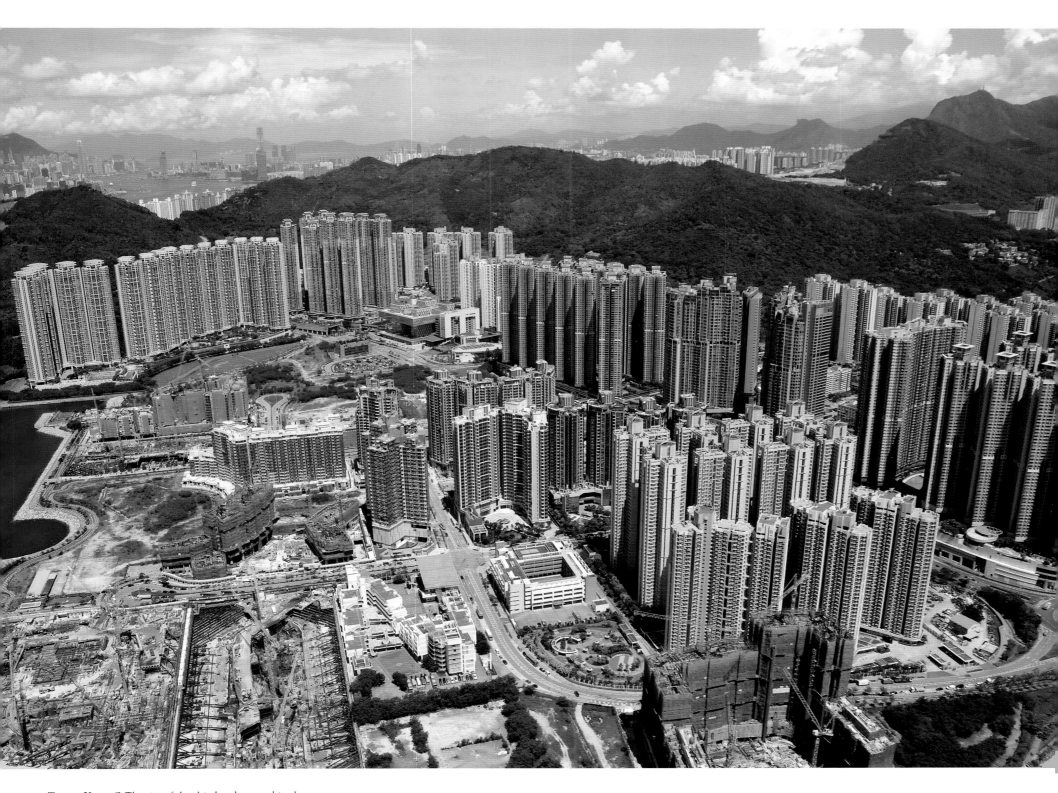

Tseung Kwan O The site of the ship-breakers yard in the photograph above left is now well inland and still Tseung Kwan O continues to grow.

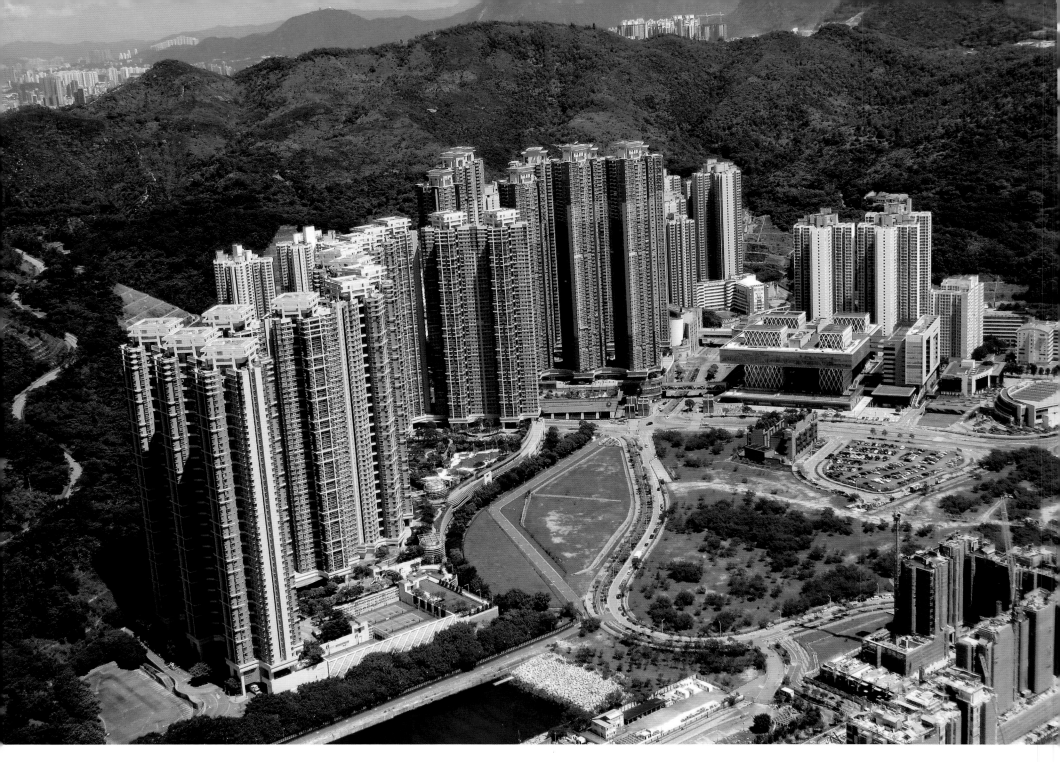

Tiu Keng Leng Tseung Kwan O – General's Bay in Chinese – used to be called Junk Bay in English. The origin of the name is obscure, one hypothesis is that is named for a Ming Dynasty soldier who once visited the area, though precisely who is not known. The town now named after the bay is one of Hong Kong's new towns and unique in its proximity to the city's urban area. A mix of private and public housing and industrial estate, it is claimed that no one lives more than five minutes from an MTR station. This picture is of Tiu Keng Leng which used to be called Rennie's Mill and the building that looks as if it has grown through its roof is the Hong Kong Design Institute.

New Territories

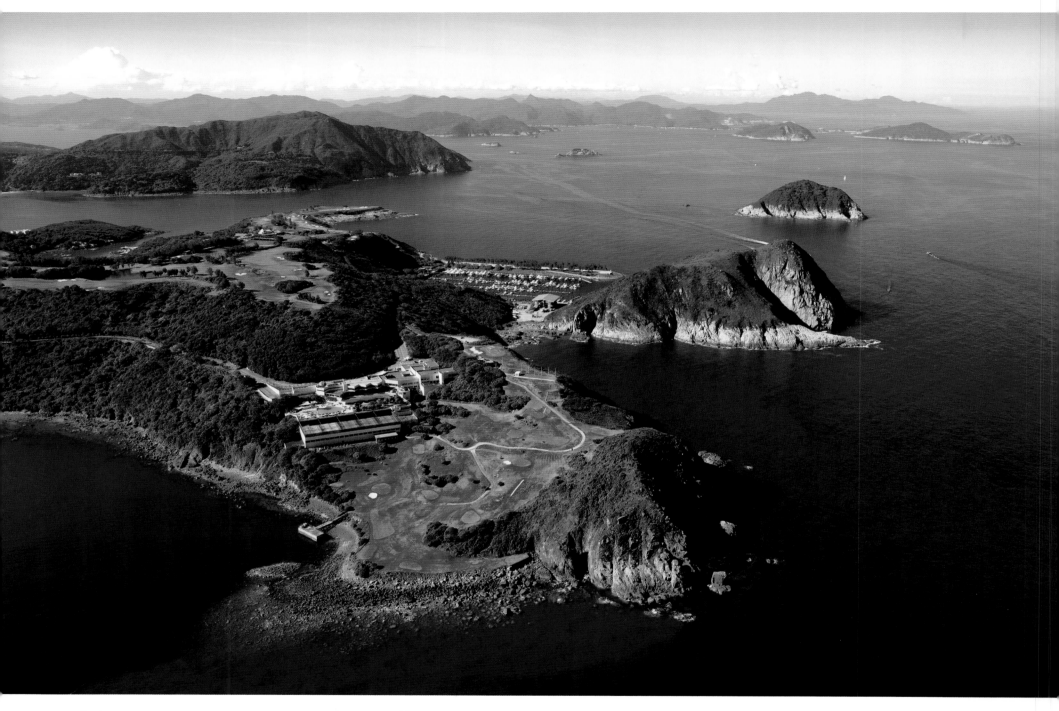

Previous page
Sheep Island Not really a desert island because of all the trees, but uninhabited Yeung Chau, or Sheep Island, has two beautiful beaches. Surprisingly, it is located only about 700 metres from Sai Kung town in the Port Shelter.

Above
Clearwater Bay Country Club The beaches aren't up to much but the 18-hole golf course of the Clearwater Bay Golf and Country Club has hosted the first PGA China Tour event outside the Mainland. The facilities and location are superb but membership of the private Club comes with a hefty price-tag. Beyond the course is the Clearwater Bay Country Park and beyond that the islands of the Port Shelter.

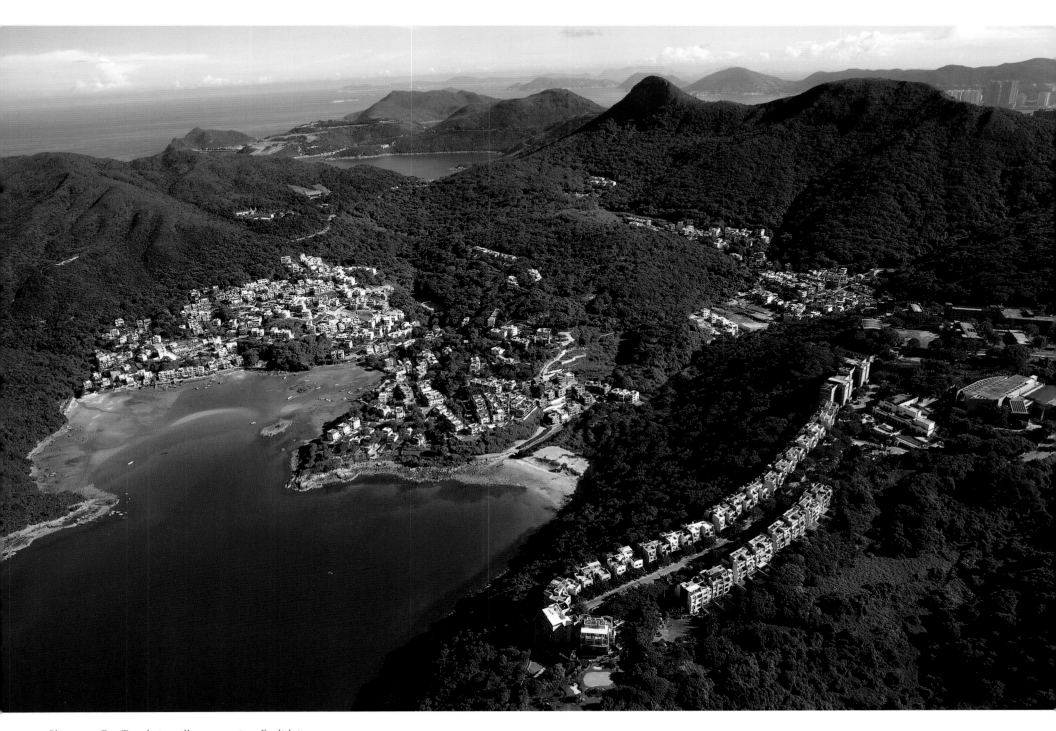

Clearwater Bay Translating village names into English is
sometimes an exercise best avoided. The village facing the largest
expanse of beach in Clearwater Bay is, in fact, three villages
together. The two sharing the waterfront are Tai Hang Hau and
Siu Hang Hau. The names translate mysteriously into Big Pit
Village and Little Pit Village. By contrast, the private ribbon-like
development in the right foreground has a much grander name,
The Portofino.

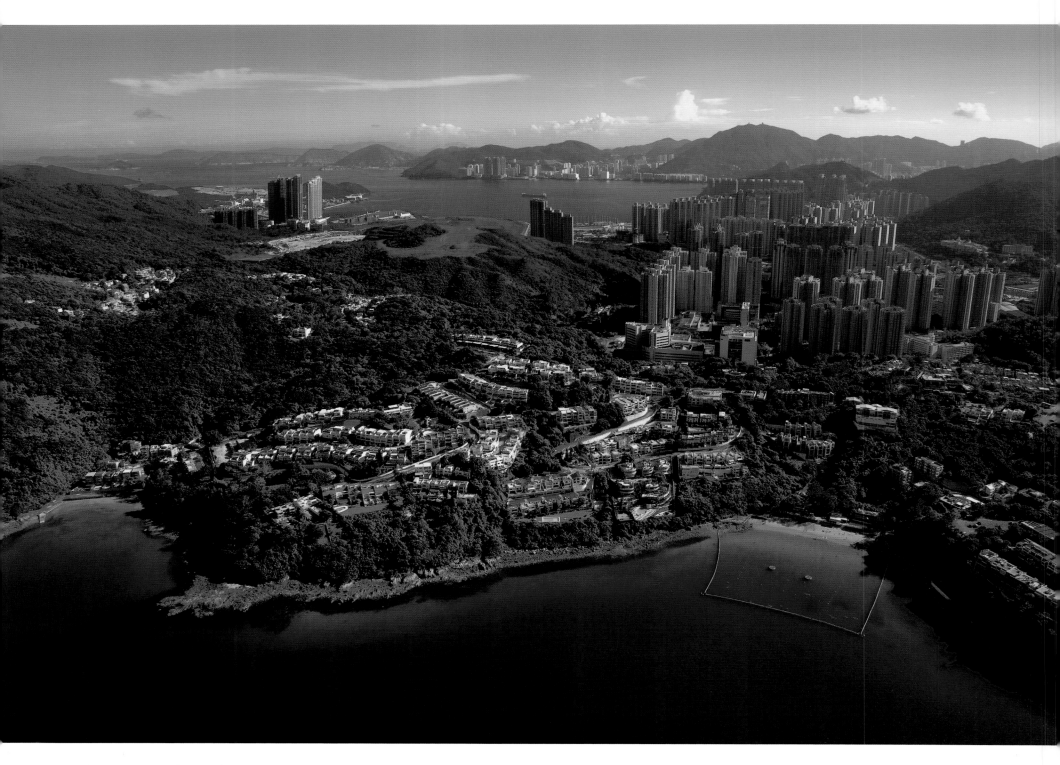

Silverstrand Beach Silverstrand Beach is a small but very popular beach in an exclusive residential area in the Clearwater Bay peninsula. Shark nets ensure the safety of bathers. The closest high-rise towers on the far side of Clearwater Bay Road are in Hang Hau, a part of Tseung Kwan O. Another reminder of the relative closeness of everywhere in Hong Kong, the buildings in the far distance belong to Chai Wan and Siu Sai Wan on Hong Kong Island.

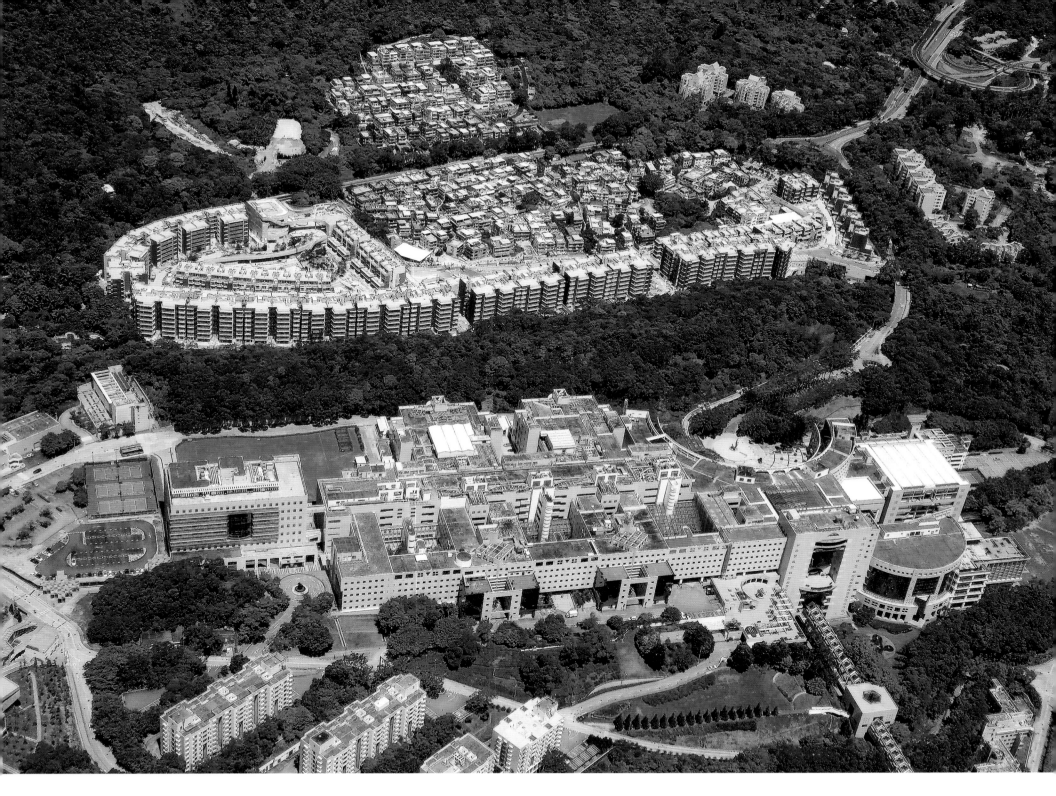

HKUST Hong Kong University of Science and Technology has the most attractive campus of all of the city's universities. Situated close to the boat-shaped Tai Po Tsai village on the northern part of the Clearwater Bay Peninsula, it overlooks the Port Shelter. The name of the university is perhaps a little misleading because, apart from science and technology, it does encompass a business and a humanities school. In academic terms, HKUST consistently ranks well in international performance surveys.

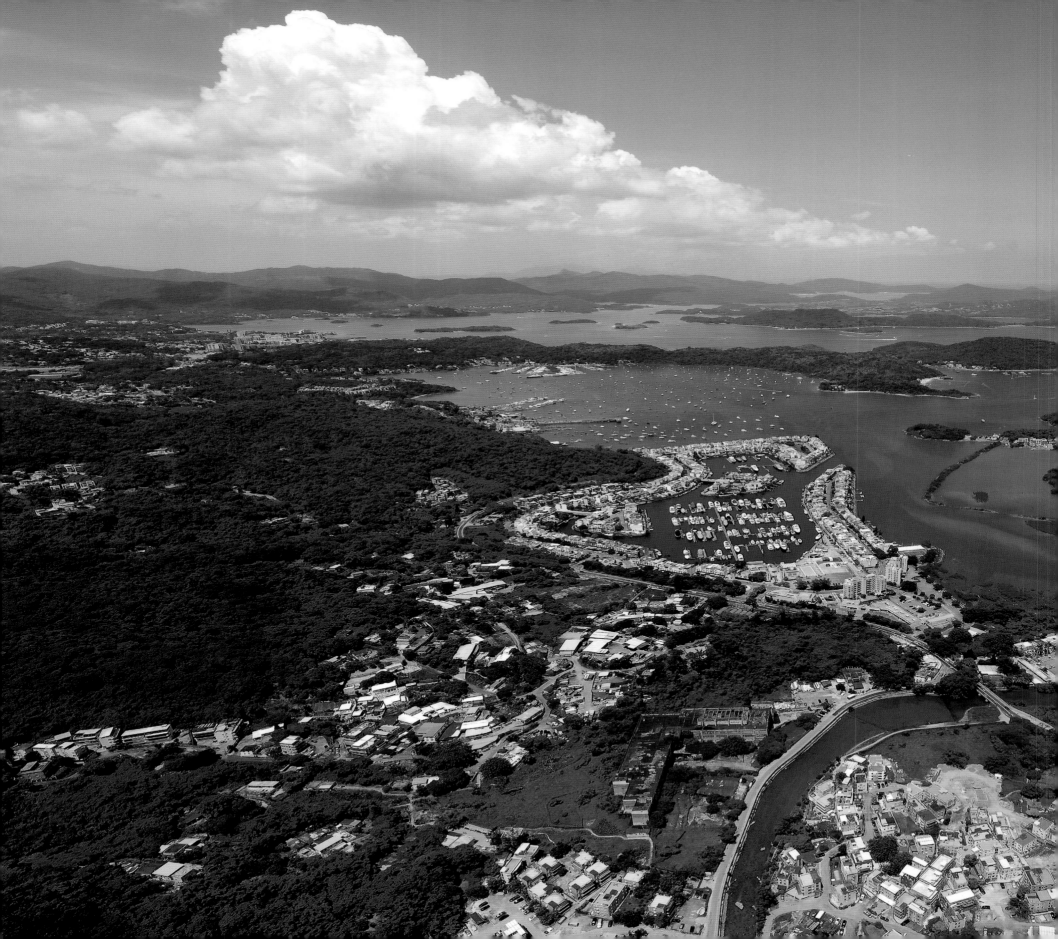

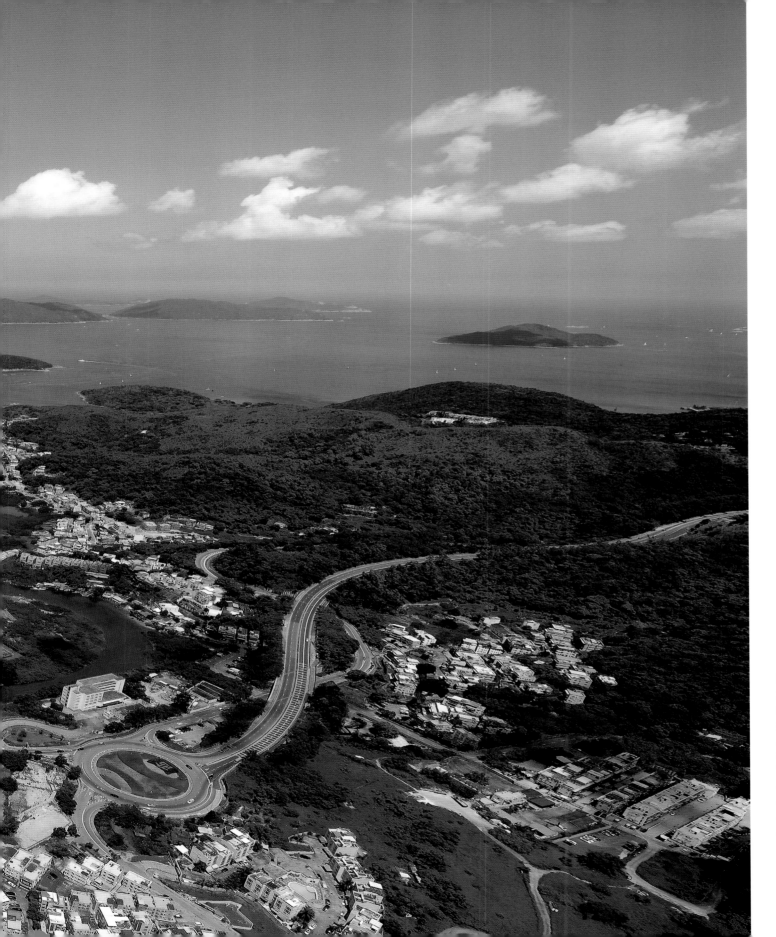

Hebe Haven In the south-western corner of Pak Sha Wan – Hebe Haven – Marina Cove is on the left and Nam Wai village on the right. The main road in the foreground is Hiram's Highway. The Chinese name for the road is simply Sai Kung Highway, so why Hiram for the English name? The reason is an abstruse connection between the nickname of the British officer in charge of the construction and a brand of American tinned sausages.

Right

Hebe Haven The number of pleasure craft moored in Hebe Haven testifies to its attraction for the yachting community as a superb sheltered anchorage.

Bottom

Hebe Haven Need a mooring space for your super-yacht? Sorry, but you will have to wait at least five years for a berth at the Royal Hong Kong Yacht Club Marina Cove in Pak Sha Wan, and probably for a similar length of time at next door Hong Kong Marina. After the Handover in 1997, the RHKYC elected, though not unanimously, to retain the Royal prefix–one of the very few local institutions to do so.

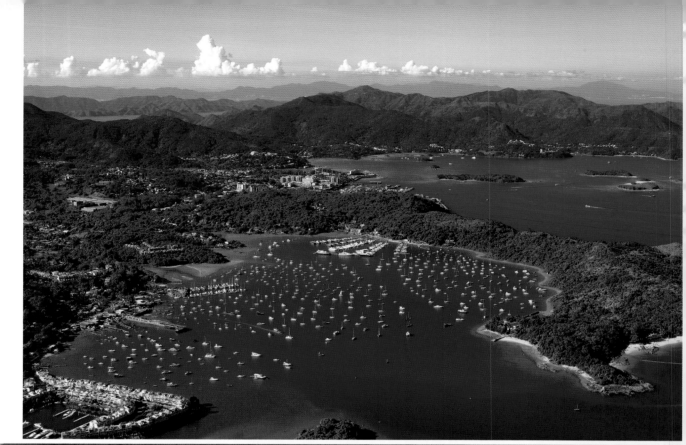

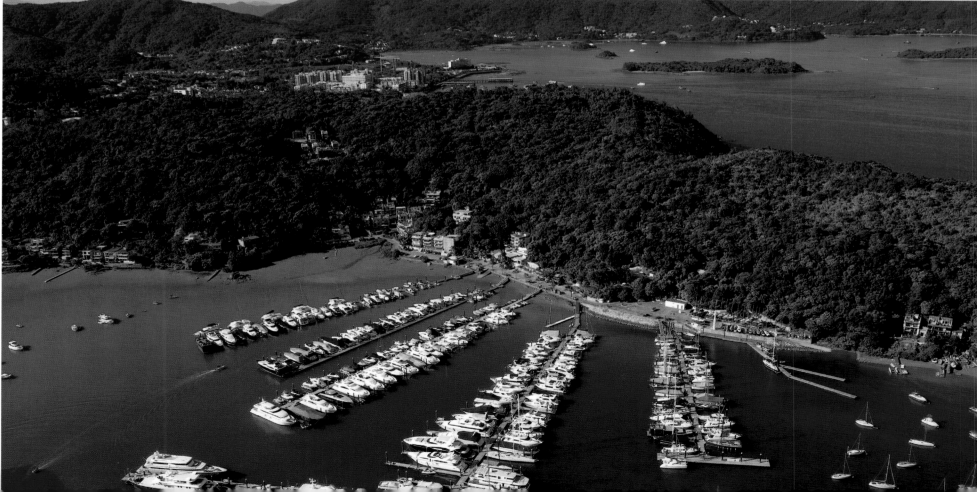

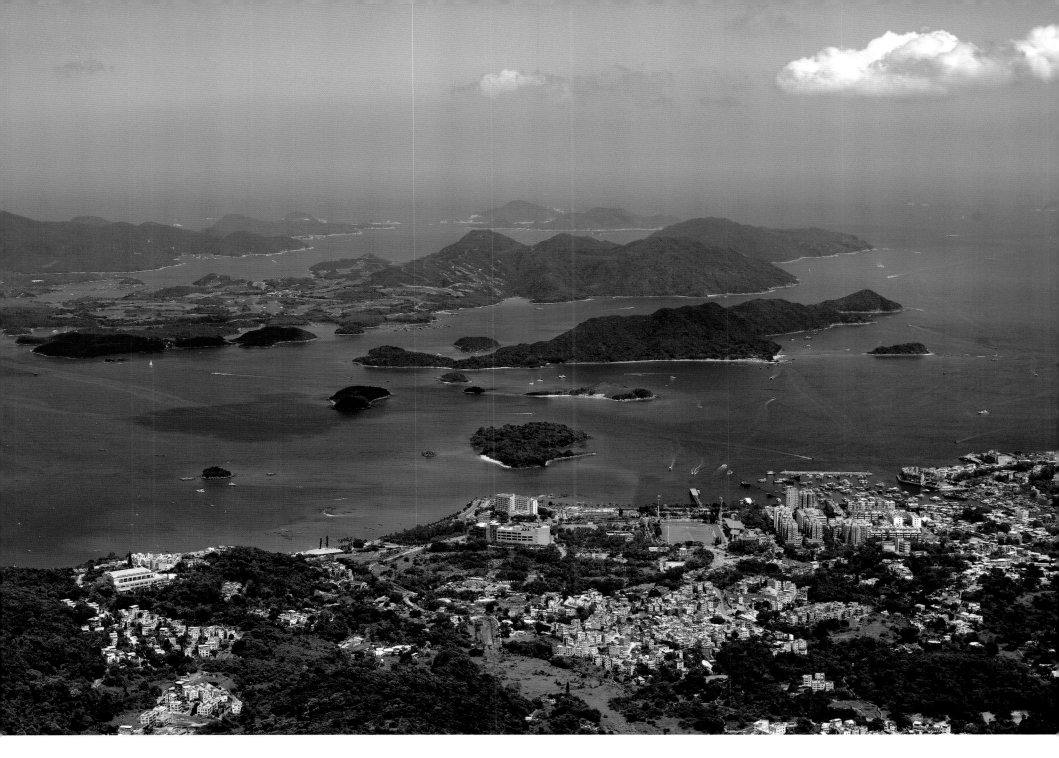

Port Shelter The stretch of water to the east of Sai Kung is the Port Shelter and it is notable for the large number of islands. In this photograph, the largest island is Kau Sai Chau. Its northern half is the Jockey Club Public Golf Course, the only public course in Hong Kong and probably one of the few in the world that you can only reach by ferry. The slightly smaller island beween Kau Sai Chau and Sai Kung town is Sharp Island, Kiu Tsui Chau in Chinese, and it is the largest island in the small Kiu Tsui Country Park. A popular recreational destination for Hongkongers, Sharp Island is also something of a geological wonderland, not only for the legacy of the old super-volcano's contribution but also for the tombolo that connects to the islet of Kiu Tau with a remarkable "pineapple bun" surface rock formation. The tombolo is only visible at low tide.

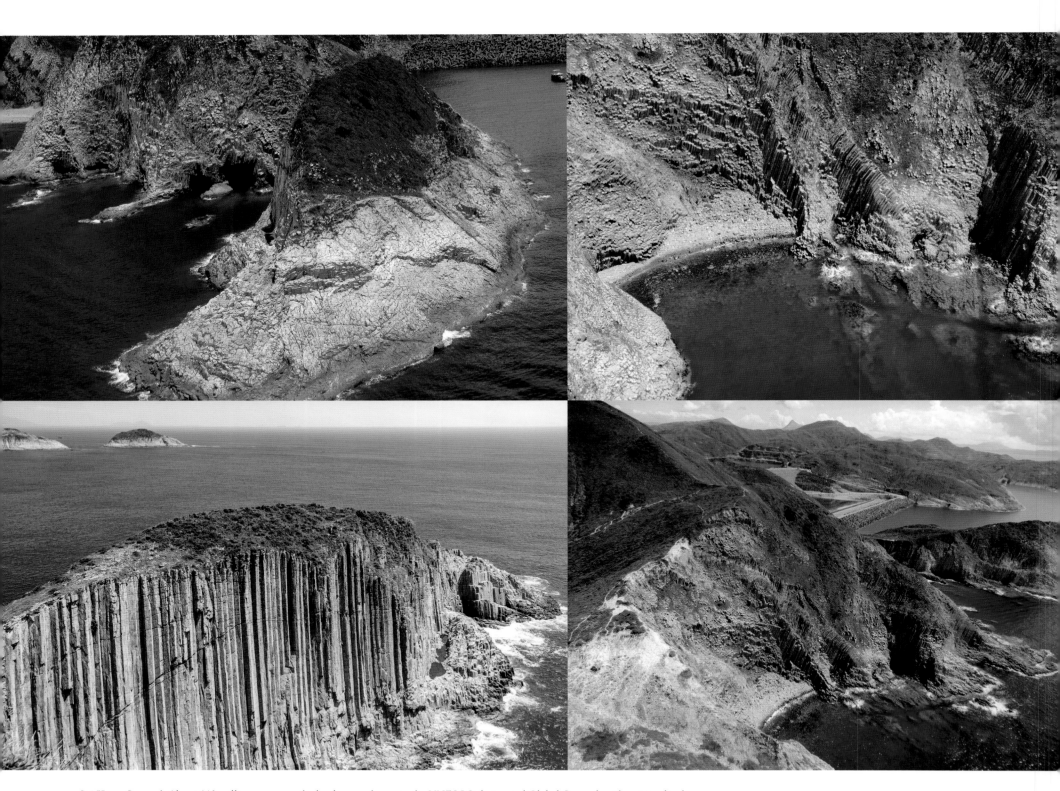

Sai Kung Geopark About 140 million years ago the landscape of
the North-east New Territories (though they weren't called that
then) was dramatically altered by the eruption of a super-volcano
in the area. The legacy left by that explosion is manifest today
in the UNESCO-designated Global Geopark with outstandingly
dramatic rock formations, volcanic and sedimentary, which
extend between Sai Kung and Plover Cove areas.

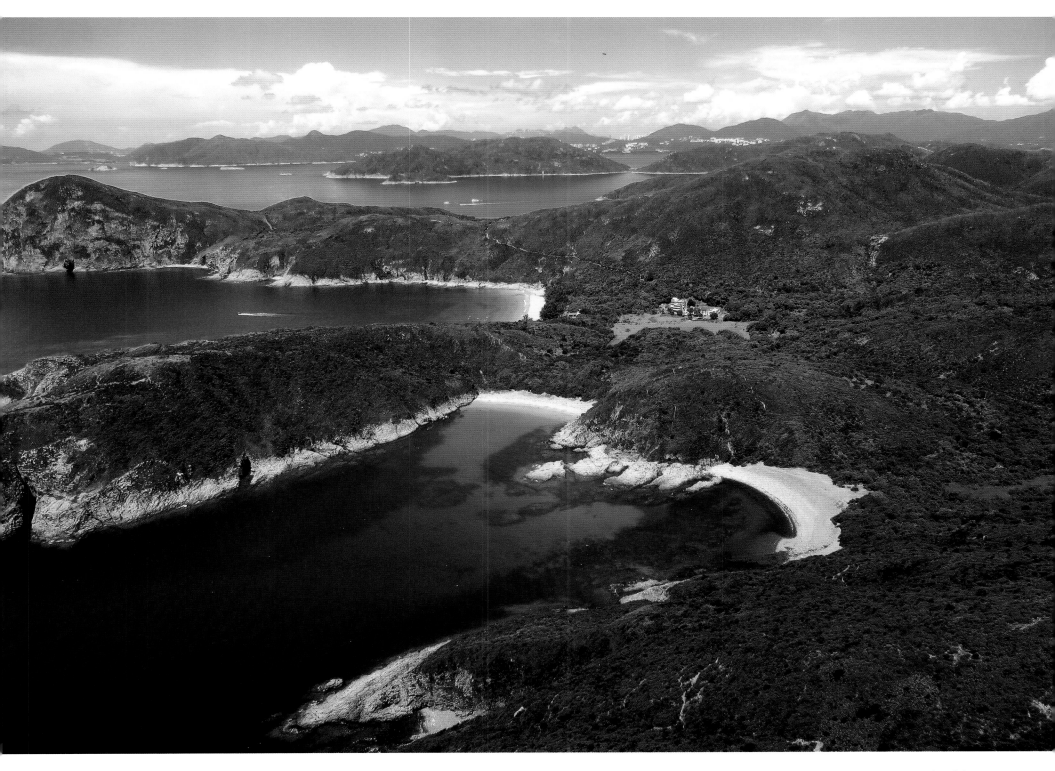

Tai Long Wan Tai Long Wan (Big Wave Bay-not to be confused with Big Wave Bay in Shek O) boasts four superb beaches that some claim to be the best in Hong Kong. Located in the Sai Kung East Country Park, access is either by a one-hour hike or by water taxi from Sai Kung pier. All four beaches are connected by hiking trails and are on the route of the Maclehose Trail. The two beaches furthest from the camera, West Bay Beach and the delightfully-named Ham Tin–Salty Field Beach-have facilities for refreshment, the hire of equipment and camping sites.

Tseng Tau Tsuen Nestling on the shore of Three Fathoms Cove
in Tolo Harbour, Tseng Tau Tsuen is one of those quiet, out-of-
the-way villages that are a delight to find. Close to Ma On Shan,
it is actually part of Sai Kung District. Just offshore is Wu Chau
or Dark Island.

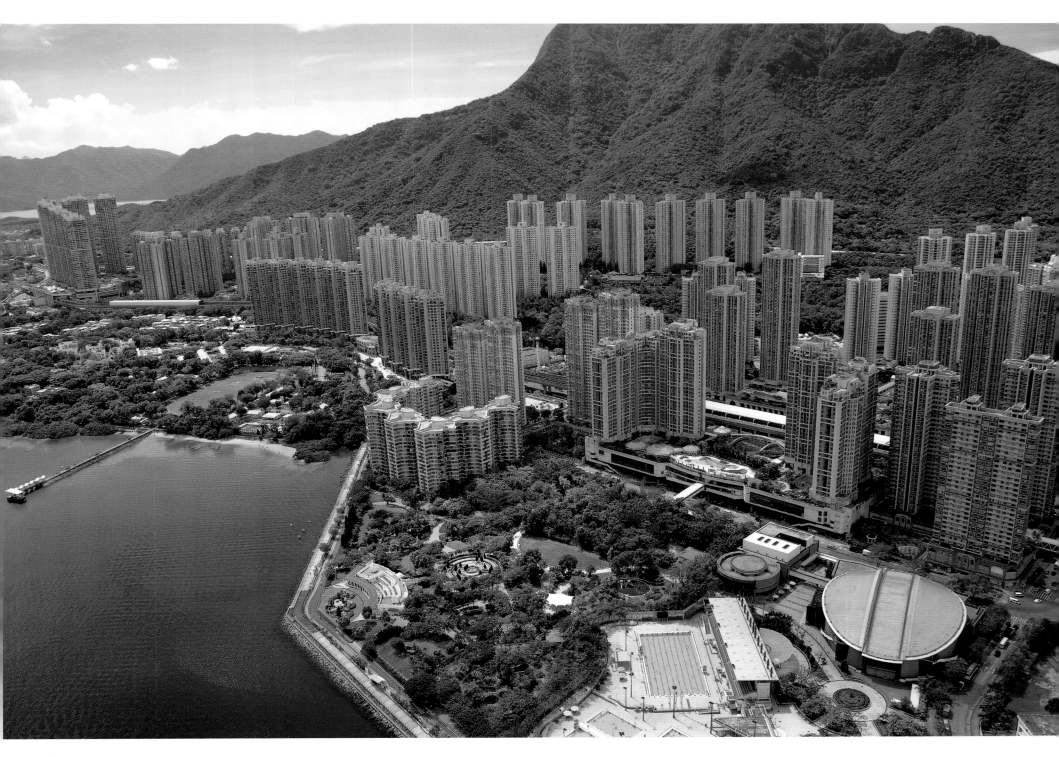

Ma On Shan Horse-saddle mountain is the English translation of Ma On Shan, the mountain that provides a backdrop to the new town that takes its name. Originally Ma On Shan was a village of about 80 families until development began in 1980 and it is still one of the smaller new towns. Hong Kong is full of historical surprises and the surprise of Ma On Shan is that the mountain is made of high-quality iron ore. Deep inside was a mine producing 100,000 tons of ore a year in the 1950s and 1960s until it became economically uncompetitive. Traces of the mine workings can still be found.

Clockwise from top right

Shatin The watercourse of the Shing Mun River emptied into Tide Cove which, in the early 1960s, extended far into what is now reclaimed land where the new town has been built. The railway to the border crosses from lower left, then follows the old road from Kowloon (before the days of the Lion Rock Tunnel) up the coast.

Shatin By the late 1970s reclamation is well underway, the racecourse has been established and scattered elements of the new town built and occupied.

Shatin In the early 1980s, the new town was well established though building work still continued. Sun Hung Kai Properties' New Town Plaza was officially opened in 1984 and Queen Elizabeth II visited it in 1986. At the time it was the largest shopping mall in the New Territories.

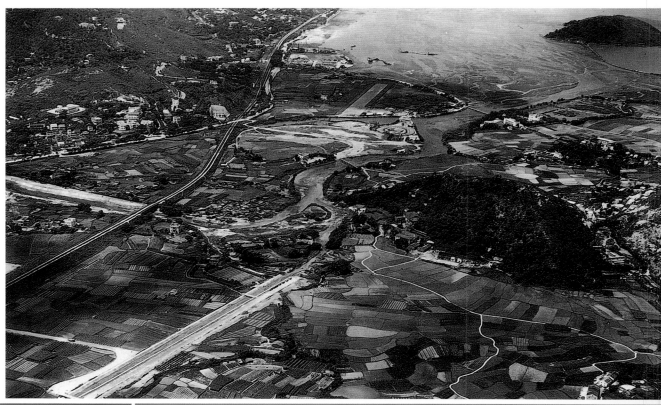

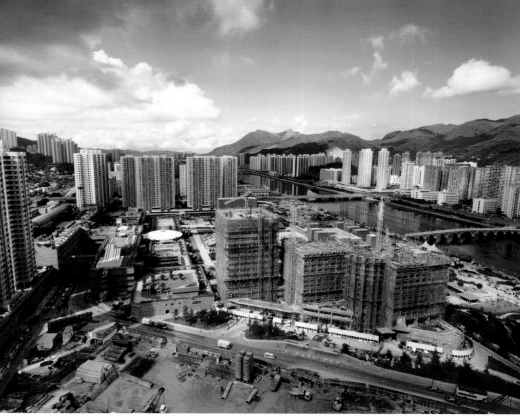

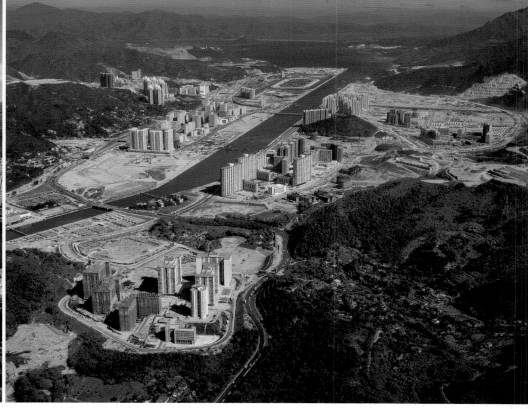

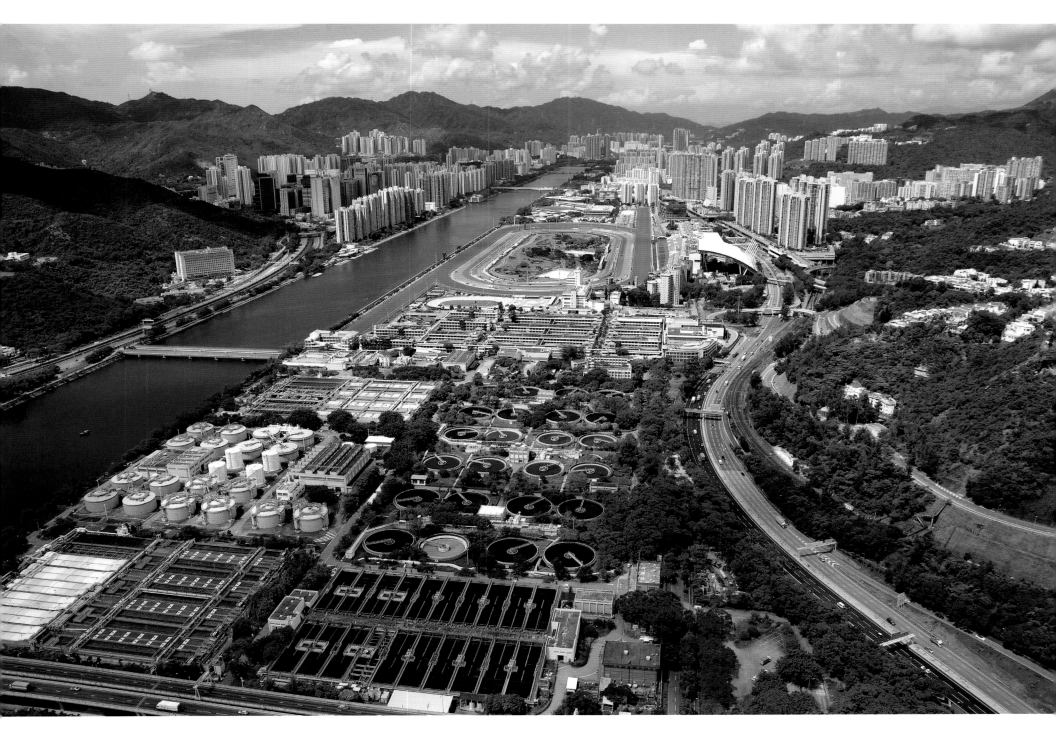

Shatin Situated next to the Shing Mun River, Shatin racecourse is unusual, though not unique, in having its own railway station. Horse-racing is one of the very few legally-permitted gambling activities in Hong Kong. Together with the first and only other racecourse, Happy Valley, it plays a large part in local popular cultural life. Shatin itself is one of the early new towns, developed in the 1970s, to accommodate the growing population of the city. It has since been expanded with the addition of City One. Shatin boasts a remarkable Hong Kong "first". In March 1911, the *Spirit of Shatin* made the first flight of a powered aircraft in the city. A replica of the aircraft now hangs above the Arrival Hall of Hong Kong International Airport.

Top

Tolo Harbour Though not quite having the same cachet as its Los Angeles namesake, The Beverly Hills, in Tolo Harbour, is an up-market and expensive residential, gated community where a flat can cost upwards of HK$70 million. Standing proudly at the foot of the Pat Sin Leng Country Park hills is the 76 metre-high white statue of Guan Yin, Goddess of Mercy, the centrepiece of Tsz Shan Monastery (Mercy Mountain).

Bottom

Science Park The golden egg of the Charles K Kao Auditorium in the middle of the Hong Kong Science Park in Shatin looks as though an alien spacecraft has landed to assist in the city's drive into the age of technology. Established in 2001 the Park provides facilities to nurture and help science and technology companies develop. Located by the side of Tolo Harbour it currently hosts over 600 local and overseas technology companies.

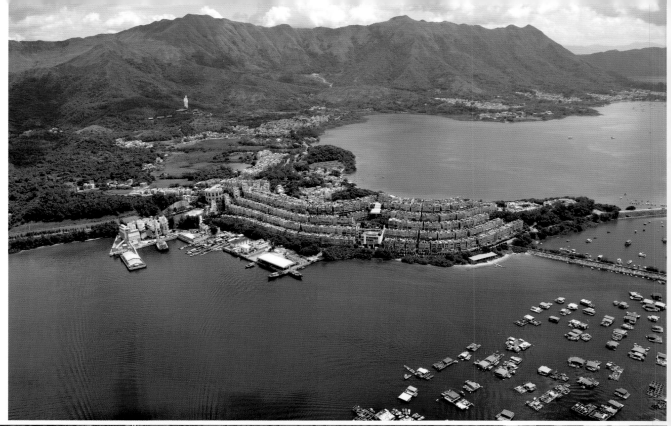

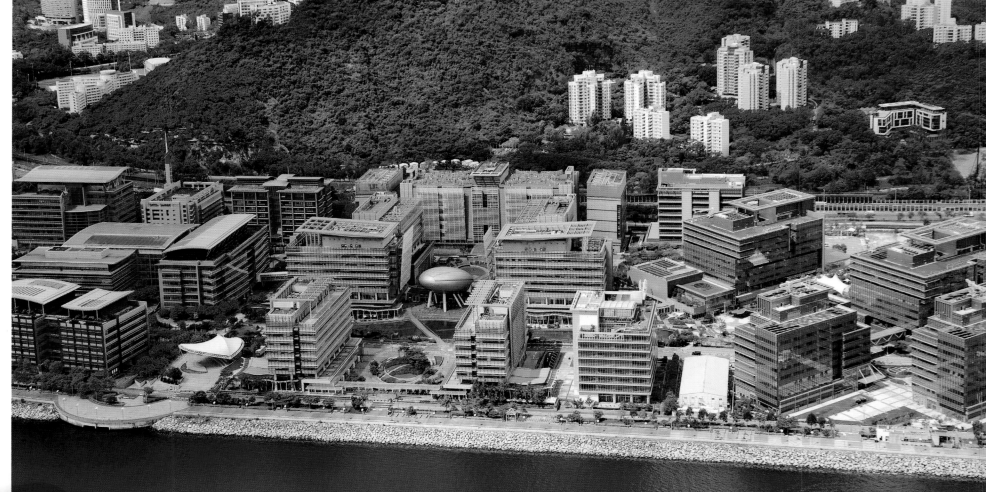

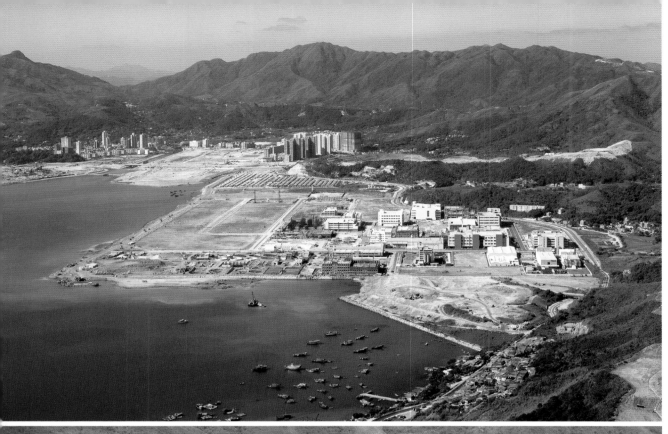

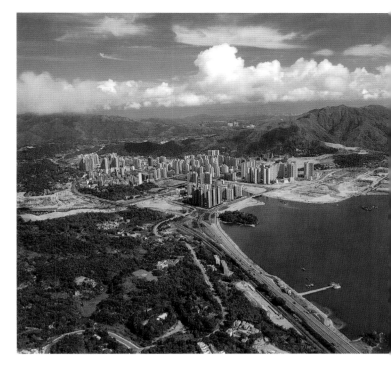

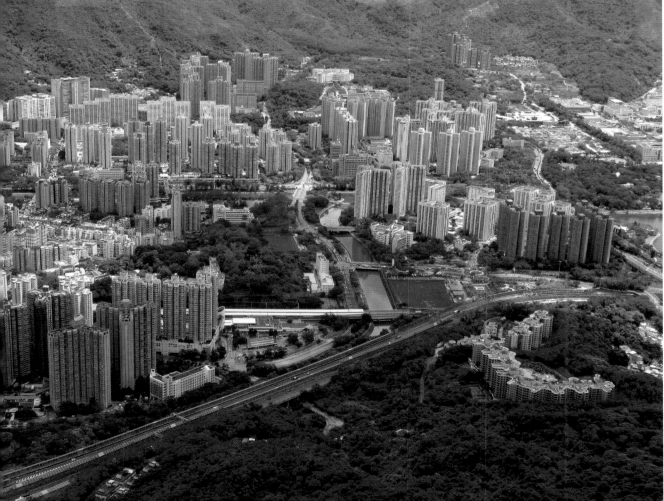

Tai Po Once upon a time this was an area of dense forest that came to specialise in pearl farming and fishing. Tai Po Market and Tai Wo became local market towns in the area that is now generically called Tai Po. Under the Hong Kong government's New Towns Development Programme Tai Po was designated as one of the three second generation new towns in 1979 although an industrial park had been created in 1974. The top two photographs are stages in Tai Po's construction during the 1980s and the lower one, the town today.

Following pages
Shenzhen The Sham Chun (Shenzhen) River marks the boundary between the Special Adminstrative Region and mainland China. Prior to 1979, Shenzhen was an agricultural area with scattered villages along the border. That all changed when, in 1979, Shenzhen was promoted to city status and then designated as China's first Special Economic Zone in 1980. Development has been remarkably rapid so that now Shenzhen is one of the biggest and most successful cities in Guangdong Province. The Hong Kong side of the border is a Closed Area, which was created in 1951 to help control the flood of illegal immigrants.

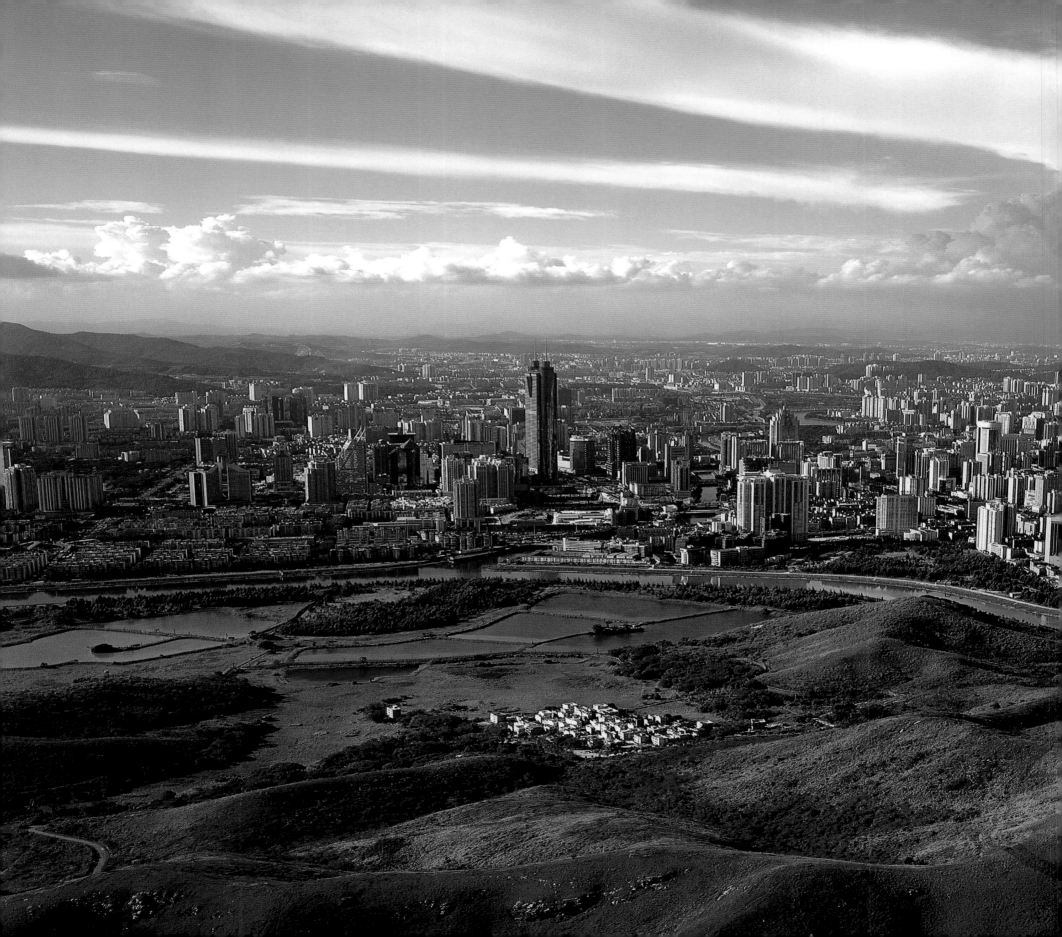

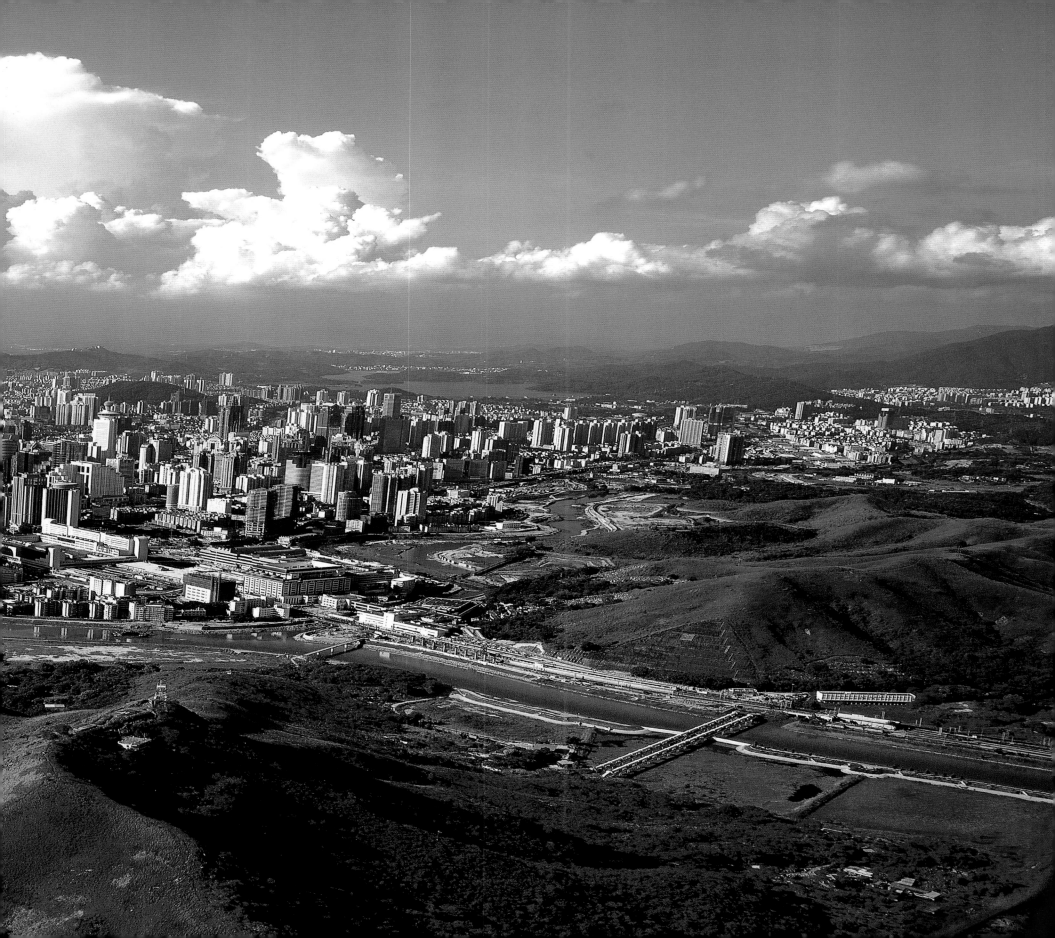

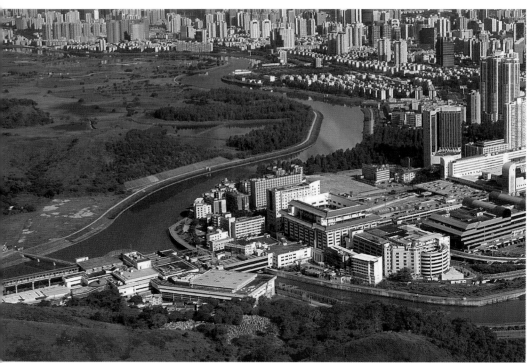

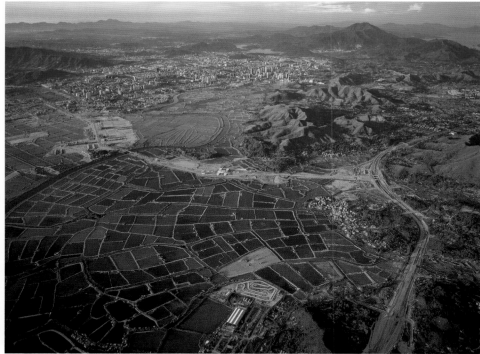

Top left

Lo Wu Until 1949 people were able to cross freely between Hong Kong and China. In an attempt to stem the flow of refugees, a control point was established at Lo Wu, the point at which the railway line to Guangzhou crossed the border. Apart from through-train passengers, all other travellers must cross on foot.

Top right

Lok Ma Chau Lok Ma Chau, which connects with Huanggang Port, was the second immigration control point (and the first for vehicle crossings) to be opened with access across the Mai Po marshes. This photograph dates from the early 1990s. Originally access was only by road but now it is also served by a spur of the MTR's East Rail.

Right

Shenzhen The latest border crossing to be opened is at Shenzhen Bay and is now a major vehicle crossing point. Access from the Hong Kong side is across this magnificent bridge snaking across Deep Bay.

Opposite

Shenzhen This photograph from October 2017 contrasts the remarkable development of the Special Economic Zone with the traditional fishponds of the Mai Po marshes – though these are now being slowly eroded by development.

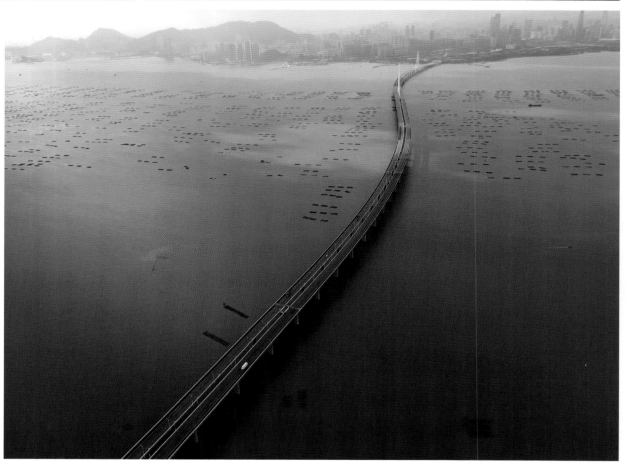

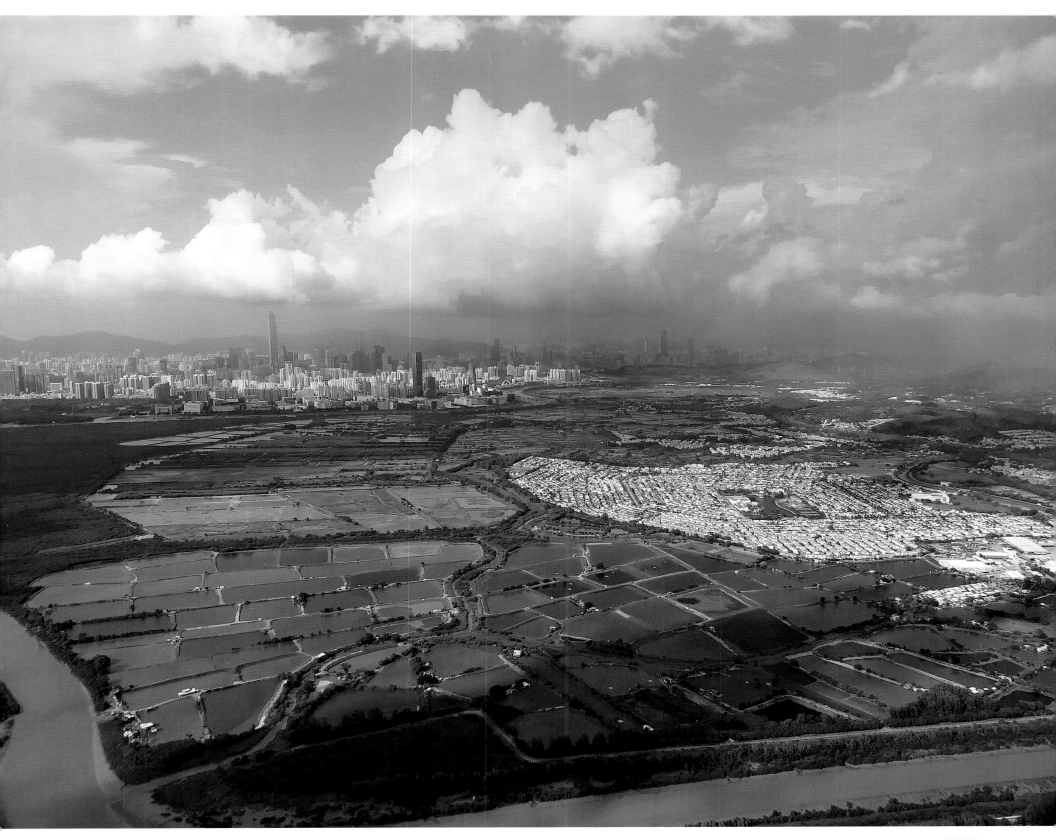

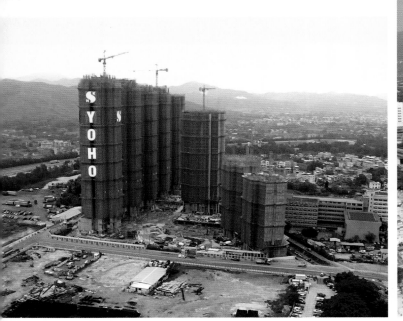
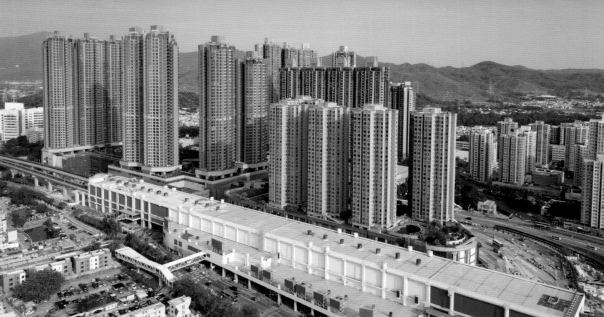
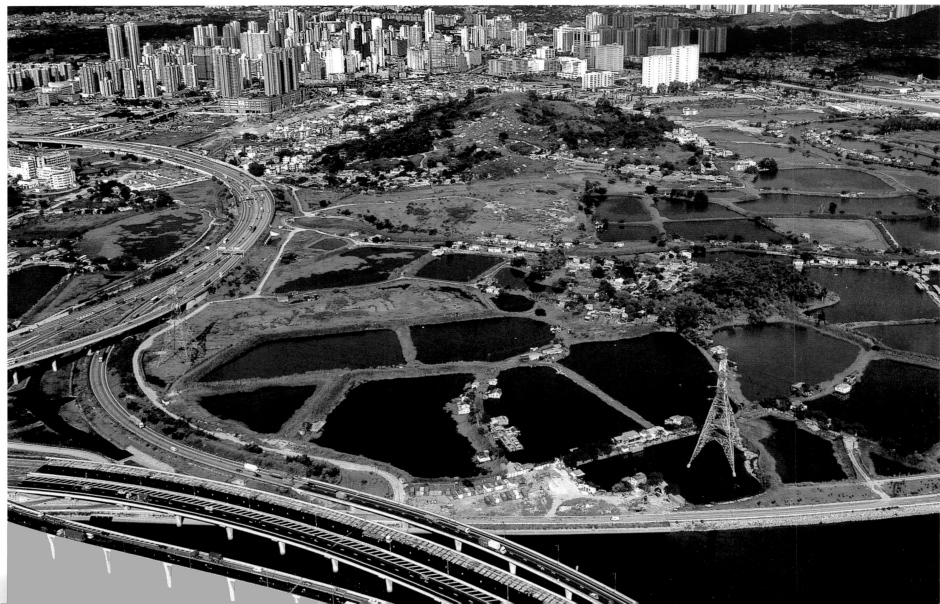

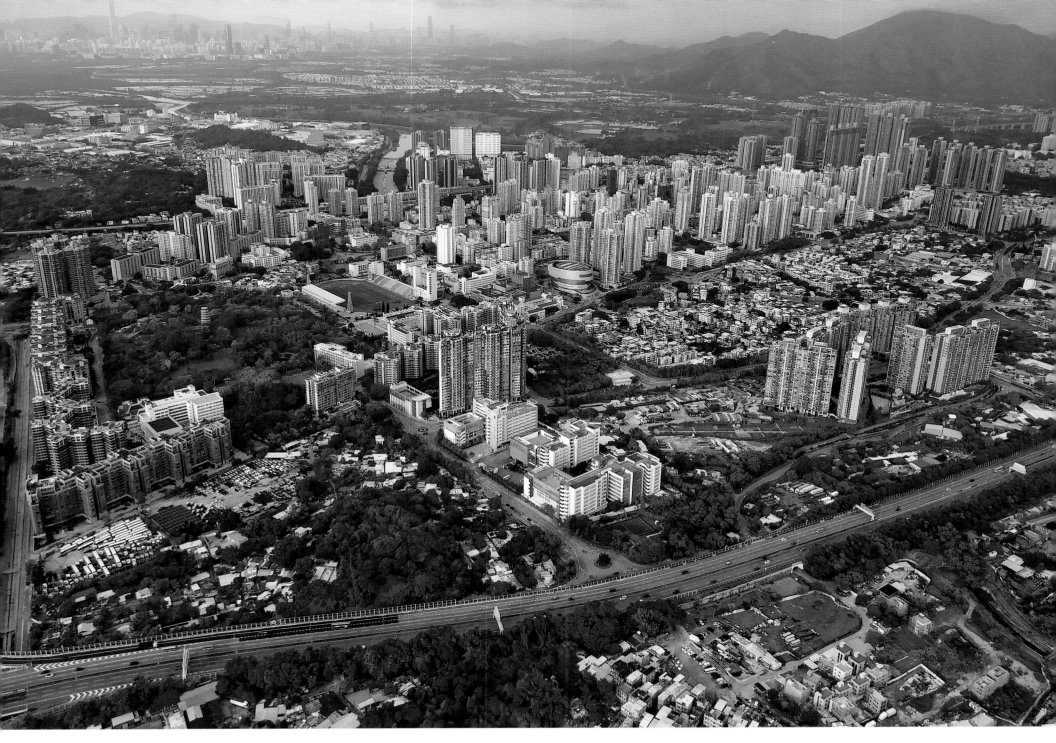

Opposite top left
Yuen Long Phase 1 of Sun Hung Kai Properties' YOHO (Young Homes) project in Yuen Long, YOHO Town (*left*) was completed in 2004. As the name suggests, the scheme is intended to make a new way of living available for younger people.

Left
Yuen Long This photograph, from 2000, dramatically demonstrates the co-existence of town and country that now dominates the New Territories.

Opposite top right
YOHO Yuen Long Grand YOHO is one of the latest of the YOHO development projects, conveniently sited close to the MTR's West Rail station.

Above
Yuen Long Although it was in the second phase of the new town development plan, Yuen Long was somewhat slower to develop than its peers. Access, particularly to the urban areas of Kowloon and Hong Kong Island, was difficult until the road network was improved in the 1990s. The completion of the West Rail line in 2003 made a big difference to the lives of those residents who have to commute to work.

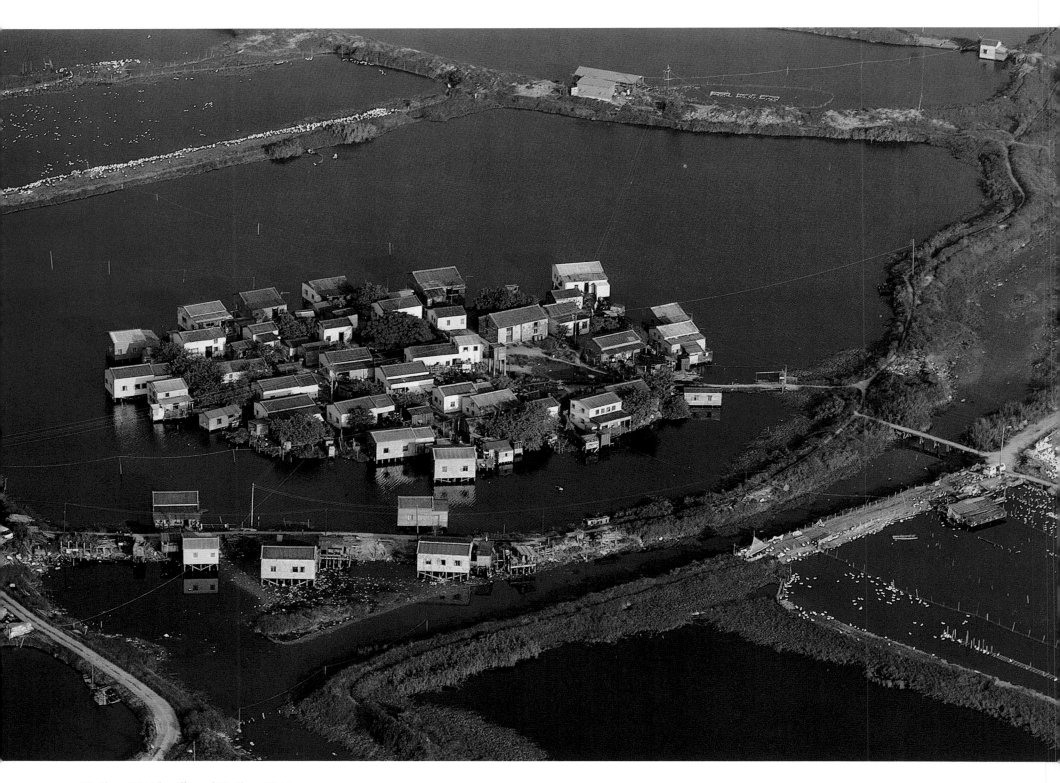

Wo Shang Wai The village of Wo Shang Wai is a squatter community slightly unusual in that it is on an island in the Mai Po marshes.

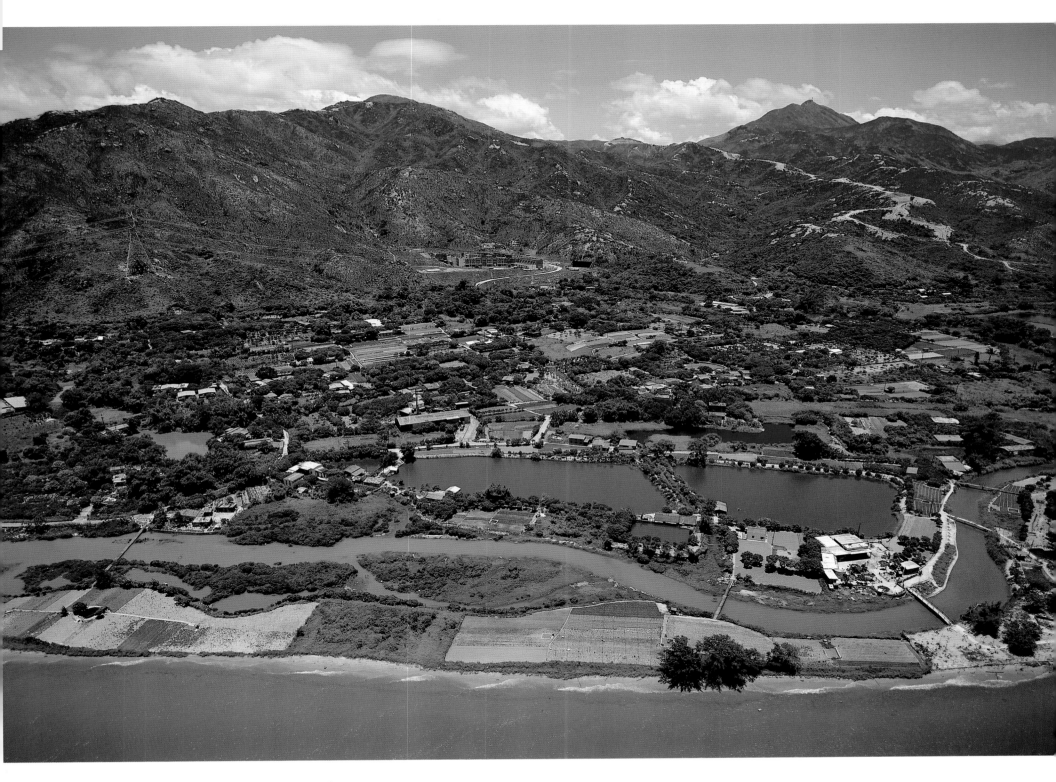

Ha Pak Nai Fringed with duck ponds and mangrove swamps this low-lying marshy area of Ha Pak Nai on the edge of Deep Bay remains relatively isolated. However, the ambiance of this 2001 scene is rather spoilt today by the presence of a large landfill site close-by to the south-west.

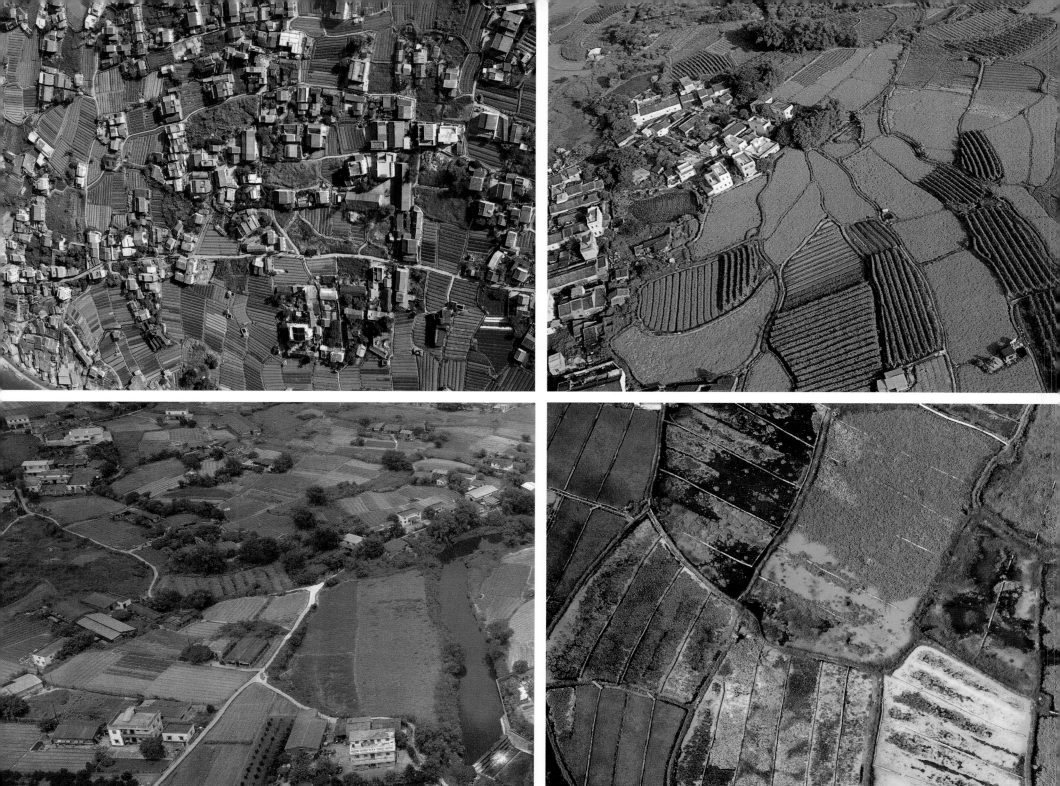

New Territories A reminder of times past when farming was still a major part of life in the North-west New Territories rather than property development and container storage.

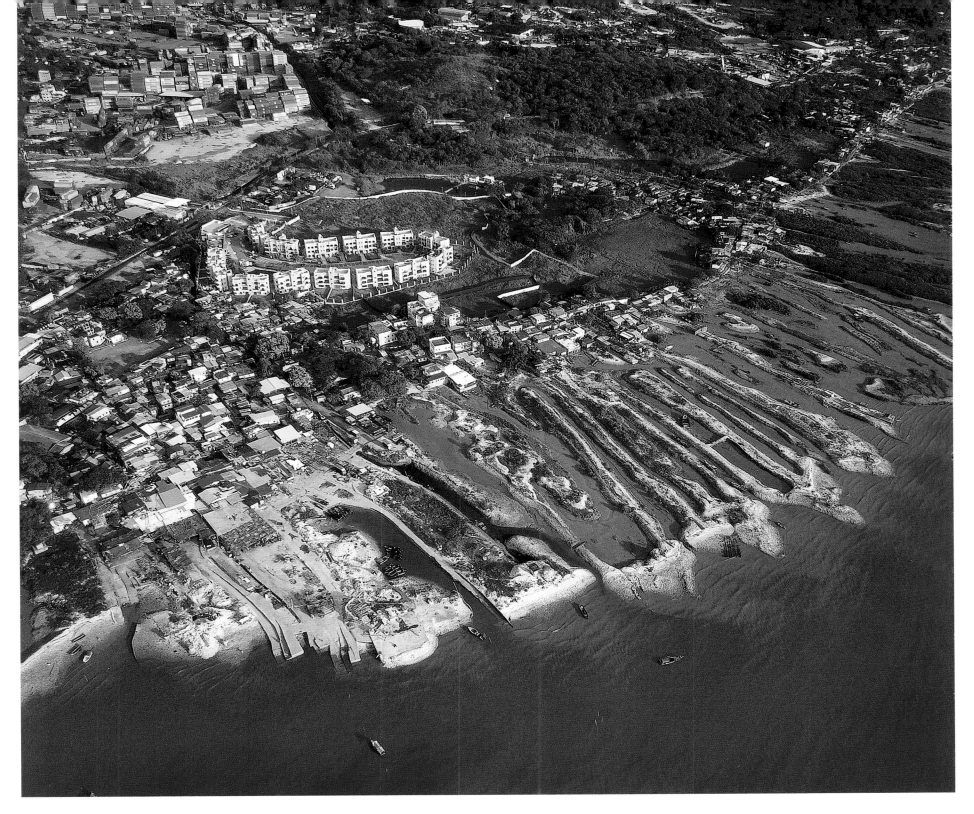

Lau Fau Shan Lau Fau Shan on the shore of Deep Bay was traditionally a gourmet paradise for oyster-lovers until pollution severely damaged the industry. The situation is much improved but few families now continue to farm oysters. The curious rock-like jetties are mounds of oyster shells. In the top left hand corner of the picture is a glimpse of the New Territories modern business model, container storage.

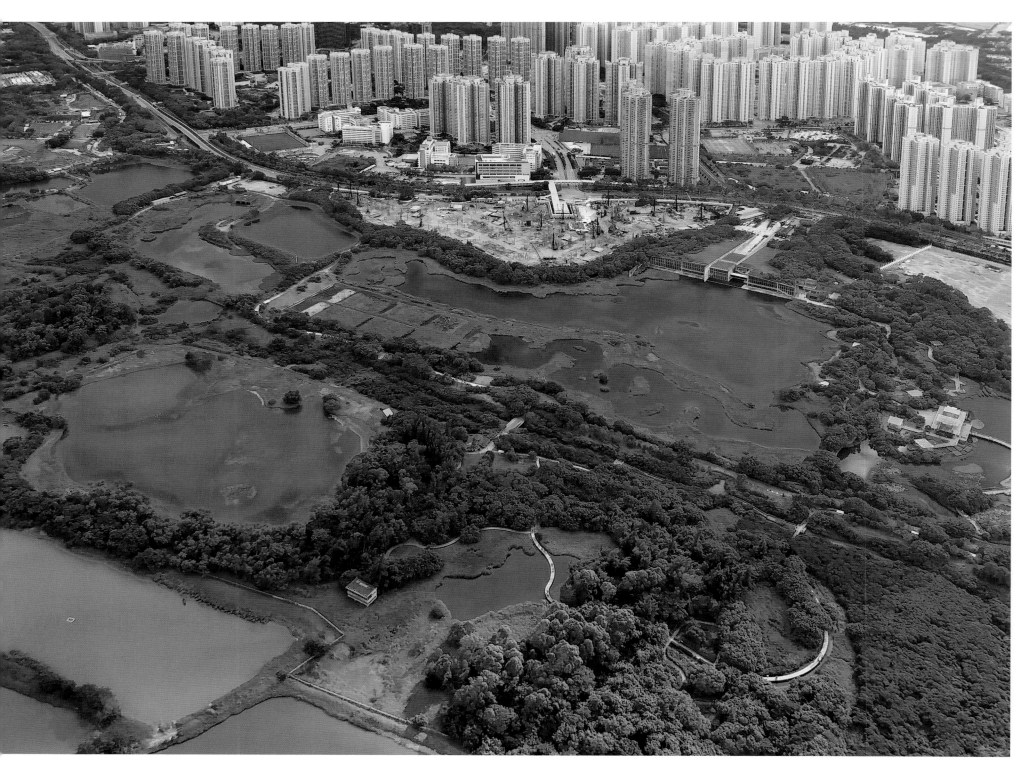

Tin Shui Wai With so much of the wetlands being lost to the development of Tin Shui Wai new town, the Wetland Park was initially established as an ecological mitigation area. In 1998, a government study decided that it was possible to expand the ecological function into an ecotourism attraction. Now the Park has a large visitor centre and the 60-hectare reserve divided into re-created habitats for water fowl and other wildlife.

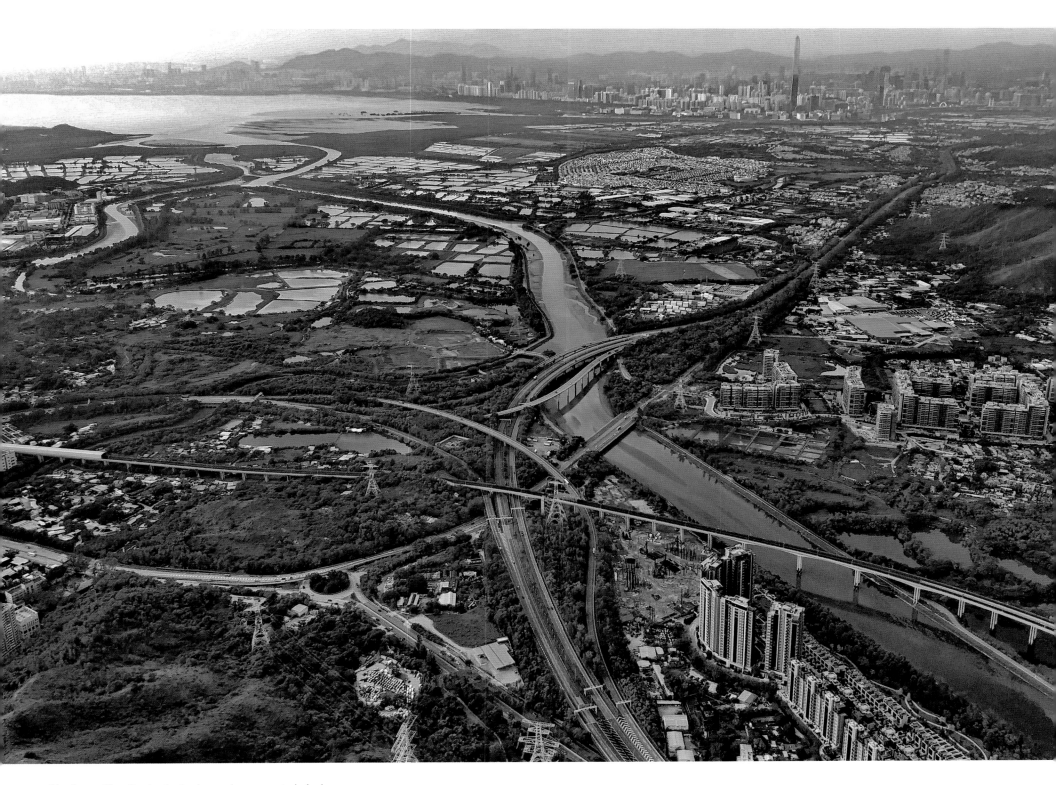

North-west New Territories In the north west particularly the New Territories presents an interesting contrast between the mix of unspoilt wetland and a patchwork industrial and residential development on the Hong Kong side of the border and the intensive built-up area of Shenzhen in the distance.

Below
Tuen Mun Today the face of Tuen Mun has further changed and the mix of light industrial areas and residential housing is apparent. One of the objectives of the new town policy had been to provide local jobs for the inhabitants. Sadly that has not come to full fruition and many people still have to commute into the old urban area.

Right
Tuen Mun Tuen Mun, or Garrison Gate, was a military port during the Tang Dynasty and in modern times was selected as one of the first new towns. Much of the land on which the town now stands has been reclaimed from Castle Peak Bay and the nullah in the centre of this 1982 picture is all that remains of the river that used to flow into the bay.

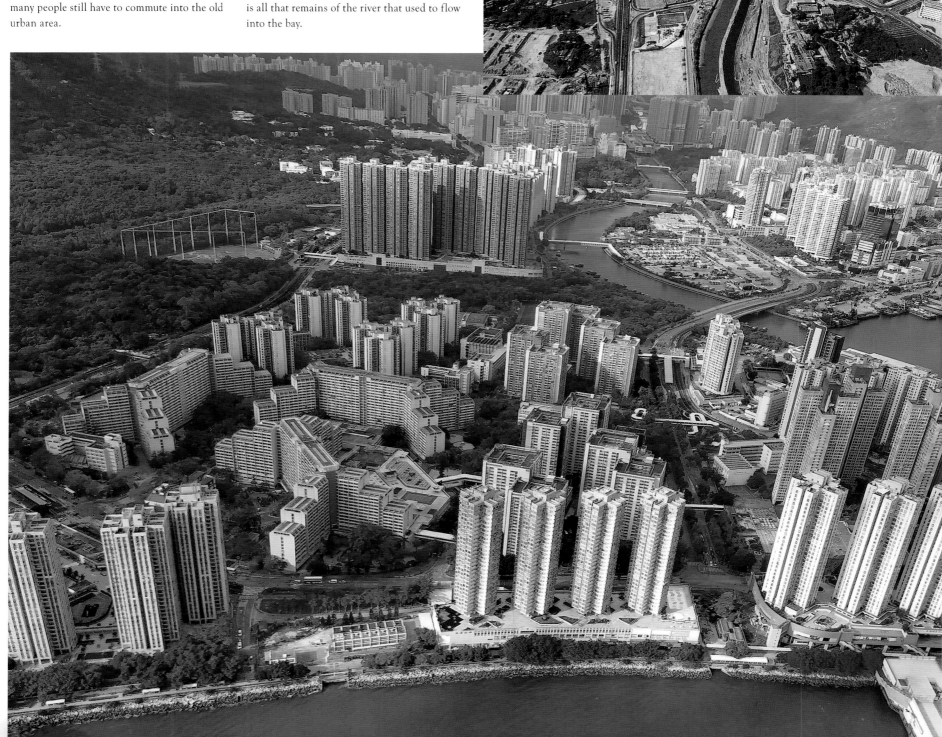

Gold Coast One aspect in which the city's property industry excels is thinking up exotic names for developments. Originally named Gordon's Hard after the general who played a large part in suppressing the Taiping Rebellion, the Gold Coast is a tourist resort in Tuen Mun district.

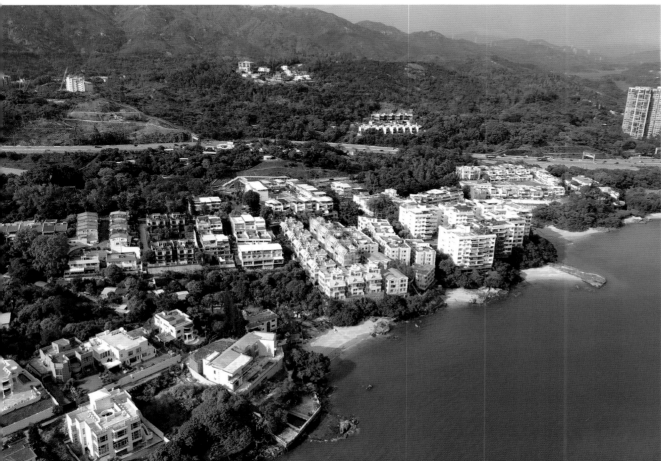

Siu Lam A little further down the coast from the Gold Coast is Siu Lam which has a mix of luxury and mid-range development. Just off to the left of this picture an old industrial area has been converted into a retail therapy facility, Lok On Pai Siu Lam Flea Market complete with barbeque area.

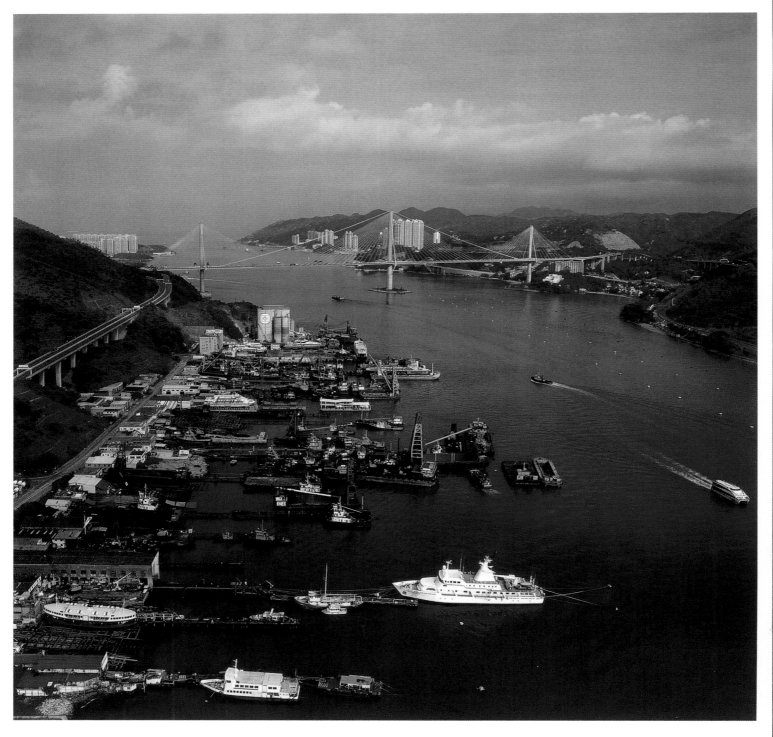

Above
Tsing Yi On the north side of Tsing Yi Island are some of the remaining shipbuilding and ship-repair yards in Hong Kong. Ting Kau Bridge connects Kowloon and Tsing Yi to the New Territories and carries Route 3 across the channel.

Right
Route 3 After crossing Ting Kau Bridge from Tsing Yi, Route 3 plunges into the Tai Lam Tunnel beneath Tai Lam Country Park on its way to the northern New Territories and the border. To the right of the picture the Tsing Ma Bridge leads off to the airport and, on the left, is Tsuen Wan and the northern entrance to the container port.

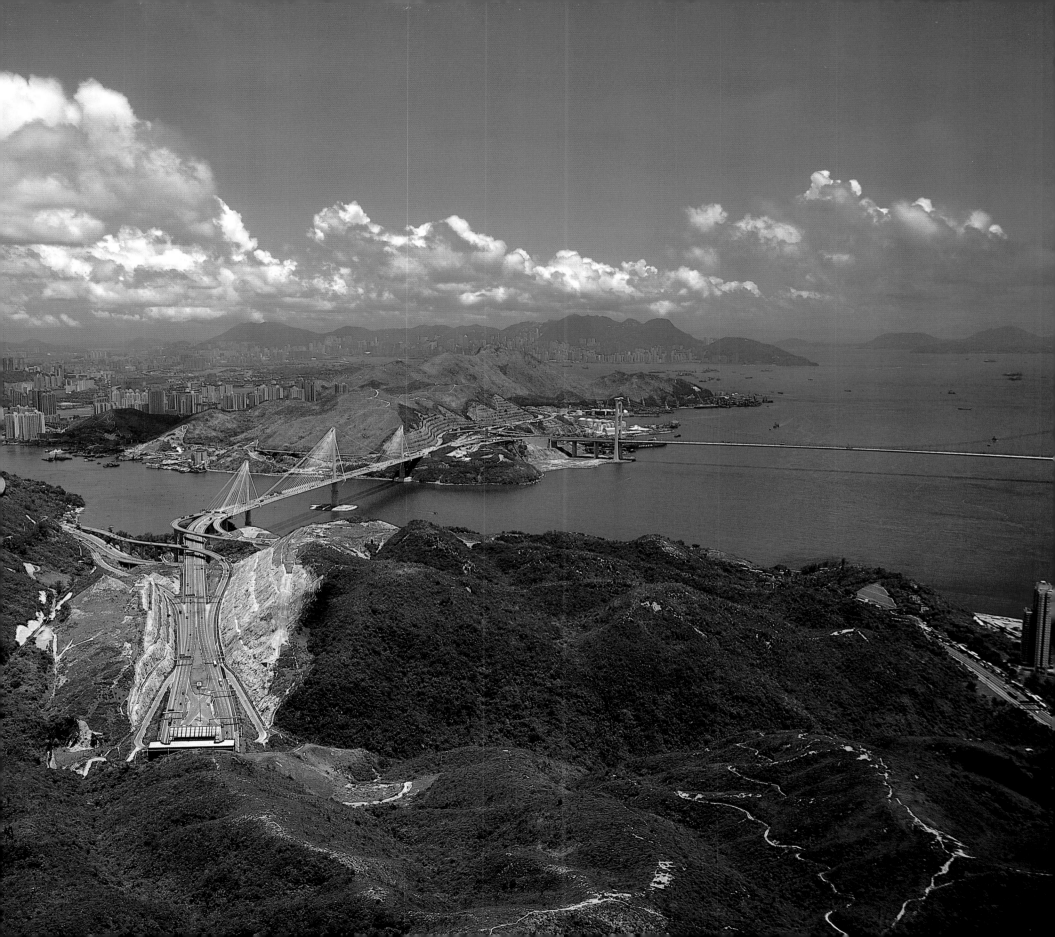

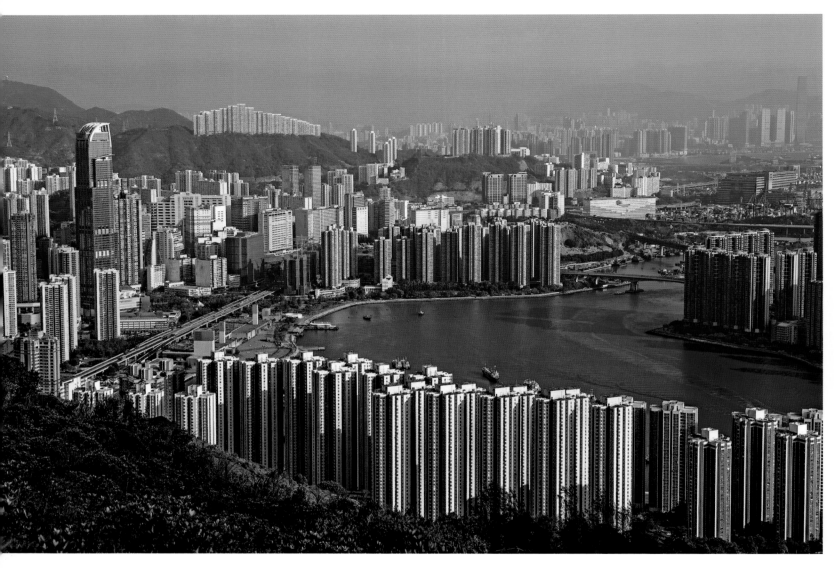

Above
Tsuen Wan The point at which the Rambler Channel turns to the west round Tsing Yi Island. Tsing Yi South Bridge that links Tsuen Wan to Tsing Yi was the first one to be built across to the island. The white block on the hill above Kwai Chung is Wonderland Villas – magnificent views but a bit inconvenient if you've run out of milk.

Right
Rambler Channel As the sun sets in the west, a glorious view of the Rambler Channel from Tsuen Wan past the Ting Kau Bridge.

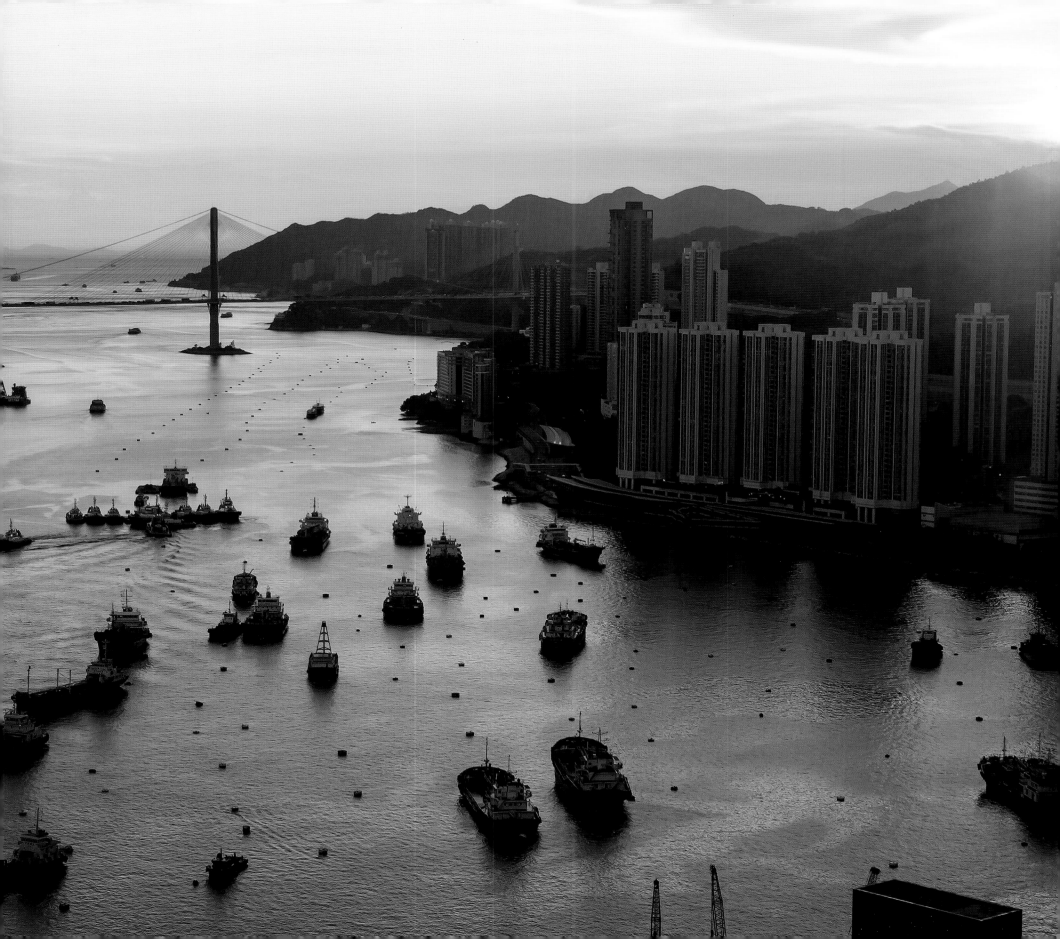

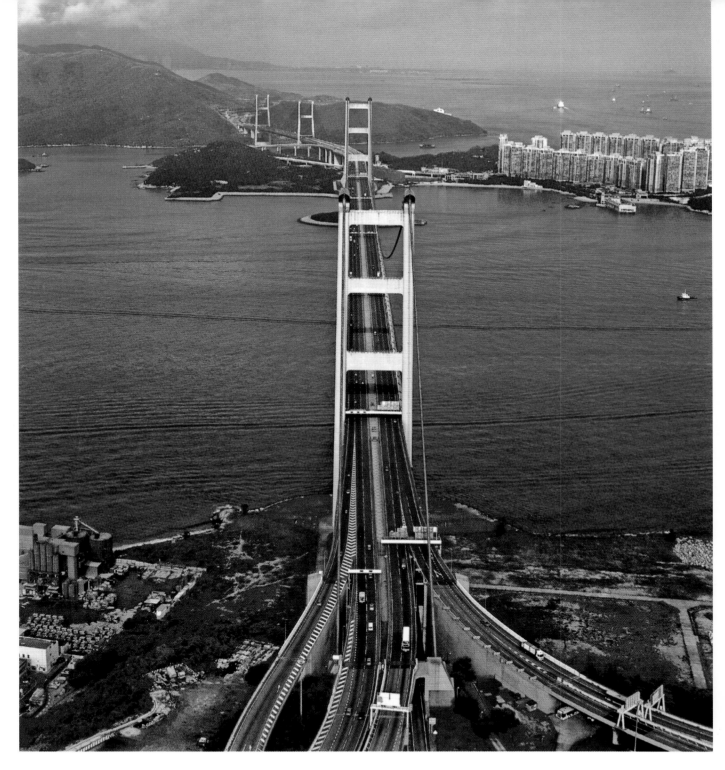

Lantau Link Until the construction of the new airport was almost complete, the only access to Hong Kong's largest island, Lantau, was by sea. For a busy international airport, this state of affairs would be unacceptable. So, the bridges of the Lantau Link were built. The stepping-stone was the island of Ma Wan where the Tsing Ma Bridge from Tsing Yi Island was joined by the Ma Wan Viaduct to the Kap Shui Mun Bridge crossing to Lantau. The bridges, which carry both road and rail traffic, were formally opened on 27 April 1997.

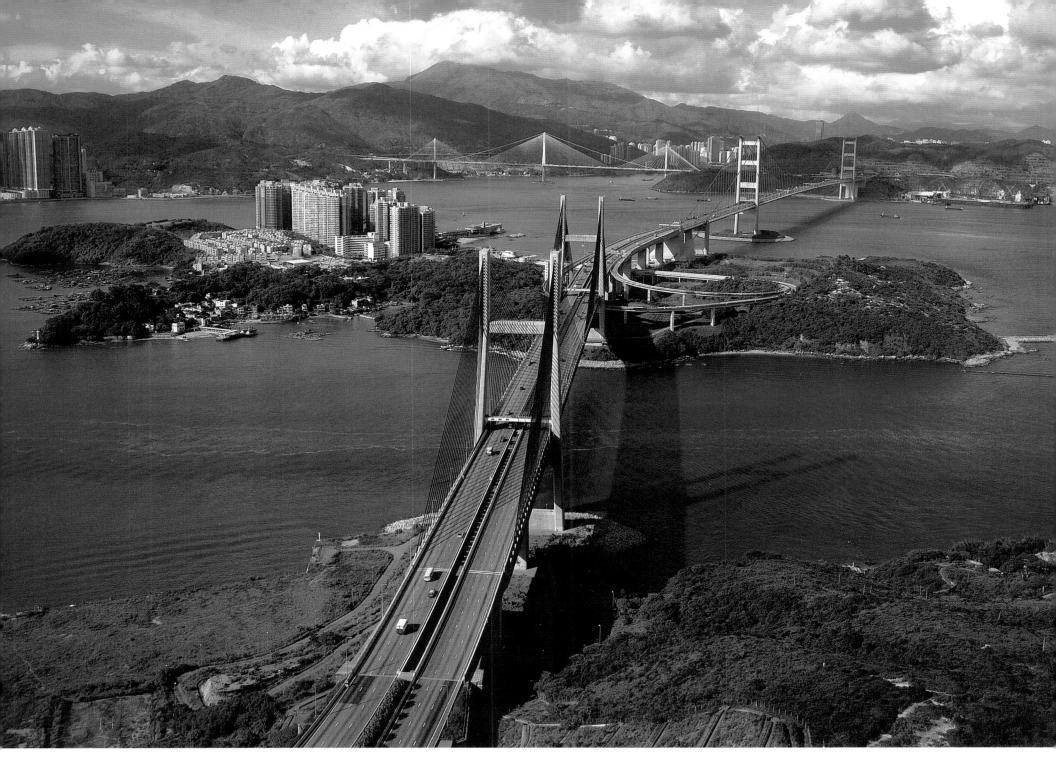

Outlying Islands

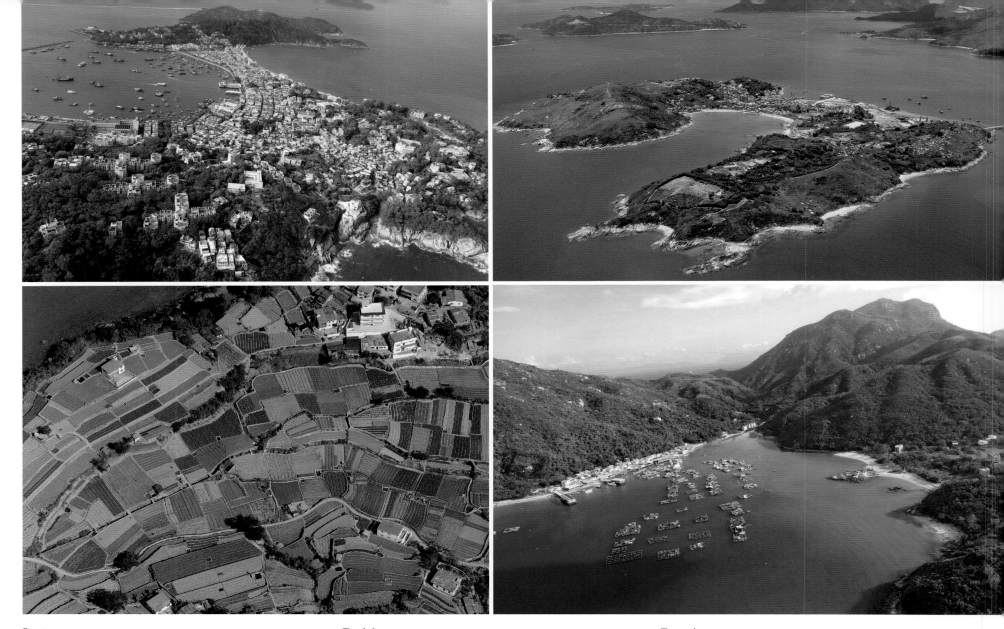

Previous page

Lantau Link The Kap Shui Mun and Tsing Ma Bridges are collectively the Lantau Link and both carry road and rail traffic. The island between the two is Ma Wan and the easy access offered by the bridges enabled the Park Island development, seen on the left-hand side. Though small, Ma Wan has a very long history of occupation; remains have been found dating from 5000 years ago.

Top left

Cheung Chau The centre "bar" of Cheung Chau is where the vast majority of the population live, many of whom commute daily to the city for work. The harbour used to support a significant fishing fleet, although nowadays, the scale of the industry is much reduced. The main economic activity is tourism-based with many local people escaping the pressures of the city for the weekend. The Cheung Chau Bun Festival is held every year, coinciding with the Buddha's Birthday.

Bottom left

Pak Kok Pak Kok Tseun is at the northern end of Lamma Island and, although farming is not now as intense as in this mid-1980s photograph, it still remains largely unspoilt and peaceful.

Top right

Peng Chau During the 1970s, the horseshoe-shaped island of Peng Chau had a busy industrial life making lime and matches. The Great China Match Factory was Hong Kong's biggest match producer until the advent of disposable lighters killed the business. In this 1985 photograph it is reverting to a more traditional peaceful lifestyle.

Bottom right

Sok Kwu Wan Sok Kwu Wan – Picnic Bay – is a small village on the east coast of Lamma Island. It is particularly noted for its seafood restaurants which, together with the fish farms in the bay, are the mainstay of the village economy. At the end of World War 2, this was a base for Japanese motor-boats packed with explosives in anticipation of an Allied invasion hidden in caves that are still accessible.

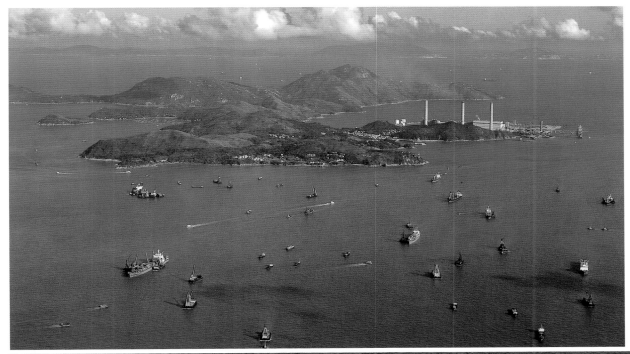

Top

Lamma Island Lamma Island, in this late 1990's picture, is the third largest of Hong Kong's islands and the site of Hong Kong Electric's power station. Most of the population lives on the western side in Yung Shue Wan – Banyan Bay – and the surrounding villages. The pace of life is very different to that of the city, more laid back and relaxed, and this makes it a popular weekend escape for city dwellers. There are no cars on the island; the only vehicles are small trucks used for transporting goods. People have to walk or bicycle.

Bottom

Waglan Island One of Hong Kong's smallest islands, Waglan Island is the first point of contact for ships arriving from the south. The lighthouse is automatic so no one lives there now.

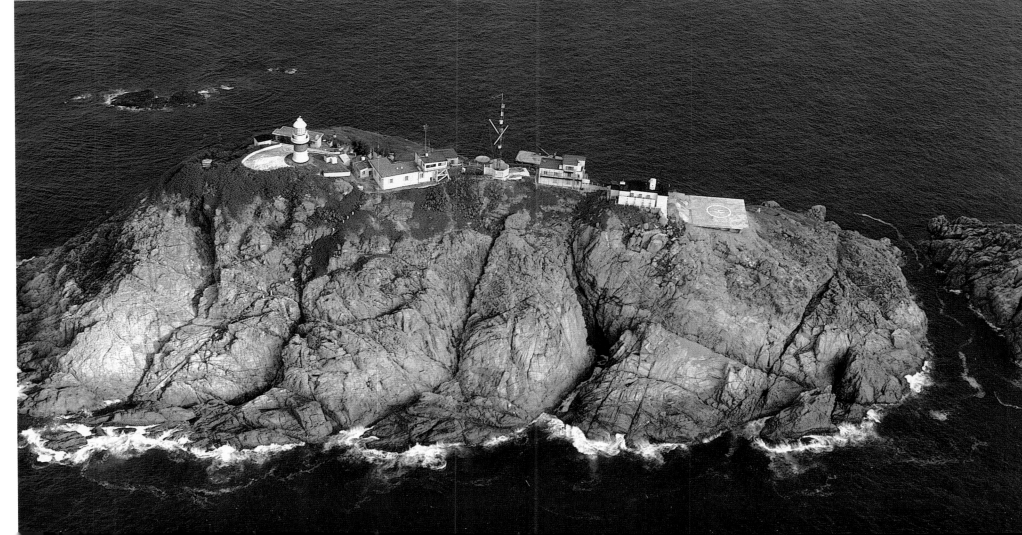

Mui Wo Until the opening of the Lantau Link, the ferry pier at
Mui Wo was the only regular point of access to Lantau Island,
and, indeed, it is still the main gateway to south Lantau. The
town has a long recorded history. The Southern Song imperial
court sought refuge here when fleeing from the Mongol hordes
in 1276. Emperor Bing, the last Song emperor, was enthroned in
Mui Wo in 1278. The alternative name for the town is Silvermine
Bay, so-called because of the silver mines that operated in the
locality during the 19th century.

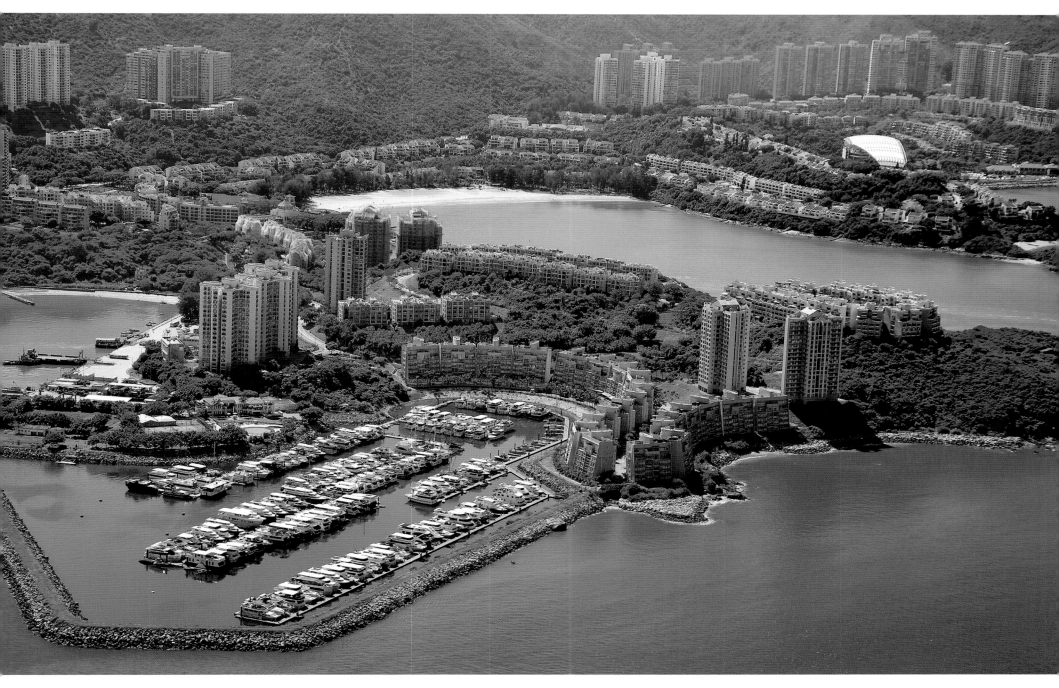

Above

Discovery Bay Discovery Bay is a private development on Lantau Island that was originally conceived as a resort facility–hence the name of the company owning and managing it, Hong Kong Resort Company. As well as up-market private residences the area includes some public recreational facilities. In the foreground is the membership-only Discovery Bay Marina Club and in the middle distance, Tai Pak Beach. The curved silver roof to the right is English Schools Foundation's Discovery College

Following pages

Ngong Ping The scene is timeless. Even though this picture of the Ngong Ping plateau on Lantau Island, is from 2000, today it is virtually unchanged. Po Lin Monastery was founded in 1906 as The Big Hut. It houses three Buddha statues and ancient Buddhist scriptures as well as being associated with the Tian Tan Buddha. With the coming of the cable car from Tung Chung to Ngong Ping village, the site has become a major tourist attraction.

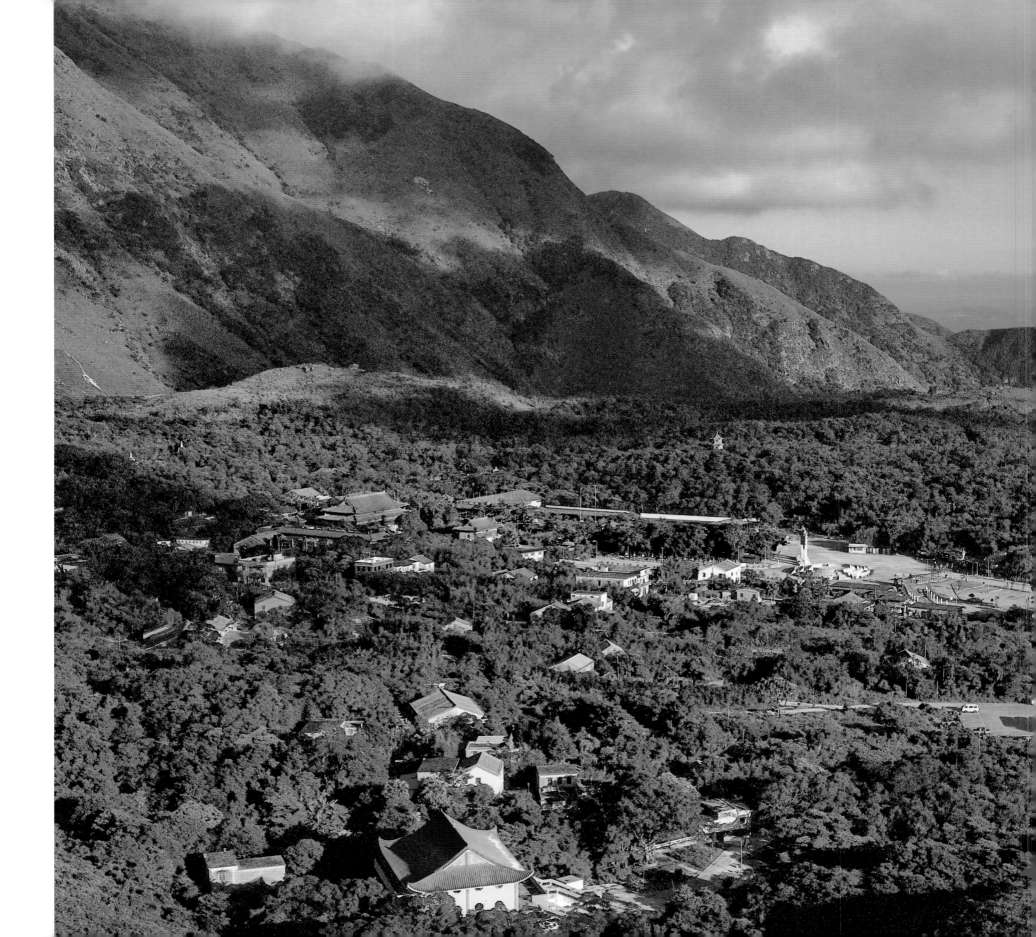

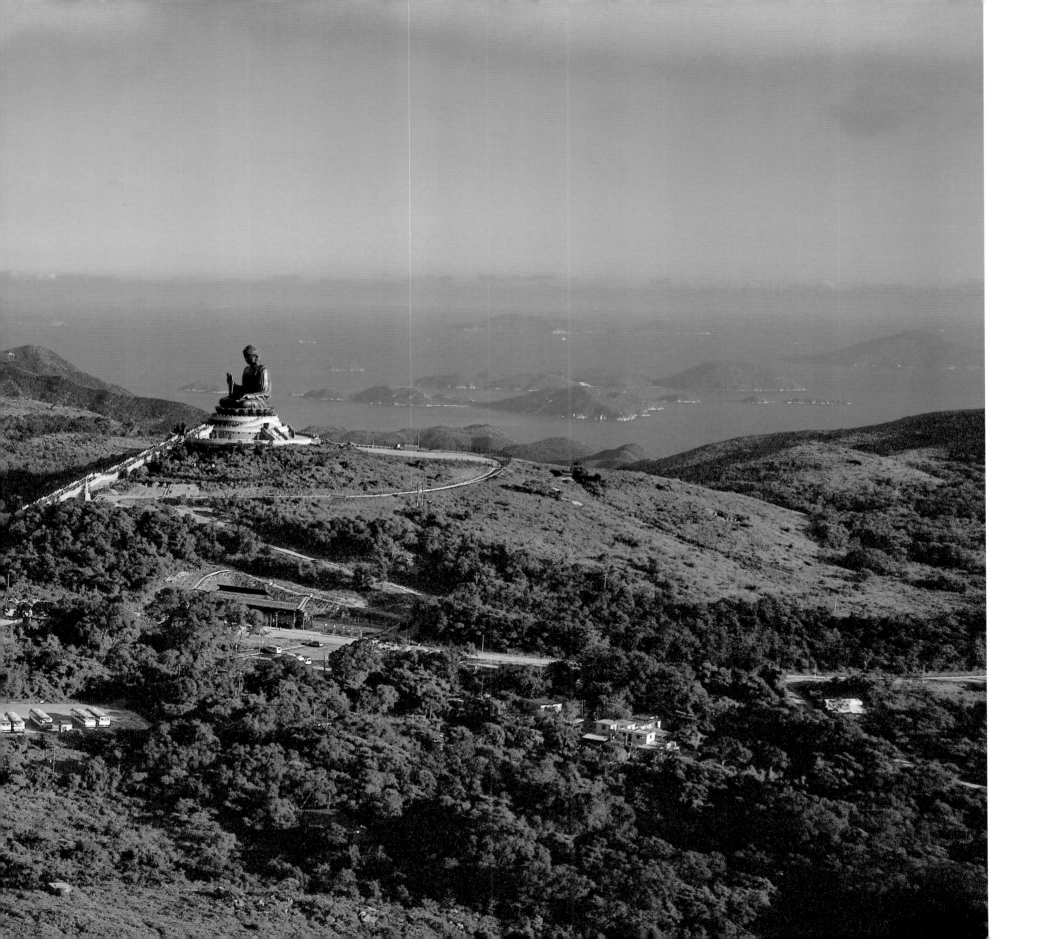

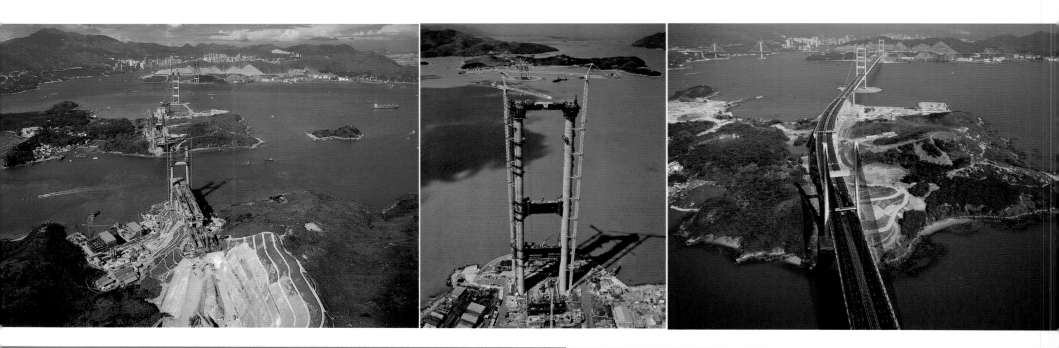

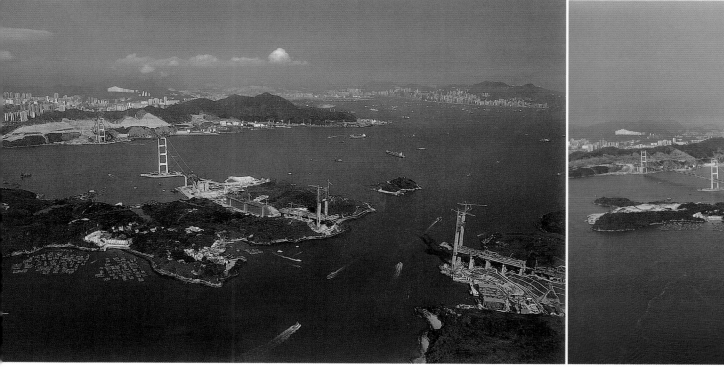

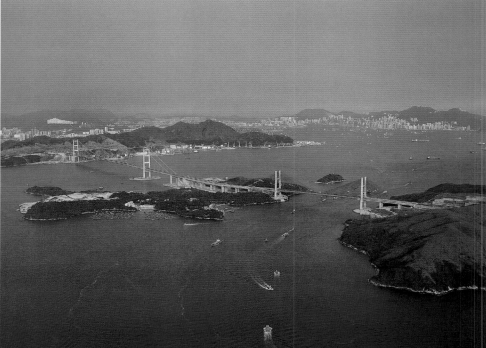

Building Bridges The Lantau Link was a key element in the new airport construction project. Without it, the challenge of getting passengers to and from the airport would have been immense and only possible by boat. Even today, 20 years after it was opened, it is the only road and rail access to North Lantau. The tiny island of Ma Wan is a vital stepping stone between Tsing Yi and Lantau.

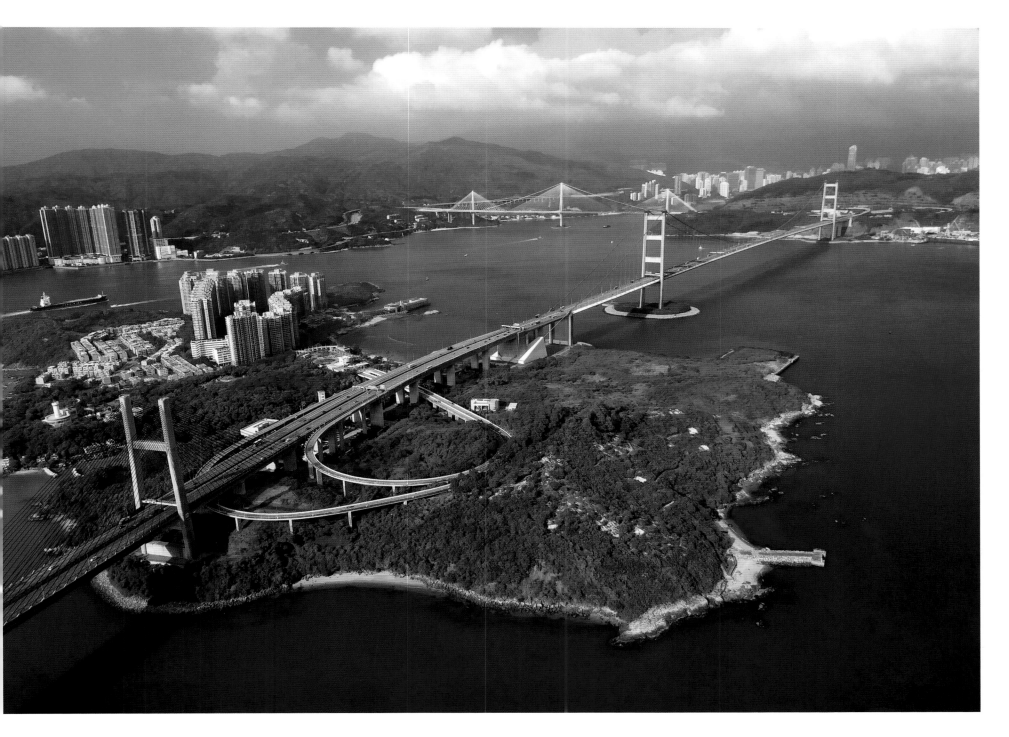

Ma Wan With the bridge complete, the opportunity arose to develop Ma Wan.
In this October 2017 photograph the Park Island development is complete and is
Hong Kong's first, and so far only, smoke-free estate.

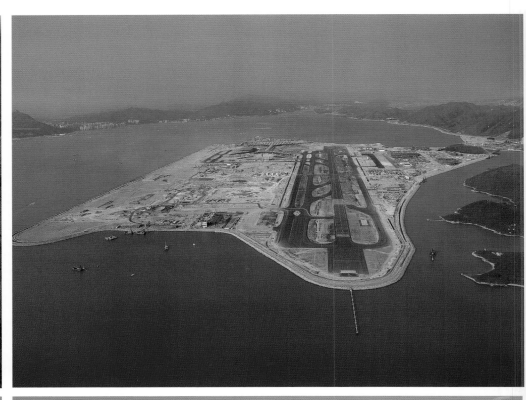
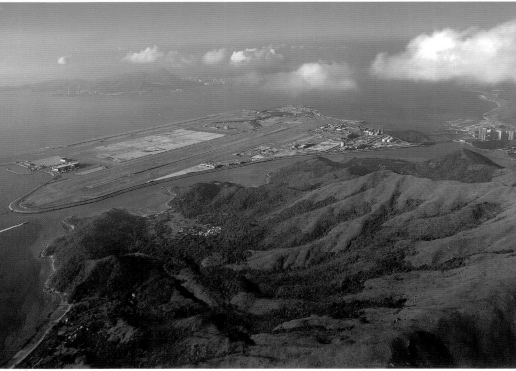
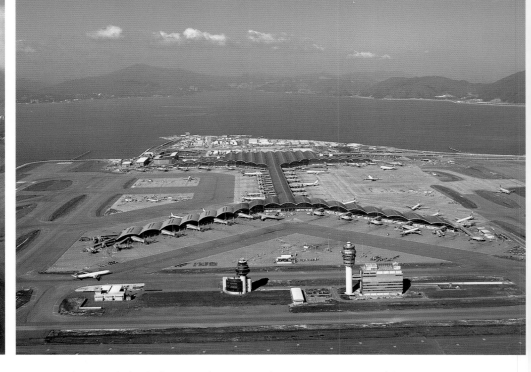

Chek Lap Kok The birth of an airport from the days prior to 1992, before construction started, and when Chek Lap Kok was a peaceful, obscure island off the north coast of Lantau to a major international aviation hub. The bottom right picture is the airport in 2003 viewed from the western end. In 2018, the airport celebrates the 20th anniversary of its opening.

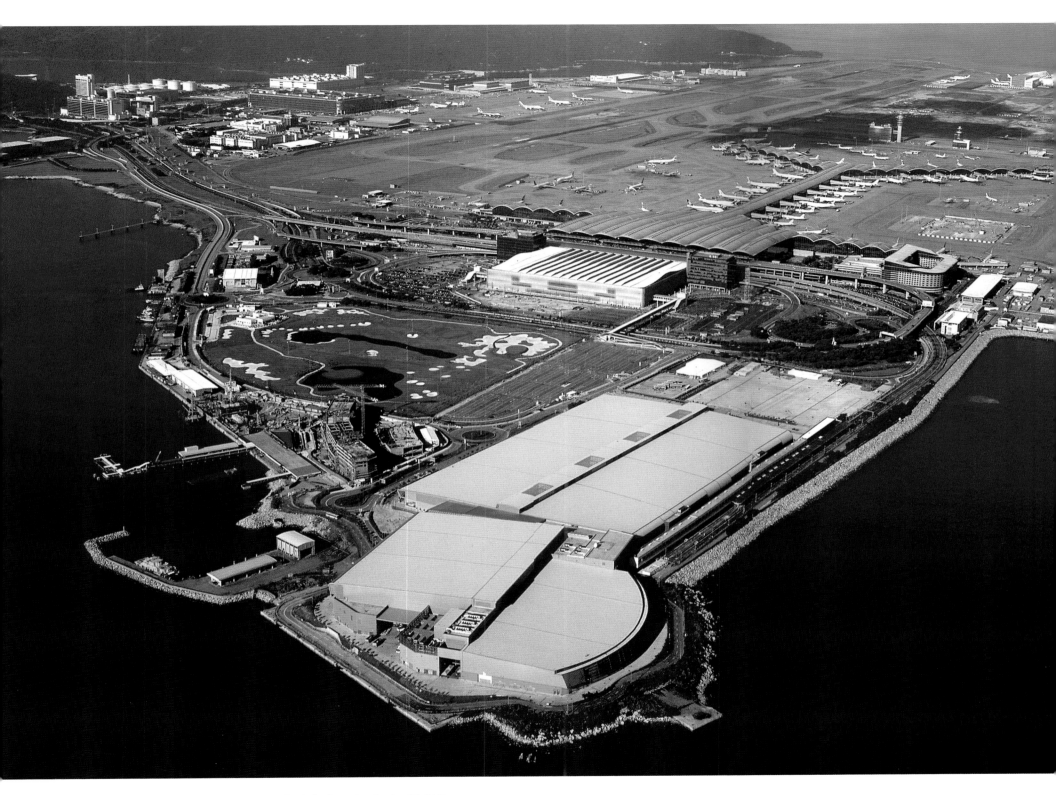

AsiaWorld-Expo As well as the airport, the former island also hosts hotels, AsiaWorld-Expo exhibition and conference centre and a golf course.

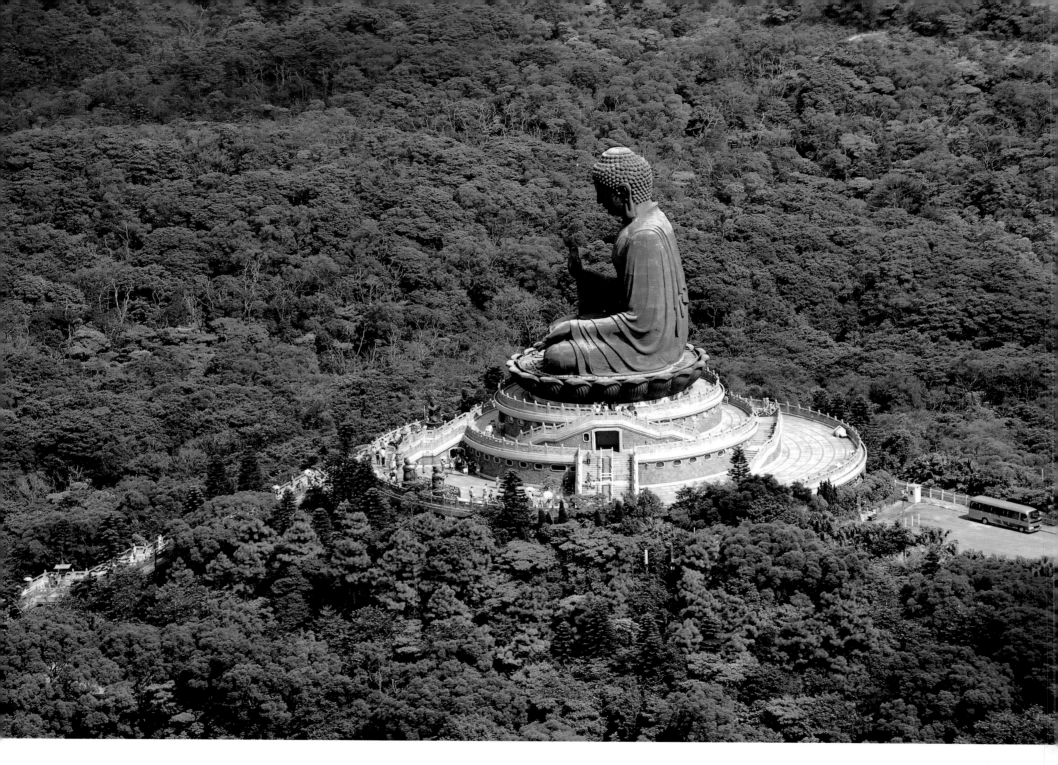

Tian Tan Buddha High in the hills of Lantau Island at Ngong Ping sits the Tian Tan Buddha which houses a relic of Gautama Buddha. Colloquially the statue is called the Big Buddha; in English Tian Tan means Altar of Heaven. Symbolising the harmonious relationship between man and nature, Buddha Shakyamuni sits serenely facing north, unusual in that all other great Buddhas face south. Po Lin monastery and Big Buddha together are a major centre of Buddhism in Hong Kong as well as being secular tourist attraction. The statue is 34 metres tall, making it one of the world's largest seated Buddhas, and built from 202 pieces cast in bronze. To reach the statue, visitors have to climb 268 steps, an act of devotion in itself.

New Technology

The Age of Drones

by D J Clark

A consumer drone introduced in early 2014 started a revolution in aerial photography. Designed and produced at the DJI headquarters in Shenzhen, the Phantom 2 solved three major obstacles to successful drone photography; a GPS lock which kept the drone in place, an electronic stabiliser eliminated the camera shake, and it was on the market for under USD1,000. For the first time in history, aerial photography was available to the masses.

Since the Phantom 2, there has been an explosion in the availability of consumer drone cameras. The machines and controllers have become smaller. Sensors, lenses, batteries, and obstacle avoidance have all been improved, as well as the range and height capabilities.

In contrast to the rapid pace of innovation is the question of legislation. Governments consider how much freedom to give the increasing number of drones in the skies. Incidents of invasion of privacy and public safety problems have occurred and these, naturally, make

headlines across the world. What the headline stories don't tell is the vast majority of times that drones have been flown safely and responsibly. The reaction of national authorities to the operation of drones is mixed. Some countries have simply imposed a blanket ban; others have introduced operators licences; yet others have opted for the bureaucratic solution of wait and see.

But for now, much of the world's skies are still open for photographers to choose a viewpoint, send up a camera, and take a perfect picture.

Previous page
The Wisdom Path Reminiscent of the computer technology of the Neolithic Age, the Wisdom Path is a series of 38 wooden steles inscribed with the Heart Sutra in the calligraphy of Professor Jao Tsung-I . Within a short walking distance of the Big Buddha the Wisdom Path is a place for calm contemplation. A drone is a fine example of modern-day computer technology that enables us to take a photograph of the Path from above without disturbing its peaceful air.

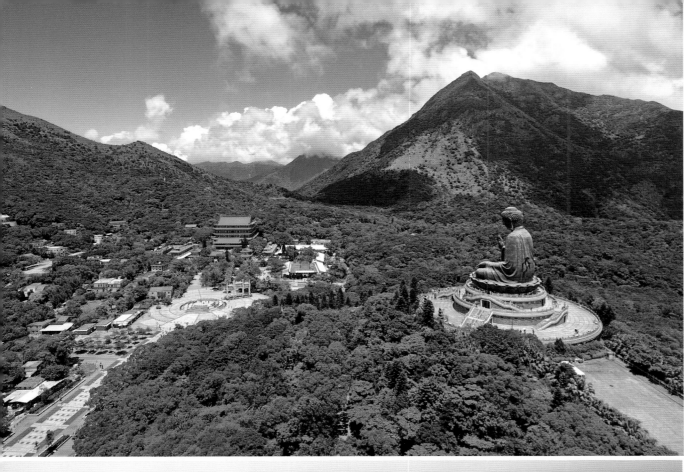

Monasteries Continuing with the theme of using modern technology to photograph religious sites without undue disturbance to their peace and tranquility, these two photographs feature two important monasteries in Hong Kong. The top picture is of the Ngong Ping Plateau on Lantau Island which hosts Po Lin Monastery and the Tian Tan Buddha.

The lower picture is of Tsz Shan Monastery in the foothills of the Pat Sin Leng Country Park near Tai Po. Dominating the scene is the 76 metre statue of Guan Yin, Goddess of Mercy. Although coated with a white, self-cleaning paint, the statue was cast in bronze and is the tallest bronze statue of Guan Yin in the world.

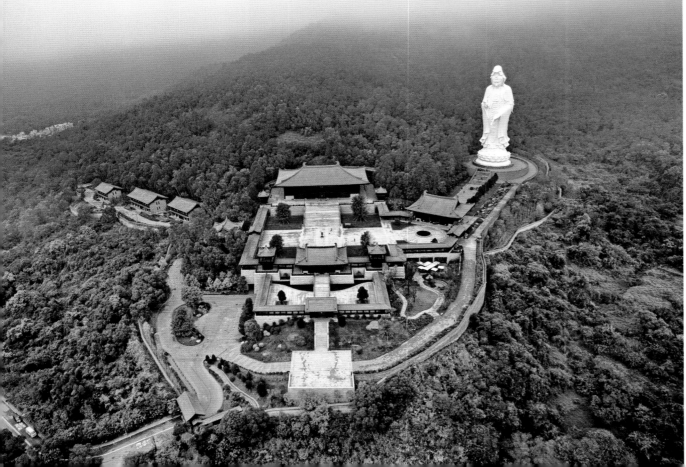

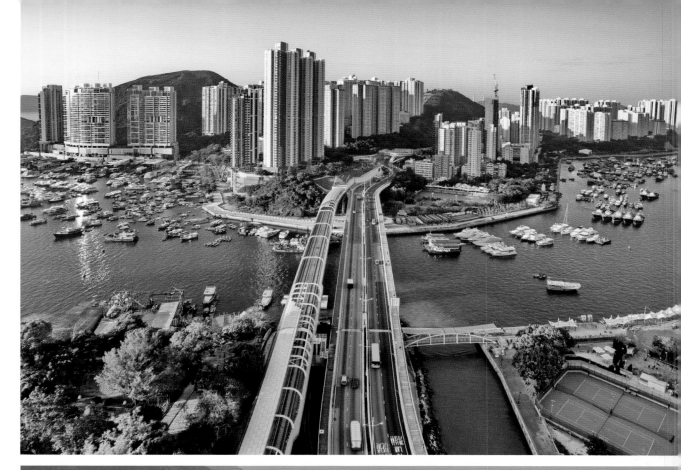

Top & bottom

Drones Drones are particularly useful for certain types of urban scenes where a helicopter flying low over buildings or open spaces would be liable to cause distress to people. In the top photograph, the viewpoint is low to accommodate the panorama of Ap Lei Chau yet featuring the road and new rail bridge over Aberdeen Harbour from Wong Chuk Hang.

By contrast, the lower picture of Tai O is one in which a drone has no technical advantage over a helicopter. The major difference, however, is one of cost and convenience. Flying time in a helicopter is expensive and transit time from base to the location has to be included. On the other hand, the capital cost of a drone is relatively low, operating costs minimal and, above all, man-portable. To paraphrase what D J Clark said in the close to his introduction, "Pitch up, launch and snap".

Tai O, on Lantau Island, is the furthest west point in Hong Kong that is inhabited. Apart from that, its main claim to fame is the remarkable collection of stilt houses that make up the older parts of the village.

Opposite page

Dragon boat racing is a popular sport in Hong Kong. The scene above was taken at the end of a day's racing when all the participants congregated for the prizegiving ceremony. This type of shot is not easy from a helicopter which would be noisily intrusive. A clue that this was taken by a drone is that, apart from one man taking a picture of the drone, no one is looking up to see what is happening, a tribute to the unobtrusiveness of the machine.

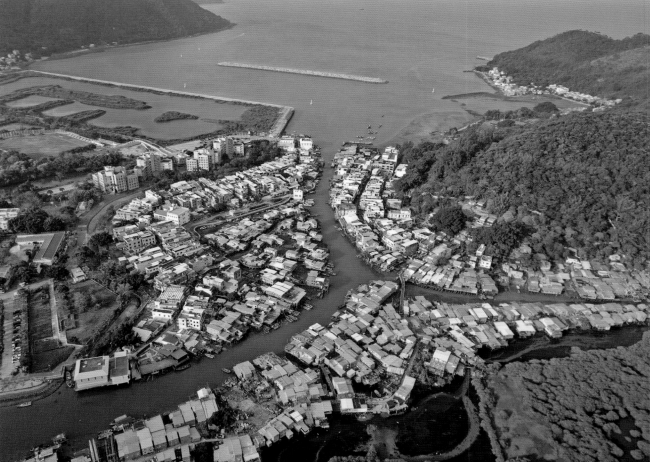

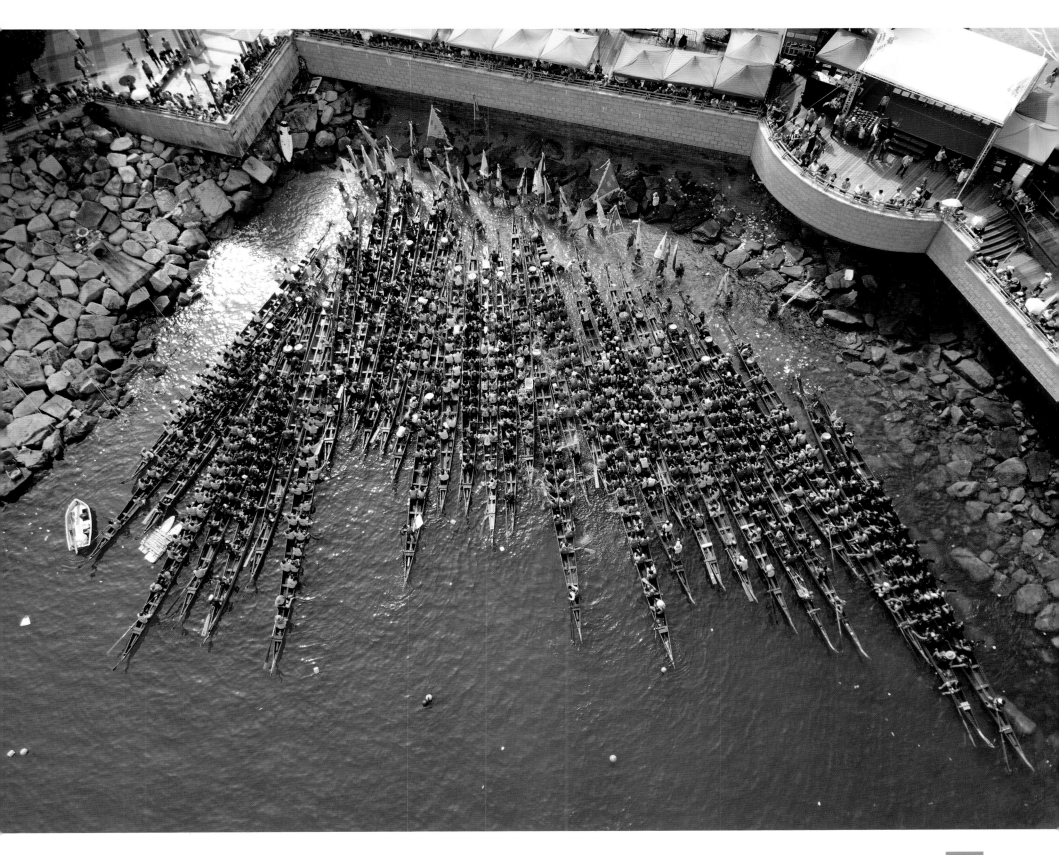

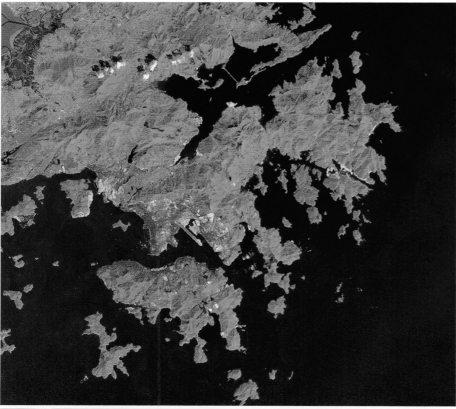

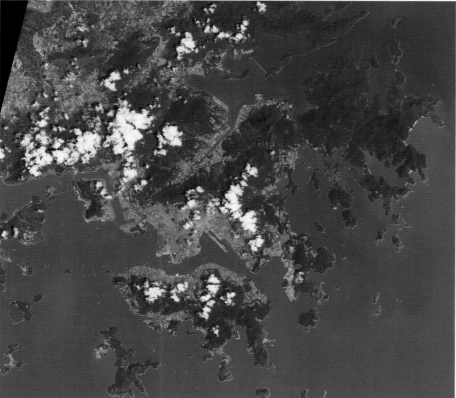

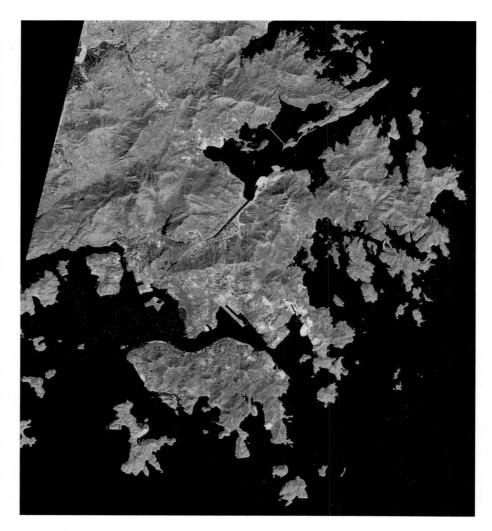

Satellite Photography The ultimate in remote photography is from satellites. The three pictures on this page are of Hong Kong in 1973, 1989, and 2017. Apart from the greater detail apparent from the increase in resolution from 80m in 1973 to 15m today, the amount of reclamation and the changes in land use are very striking.

The picture on the opposite page was taken from 700 km above the earth by Landsat 8 on a sunny day in August. Even reproduced at this small size, it is amazing how much one can see; the remarkable urbanisation of the New Territories, the extension of the container port, the bridges of the Lantau Link and the new Hong Kong-Zhuhai-Macau Bridge.

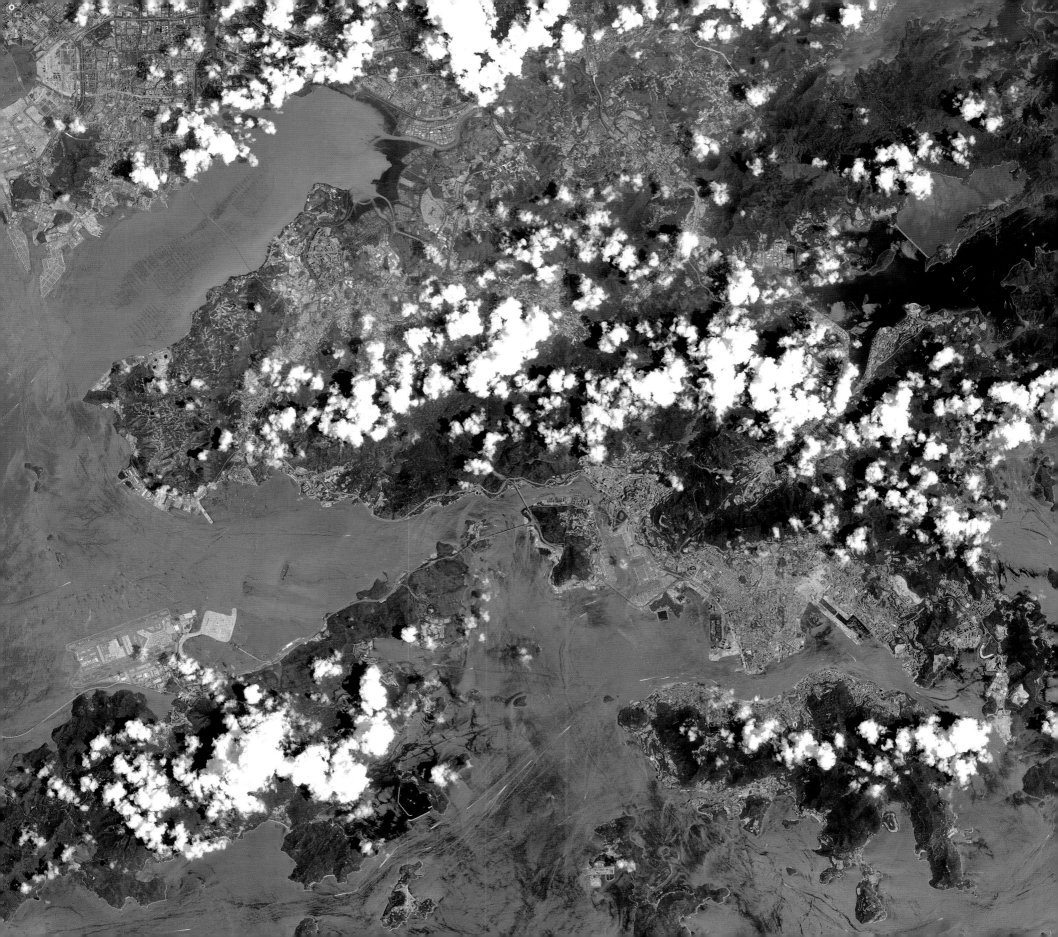

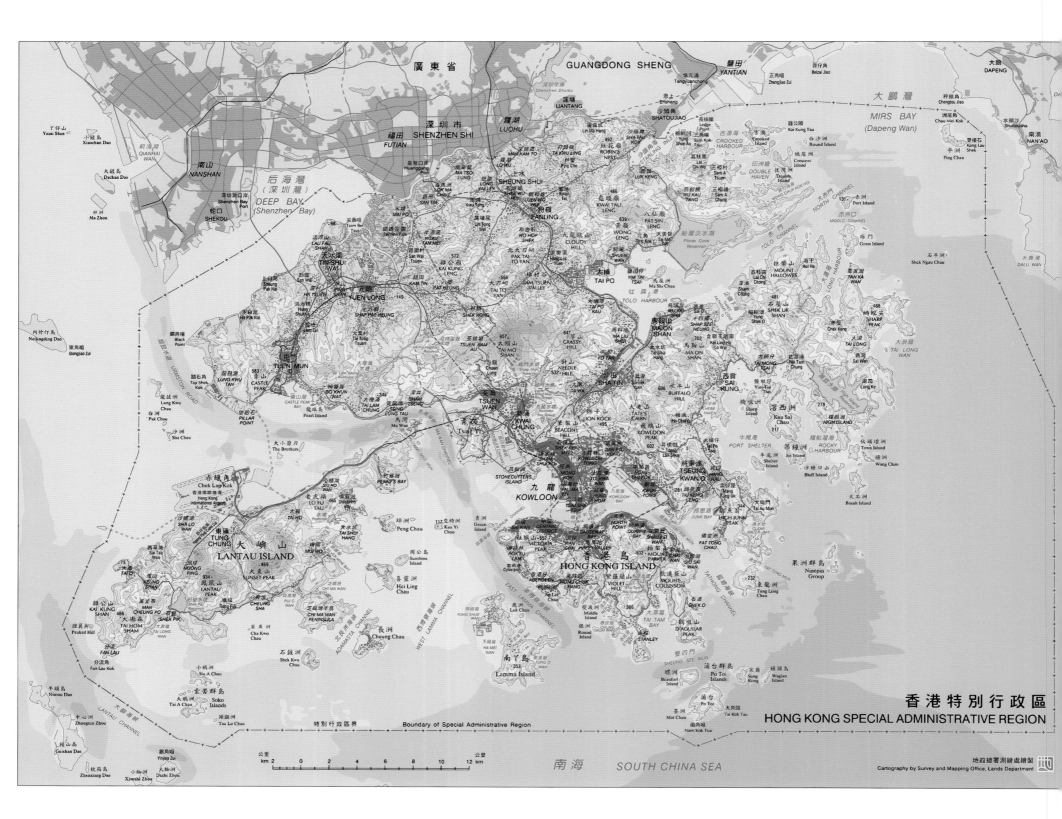

Index

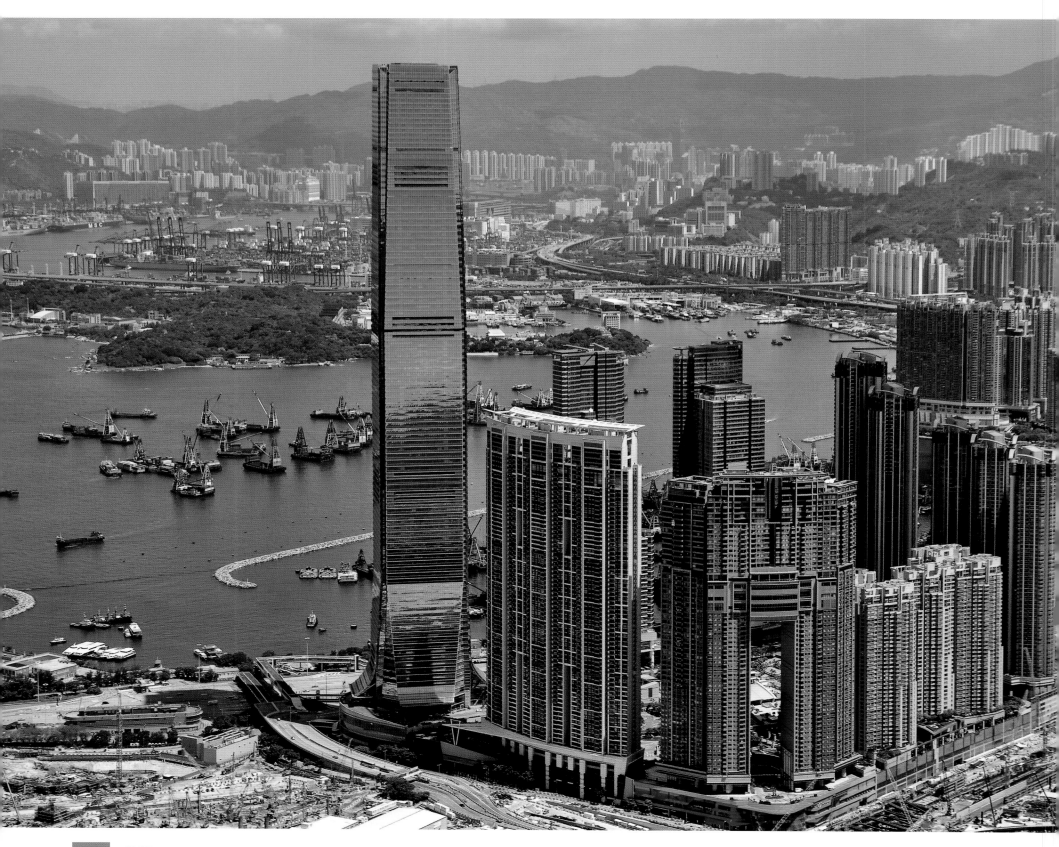

Postscript

YIP Dicky, Peter, BBS, MBE, AE, JP

Viewing Hong Kong from the air is the best way to appreciate the great diversity of Hong Kong's scenery. The fact that over 60% of land in Hong Kong is not developed is easily noticeable from above. Readers of this book will enjoy Hong Kong's beautiful green hillsides, blue seas, large and small islands as well as magnificent buildings and the fascinating interweaving of bridges and roads.

As a book celebrating 35 years since the publication of the first volume, the historic aerial photographs demonstrate the growth, energy and foresight of the changes to the city that have taken place.

As an aviator myself, I wish to pay tribute to the pilots and aircrew and all those associated with the production of the magnificent aerial shots, by day and by night, seen in this publication.

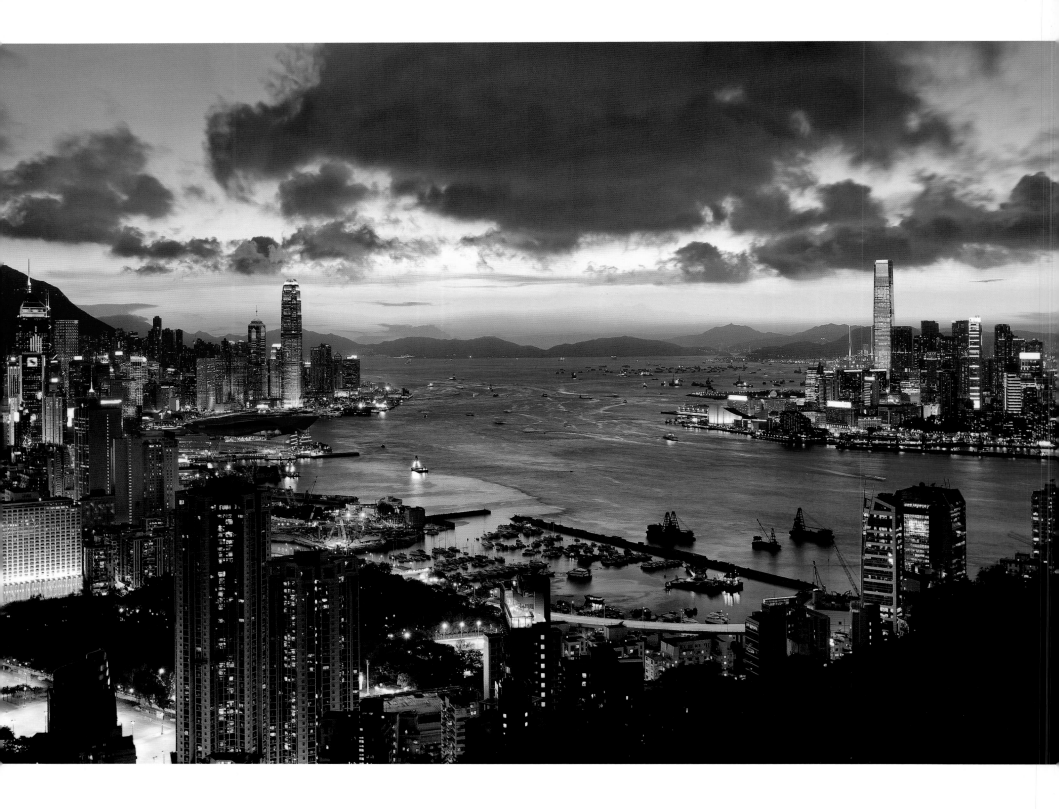